The Aesthetic in Education

CURRICULUM ISSUES IN ARTS EDUCATION

Series Editor: Malcolm Ross, University of Exeter

Vol 1 The Arts and Personal Growth

Vol 2 The Aesthetic Imperative

Vol 3 The Development of Aesthetic Experience

Vol 4 The Arts: A Way of Knowing

Vol 5 The Aesthetic in Education

Other title of related interest

MALCOLM ROSS
The Aesthetic Impulse

Related Pergamon journals *

EVALUATION IN EDUCATION

Editors: B H Choppin and T N Postlethwaite

The aim of this journal is to inform those involved in educational evaluation in both developing and developed countries of progress in the various aspects of the theory and practice in educational evaluation.

CHILDREN AND YOUTH SERVICES REVIEW

Editor: D Lindsey

An interdisciplinary forum for critical scholarship regarding service programmes for children and youths. The journal contains full length articles, current research and policy notes, and book reviews.

*Free specimen copies available on request.

The Aesthetic in Education

Edited by

MALCOLM ROSS
University of Exeter

PERGAMON PRESS
OXFORD · NEW YORK · TORONTO · SYDNEY · PARIS · FRANKFURT

U.K.	Pergamon Press Ltd., Headington Hill Hall, Oxford OX3 OBW, England
U.S.A.	Pergamon Press Inc., Maxwell House, Fairview Park, Elmsford, New York 10523, U.S.A.
CANADA	Pergamon Press Canada Ltd., Suite 104, 150 Consumers Road, Willowdale, Ontario M2J 1P9, Canada
AUSTRALIA	Pergamon Press (Aust.) Pty. Ltd., P.O. Box 544, Potts Point, N.S.W. 2011, Australia
FRANCE	Pergamon Press SARL, 24 rue des Ecoles, 75240 Paris, Cedex 05, France
FEDERAL REPUBLIC OF GERMANY	Pergamon Press GmbH, Hammerweg 6, D-6242 Kronberg-Taunus, Federal Republic of Germany

First edition 1985

Library of Congress Cataloging in Publication Data

Main entry under title:
The Aesthetic in education.
(Curriculum issues in arts education ; v. 5)
1. Arts — Study and teaching — Great Britain —
Addresses, essays, lectures. I. Ross, Malcolm, 1932–
II. Series.
NX343.A48 1985 700'.7'041 84–16625

British Library Cataloguing in Publication Data

The Aesthetic in education. — (Curriculum issues in arts
education v. 5)
1. Aesthetics — Study and teaching
I. Ross, Malcolm, 1932– II. Series
700'.1 BH61
ISBN 0–08–031843–6

Introduction to the Series

MALCOLM ROSS

This series of books springs from a particular
impulse: a feeling that those of us active in the
field of arts education must redouble our efforts
to ensure the greater effectiveness of our work.

The impulse is strong, the felt need a matter of
urgency, even emergency. It arose against a back-
ground of economic cut-backs and ideological re-
activism: the troubles besetting our society were
being identified not merely by the politicians and
economists but by the populace in general with the
alleged failure of the schools to produce suitably
trained personnel for the country's industrial and
technological needs. With the judgement that we'd
all been having it too good (and on the cheap).
And with the call to apply the strictest, most
utilitarian and cost effective criteria to an over-
all assessment of our society, the way it works,
the services it relies upon and the output it
generates. In such a climate we should expect the
arts, arts education, the life of feeling, intui-
tive knowing and the things of the spirit all to be
severely tested - and, as I write, the evidence
offers all too plain an endorsement.

But I should like to think that we might have
launched this project even in less searching times
- for the impulse is not merely a reflex act in
self defence as it were. Behind the decision
regularly to publish a collection of papers treat-
ing the arts in education not as separate subjects
but as a *single discipline* lies the conviction
that it is only through the recognition of their
common educational function (as distinct from
their separate several identities and processes)
that the arts will ever come to play the signifi-
cant part in the education of everyone, young or
old, artistically gifted or otherwise, that we
confidently proclaim they should. It is because
we feel that arts teachers, artists and everyone
involved in arts education wherever and at what-
ever level they work must find common cause, dis-
cover their common interest and express themselves
as far as possible in a common language, that this
series has been conceived. Our hope is that these
books - and the conferences from which, in large
measure, they will derive - will make a useful
contribution to the establishment of this sense of
identity and towards the strengthening of the
hands of individual teachers in their efforts to
create the appropriate grounds for their encounters
with those whose feeling lives they seek to en-
liven and enhance.

 MALCOLM ROSS

Preface

This series was launched five years ago. At the
time the Great Debate was in full swing and, as
the Introduction to the series makes clear, there
was a widespread feeling among arts educators that
the claims of the arts were being largely ignored
and that we would need to assert ourselves
urgently or risk being pushed to the wall. The
sentiments expressed in that Introduction seem no
less relevant today than they did then - which is
why I have chosen not to rewrite it. It would not
be difficult to argue that the signs remain dis-
tinctly inauspicious though, as I shall want to
suggest, we would be wrong to take too jaundiced a
view. Sir Keith Joseph's New Deal - the
"Sheffield" speech in which he signalled his plans
for raising standards and establishing a more
fully co-operative relationship with the teaching
profession - whatever one might think of its
likely impact (it was greeted enthusiastically in
most quarters), made only passing mention of the
arts. His address in June 1984 to the Confeder-
ation of Art and Design Associations, whilst
endorsing the importance of the arts for all
children, was heavily weighted towards design and
largely preoccupied with the issues of profit and

business efficiency. The cry seems to be for more
examinations to improve pupil motivation, and for
a greater emphasis upon science learning and pre-
vocational training as a long-term solution to the
nation's social and economic ills. Meanwhile the
Manpower Services Commission and the Department of
Trade and Industry seem determined to extend their
stake in formal education. In other words, there
is little evidence to suggest that the top people
have tempered their functionalist and benighted
perception of the kind of education the country
needs. And that despite the urgent and eloquent
arguments carried by the Gulbenkian Foundation's
report, *The Arts in Schools*, addressed directly to
the Secretaries of State. In terms of the arts as
a whole - i.e. of the larger community to which
arts educators belong - the scene is equally grim.
There is wide condemnation of the Government's
proposals to abolish the metropolitan councils and
the GLC. The Arts Council budget is palpably
inadequate and its redistribution of available
funds, whilst welcomed in the regions, brings
hardship and threatens worse to many established
and experimental concerns. All of which would
seem to suggest that we are being drawn steadily
deeper into the wood.

In this context it is interesting to look at the
response of the arts. I have already mentioned
the Gulbenkian Report, certainly the most pres-
tigious counterblast to be directed at the walls
of Elizabeth House. It is difficult to gauge its
actual impact, despite a recent glowing and opti-
mistic account carried by the *Guardian* newspaper.
Undoubtedly it has been widely read (it is,
apparently, the Foundation's own best-seller): one
senses, however, that all that cogent and carefully

articulated argument works best with those who
need no persuasion, and has actually done little
for the plight of the teacher in the classroom.
Open criticism of the document by arts educators
themselves has been understandably muted since
everyone must recognize the importance of closing
ranks in times like these.

This past year, however, has seen a whole crop of
important developments, many in more or less
direct response to Gulbenkian. In November 1983
the National Association for Education in the Arts
was established after a series of exploratory
meetings at the London University Institute of
Education. The aim of the Association is to
improve links between the different arts interests
in education and, as occasion demands, to lobby
for arts education on particular issues. It is
still too early to judge the likely value of this
initiative: everything will depend upon its per-
ceived credibility within the profession. (Its
first full conference was very strongly supported.)
Much the same has to be said of the National Lobby
for the Arts, established early in 1984. The con-
cern of this group (and another calling itself the
British Arts Voice) is to represent the interests
of the professional arts in the national debate
about the development and distribution of resour-
ces. Perhaps the bravest and potentially most
effective initiative has come from Ken Robinson
and Jonathan Croall whose new monthly arts journal,
Arts Express, made its first appearance in
February 1984. If the idea catches on - and
everything will again depend upon the paper's
appeal to the arts shop-floor - then we have a
potentially powerful instrument for marshalling an
informed body of opinion. Behind its inception is

the belief that much of the failure of the arts to
influence educational decision-making is attribu-
table to a degree of pernicious insularity whereby
each art discipline has, in the past, jealously
(even complacently) guarded its own territory and
its own identity. Such a view, this paper rightly
implies, is now no longer tenable - and, as its
initial success seems to imply, no longer represents
the way arts teachers are thinking and feeling.

In many respects the signs and portents are more
encouraging than they have been for years. The
Arts Council has doubled its educational budget,
which has to be seen as a resounding endorsement
of the work of Sue Robertson and her colleagues.
The DES has finally published the Assessment of
Performance Unit's "Aesthetic Development" Report,
which, despite its patchy quality and the Depart-
ment's adamant decision to withold research and
development funds, is likely to reawaken interest
in the assessment issue amongst arts educators.
The somewhat prolific outpourings of the Further
Education Unit include a trenchant document on the
Core Curriculum which strongly endorses the rôle
of aesthetics and of the creative arts. Channel 4
tv's excellent series of programmes, Questions of
Education, ended with an interesting and vigorously
argued account of the rôle of the arts by ILEA's
new Chief Inspector, David Hargreaves.
Dr. Hargreaves' own report on Improving Secondary
Schools is similarly supportive of the Arts. The
Society of Secondary Heads insists, in its paper
"View from the Bridge", that room must be found
for the arts in a radically realigned curriculum.
The National Book League is about to launch its
first travelling exhibition on The Arts in
Education. The educational journal *Educational*

Analysis published a volume entirely devoted to
the arts in November 1983. And there is rumour of
a new national arts project to be sponsored by the
Schools Curriculum Development Committee.

I think it is fair to say that nothing on this
scale was evident when this series began, and,
whatever one might feel about some of these manifes-
tations of collective fight-back individually, we
can and should take courage from the energy, care
and enthusiasm shown by all those responsible for
what, spelt out in this way, represents a not
inconsiderable achievement. Certainly no one could
accuse us of simply taking our punishment lying
down. I naturally hope the present volume will
prove a useful additional resource. Once again it
features papers presented at Exeter University's
Annual Creative Arts Summer School (Dillington
House College, July 1983) together with additional
material especially solicited. Contributors were
asked to apply themselves to the idea of the
aesthetic as a special dimension of education, and
the volume embraces what I think is an exhilarating
range of perspectives: philosophical accounts of
art, aesthetics and creativity; multi-cultural
education; the sociology of art; the arts in
further education.

Time alone, of course, will tell whether all this
activity will have any long-term effect. It is
difficult, looking back over, say, the past 10
years, to find a book, a report or a speech that
has had the same *practical* impact upon arts
education as, for example, the Bullock Report has
had upon English teaching. Clearly something as
comprehensive and as thorough-going is urgently
required. Without vigorous and stiff debate and

discussion among arts educators themselves, there
is little prospect of vigorous and relevant action
in schools and colleges. Still less is our work
to be understood and appreciated outside the arts
community. We are, however, seeing the emergence
of a critical discourse - and in so far as each of
us needs to be his or her own PR person, we have a
responsibility to engage with it. And whatever
else might be said about the initiatives I have
been reviewing, they do for the main part represent
a concerted commitment to mutuality. If our
leaders seem to manage their aloofness and indis-
tructability with somewhat daunting acumen, at
least we can point to a growing body of colleagues
actively committed to resisting the encroachment of
the threatened new Dark Age and determined to put
their own house in order as the only responsible
basis of a claim to full participation in what
Professor Tom Stonier has predicted will be the
nation's next boom industry: education.

Note: Details of publications and initiatives
 mentioned in this Preface.

 1. *The Arts in Schools* (£4 + 60p postage).
 The Calouste Gulbenkian Foundation,
 98 Portland Place, London W1M 4ET.

 2. The National Association for Education in the
 Arts - NAEA (Subscription £5, £2.50 not
 employed). Membership Secretary:
 David Elliott, Briar Wood, 28 Oakroyd Close,
 Potters Bar, Herts, EN6 2EN.

 3. The National Lobby for the Arts,
 Chairman: Peter Brinson, 39 Lord Road,
 London SW9 0AB.

4. *Arts Express*, Editors: Jonathan Croall and
 Ken Robinson (Price 75p, Subscribers 65p -
 Annual Subscription £7.80).
 66 St. John's Road, London SW11 1PT.

5. *Education Bulletin*, The Arts Council,
 105 Piccadily, London WC1.

6. *Aesthetic Development*, The Assessment of
 Performance Unit, DES, Elizabeth House,
 York Road, London SE1 7PH.

7. *A View from the Bridge*, The Secondary Heads
 Association, 26 Gordon Square, London WC1.

8. *Common Core Teaching and Learning*, Further
 Education Unit, DES, Elizabeth House,
 York Road, London SE1 7PH.

9. *The Arts in Education*, Travelling Exhibition.
 Andy Patterson, National Book League,
 Book House, 45 East Hill, London SW13.

10. The Arts in Education, *Educational Analysis*,
 Vol. 5, No. 2. Falmer Press, Falmer House,
 Barcombe, Lewes, East Sussex, BN8 5DL.

 MALCOLM ROSS

 Exeter University

Contents

Contents

Contributors

JOHN BLACKING, Professor of Social Anthropology at the Queen's University of Belfast and President of the Society for Ethnomusicology.

VICTOR HEYFRON, Senior Lecturer in Philosophy of Education, Worcester College of Higher Education.

PHILIP MEESON, Senior Lecturer in Art Education, Brighton Polytechnic.

HAROLD OSBORNE, Writer, philosopher, author of the *Oxford Companion to Art*, President of the British Society of Aesthetics.

RICHARD PRING, Professor of Education at Exeter University School of Education.

LOUIS ARNAUD REID, Professor Emeritus of Philosophy of Education at London University.

MALCOLM ROSS, Senior Lecturer in Education at Exeter University School of Education.

ALAN SIMPSON, Senior Lecturer Department of Arts
and Humanities Education, Manchester Poly-
technic.

JANET WOLFF, Senior Lecturer Department of
Sociology at Leeds University.

Introduction

John Blacking opens his paper by underlining two
complementary facets of musical experience.
Musical performance, he proposes, is both "a
public social act and a private rite of transcen-
dence". He goes on to argue that the notion of
multicultural education is inherently contradict-
ory, that it promotes misleading ideas of culture
and human creativity and that it is dangerously
opposed to artistic enterprise and to the culti-
vation of individual freedom and imagination.

Victor Heyfron analyses the concept *creativity* and
proposes that although two different activities
might both reasonably be described as creative, it
does not distort the term "to claim that one act-
ivity is more creative than another". He begins
his discussion by distinguishing between the
creative product, the creative process and the
kinds of value set upon creativity. He then
establishes a set of logical conditions governing
the usage of the term. He concludes by suggesting
that in artistic contexts the term is used to pick
out activities in which versions of these con-
ditions are present.

Philip Meeson, like other contributors to this
volume, is concerned about the kinds of arguments
used to justify the arts in education. He opens
his paper with a historical appraisal of
"aestheticism", tracing its use since the early
nineteenth century (in particular citing
Walter Pater's book, *The Renaissance*). He sees
the notion of "child art", popularized by
Herbert Read, as in the direct line of the con-
cept's development. For all one's reservations
about the élitism inherent in the aestheticist
position, Meeson senses within it the possibility
of "a true understanding of the nature of art".
He concludes by suggesting a practical programme
for the arts in education that might responsibly
accommodate the seemingly conflicting demands for
personal fulfilment and social relevance.

Harold Osborne divides his paper into two sections.
The first he entitles "The Ubiquity of the
Aesthetic", and the second "The Value of the
Aesthetic". He begins by suggesting that when we
speak of the aesthetic in education we are con-
cerned not so much with one subject among others
but rather with an attitude of mind and a mode of
awareness which permeates broadly throughout our
mental outlook and performance. Of works of art
he says, "they exist expressly to be used as
vehicles for evoking and sustaining aesthetic
awareness at a high level". In the second part of
his paper he gives his reasons for believing that
"the exercise of aesthetic sensibility is a skill
to be cultivated and trained".

Richard Pring looks at new developments in secondary
and further education and asks what likelihood
there is of some of the progressive ideas embodied

in the proposals for the Certificate of Pre-
Vocational Education leading to actual changes in
the institutions concerned. Without appropriately
funded staff and curriculum development work, it
may well be the familiar story: the more everything
changes, the more it remains the same. In par-
ticular he examines the theme of "creative develop-
ment" and poses some important and difficult ques-
tions for arts educators whose students are facing
"an unpredictable future" and for whom "the system-
atic study and practice of music, painting, or
dance has meant very little in the past".

Louis Arnaud Reid begins his assessment of the
aesthetic in the curriculum by exploring the
relations of different kinds of knowledge to
personal experience. He goes on to distinguish,
broadly, between the knowing and understanding of
the factual and the conceptual, and the knowing
and understanding of values. He finds scope for
"aesthetic delight" - what he calls "the discovery
of relative cosmos from relative chaos" - through-
out the curriculum. Clearly the arts subjects
have a special responsibility for the aesthetic.
Arts education has two sides: the cultivation of
aesthetic perception and the study of art. This
latter function has been undervalued in recent
years and needs re-asserting.

Malcolm Ross attempts to establish the arts as a
paradigm for research in education. He suggests
that the monopoly of the scientific approach
needs to be challenged; that the arts, as a dis-
tinctive way of knowing, offer the possibility of
valuable insights into areas of experience inimical
to more traditional methods. He takes as his
example what he calls "Open Group" work - an

approach to learning that is reality-based and
where creative learning is itself a form of
research. He concludes by relating his perception
of the conditions for an arts-based research to
Victor Heyfron's "conditions of creativity", set
out elsewhere in this volume.

Alan Simpson sees Utilitarianism - the practical,
well-intentioned view of things - in the well-nigh
impregnable position of being so thoroughly
embedded in contemporary language and thought that
it is part of our way of life. There is no denying
its value, despite the fact that the ends of utili-
tarianism are not only vague but also often
inadequate. Utilitarian aims have been attributed
in various guises to the arts in education: Simpson
argues that the instrumental, means-end model leads
to various justifications for arts education which
are difficult to substantiate but easy to dis-
mantle. Whilst not dismissing the utilitarian
arguments outright, he warns against their vacuous-
ness and proposes the corrective, traditional
notion of the unique value of aesthetic experience,
i.e. "disinterested interest". The arts are of
value in themselves.

Janet Wolff complains that most writing on arts
education fails to examine critically the key words
"arts" and "education". They can only properly be
understood in the context of the historical
development and present nature of our education
system and cultural heritage. Her analysis exposes
the ideological character and function of art and
education, particularly in relation to the
inequalities of class and of gender in our society.

A False Trail for the Arts? "Multicultural" Music Education and the Denial of Individual Creativity

JOHN BLACKING

MAKING SENSE OF MUSIC IN CONTEXT

The phonograph and the tape recorder have made us more aware of the importance of presence, context, and general human creativity in the invention, performance and appreciation of music. They have abolished what had been seen as essential differences between written and unwritten musics, between "art", "popular" and "folk" musics. Analyses of recordings of unwritten music have revealed that "folk" musics and some traditions of Asian "art" musics are much less improvised and more stable and systematic than had generally been thought; and recorded interpretations of written music have shown that even for the most scholarly and careful performers, the score is only an approximate guide to performance. Just as multiple recordings of a Beethoven symphony show that there are as many readings as there are orchestras and conductors, so recordings of apparently "spontaneous", improvised African musics reveal a consistency of performance which suggests that the musicians hold in their heads both the grammar of a musical system and the equivalent of a musical score.

1

The "presence" of musical performance is as significant for a solitary hi-fi listener as it is for an Igbo participating with several hundred other Nigerians in *egwu*, which incorporates in a single event song, dance, drumming, art, drama and costume. On the one hand, music is a social fact, whose meaning can be influenced by context, and listening is informed by experience of the symbols of a cultural system and of the life of feeling that is suggested by the public images of sentiment provided by art, myth and ritual. On the other hand, the act of making sense of music is private, and indeed music is generally considered to be most effective when it enables people to transcend context. Playing chamber music and singing in a choir are social events, and the pleasure of meeting other people is an incentive to regular rehearsal. But the great moments are those when one is absorbed in the music and oblivious of time and place. Musical performance is both a public social act and a private rite of transcendence.

The importance both of context and of transcending context are recognized in the aesthetics of many traditions of unwritten music. For example, in a study of the music of the Venda of Southern Africa between 1956 and 1958, I found that the three major styles of music - *ngoma*, *tshikona*, and *domba* - were so intimately associated with important social events, that it was impossible to distinguish between performances in which the music was considered ancillary to the impact of the social situation and those in which it was the crucial factor in people's experience. The musical could not be divorced from the social, and people's responses were influenced by their

different roles and by the contexts in which they
heard the music. But even when the effectiveness
of music depended very much on performance in the
proper social context, there were still *musical*
criteria that influenced the quality of experience.

There was a Venda song about loneliness and death
which I heard sung with great gusto at a party and
with no trace of sorrow. On another occasion, I
was talking to an old, blind master of initiation,
and he suddenly began to sing this same song. He
was about to stand up and dance when his son
stopped him, saying, "Don't dance, old man!"
Since his father was singing a sad song, he
thought he must be feeling sad and so there was no
point in intensifying the emotion by dancing,
especially as there was a risk that he might fall
and hurt himself. His son was visibly moved, but
when I asked him about the song he replied simply
that it was a *malende* song, giving it its formal
classification.

Ngoma dza midzimu (lit. drums of the ancestor
spirits) provided, by common consent, one of the
most powerful, affecting experiences in tradition-
al Venda society, but its effectiveness depended
on the context in which it was both performed and
heard. Anybody could dance *ngoma*, but only mem-
bers of the cult were "taken" by the spirits of
their ancestors, and then only when they were
dancing at their own homes, with which the ances-
tral spirits were expected to be familiar. More-
over, a dancer could not be "taken" unless
drummers, rattlers and singers provided a rhythmi-
cally steady, accurate performance of the music,
which enabled her to attain the right somatic
state. At every *ngoma*, at least four kinds of

people could be moved deeply by a good musical
performance. There were (1) members of the cult
group for whom *ngoma* was being held; (2) members
of the cult who came from other groups; (3) mem-
bers of the audience who chose to dance or play
the drums and performed well; and (4) members of
the audience, such as myself, who performed
occasionally or not at all. The first three kinds
of people, at least, appeared to have the same
intense musical experiences, but only the members
of the particular cult group were possessed.

How could the same music, played on the same
occasion and in the same context, affect individ-
uals systematically in at least four different
ways? In the first place, correct performance of
ngoma gave people the chance to experience a way
of feeling and relating to each other that was
different from ways of feeling associated with
other musical styles. The interdependence of
parts was based on polyrhythmic principles common
to all Venda music; but the tempo, the style of
drumming, the length of period and of solo and
chorus, were different and *felt* different. Assum-
ing that all four "types" of participant were
equally moved by *ngoma*, why were they not, for
example, all possessed? If those who would have
been possessed in another context were not posses-
sed, were they unmoved by the dance, or had they
not performed with the same energy? Such argu-
ments are irrelevant; for the crucial difference
between people's responses lay in the definition of
the other self who was invoked by the transcendent
state of the self.

Spectators (4) could share with *others* a common
group identity, and the communion enhanced by the

music was an end in itself. Good performers (3)
who were not members of the cult could share a
general *fellow-feeling* which transcended normal
sociability, in much the same way that all music-
making and dancing offered people different ways
of feeling. Members of other cult groups (2) con-
centrated more on expressing their *selves* as fully
as possible, without infringing the rights of the
members of the organizing cult group (1) to
exhibit their *other selves*, in the form of the
ancestral spirits who returned to earthly society
through their bodies.

These very personal manifestations of transcenden-
tal experience by members of possession cult
groups were special cases of the kind of shared
experience of individuality in community which
could be acquired by organizing patterns of social
interaction with musical symbols. Musical sounds
were produced by the rhythmical stirring of inter-
acting human bodies, and individual sensuous
bodily experiences were a consequence of correct
musical performance. Having feelings through
music could be an end in itself or a means to an
end, depending on the context of the feelings and
of the person having them. The surface sounds of
Venda polyrhythms can also be produced in a "non-
African" way; but in an alien environment, and
without the tension of the original performance
context, they cannot have the same significance
for performers and audience. They lose their art-
istic force, in much the same way as a string
quartet performed on a piano.

Context influenced the making of music in Venda as
much as its appreciation. Although there were
established "performance scores" which enabled

people to co-operate in producing the music which
allowed participants to have the personal
experiences described above, these "scores" were
always subject to individual variations which were
generated by differences in social situation.
Performances of a girls' *tshigombela* dance-song
lasted from ten to more than thirty minutes, dep-
ending on factors such as the time of day, the
size and status of the audience, the number of
girls and their musical experience. A formal
analysis of different performances was also an
expressive analysis of the quality of interaction
and decision-making of the participants. Simi-
larly, two performances of the same hymn by the
same Venda Christians during the same service, at
10.30 p.m. and 4.0 a.m., varied in tempo, texture,
and significance, because of changes in the mood
of the congregation and the topics of the service.

Venda responses to the challenge of context were a
consequence of general human creativity, which can
be manifested in music-making no less than in
speech and other activities. The notion that some
human beings lack musical capacities has been dis-
credited by studies of music-making in societies
where people are not categorized by the division
of labour into musical and unmusical, or musically
active and passive. Obviously, not all people are
creators of new musical styles. That is why I
distinguished in the opening paragraph of this
article between "general human creativity", which
is exercised whenever people make sense of music
as audience and as performers and to a certain
extent re-create it, and "invention", which is the
systematic composition of music.

The evidence of individual creativity and of the
significance of context in the understanding,
appreciation and making of music, forms the basis
of my criticism of so-called multicultural edu-
cation, especially in the arts. I shall argue
that the notion of "multicultural education" is
inherently contradictory, that it promotes mis-
leading ideas of culture and human creativity, and
that it is dangerously opposed to artistic enter-
prise and to the cultivation of individual freedom
and imagination.

CULTURE, CREATIVITY AND THE ARTS

This paper is concerned with some problems of arts
education in general, and music education in par-
ticular, in the context of what are currently des-
cribed as "multicultural societies". My views
about state responsibility towards its citizens'
cultural resources are coloured by the conviction
that an emphasis on cultural, as distinct from
personal, identity is restrictive: the ability to
live *beyond* culture and not *for* culture is funda-
mental to human vision, and hence to creativity
and cultural evolution.

"Culture" is not, of course, merely "the arts",
which are *part* of the general culture of a group.
Edward Tylor defined "culture" in 1971 as "that
complex whole which includes knowledge, belief,
art, morals, law, custom and any other capabili-
ties acquired by man as a member of society"
(Tylor 1958: 1). Culture is a floating resource
which is available for use, or not, as part of the
process of developing human capabilities through
social interaction, the sharing of ideas and the

learning of skills. Although individual person-
ality is the most precious and (at least in
children) lovable attribute, it cannot begin to
develop without society and without some sort of
tradition of communication by which people can
refine and develop their thoughts and feelings by
exchanging and reflecting on their experience
through the use of commonly accepted symbols.

Cultures are the experiments which human communi-
ties have devised at different times and in dif-
ferent places not only to get a material living,
but above all to provide a framework for making
sense of profound emotions, institutionalizing
love and the joy of association, and finding new
ways of extending the body. Cultural systems have
not always succeeded in providing the means for
all members of a society to live freely and at
ease and to realize their full potential, and/or
for a society to live in peace with its neighbours.

One of the most terrifying consequences of the
developments in material culture of the past two
centuries is that they have made possible the con-
centration of wealth and authoritarian power in
the hands of tiny minorities of people. The fail-
ure of human beings to develop their *non*-material
culture as efficiently as their technology and
techniques of communication is the major problem
of the modern world. It has alienated millions of
people and driven them to look back to a past that
was in many respects no better, in desperate
attempts to adapt to and re-educate themselves for
contemporary evolutionary challenges. A high
value is placed on cultures and "cultural ident-
ity", as if cultural systems had intrinsic merits
as permanent solutions to the problems of living,

and as if cultures, and not individuals, were
sources of the imagination and invention which are
always necessary to solve the recurring problems
of relationships and institutional organization
that hinder human development. Thus people often
emigrate from a country because its cultural sys-
tem is deficient and restricts their "self-
actualization". Then, because the cultural system
of their country of adoption is also deficient and
they feel ill at ease, or superior, or oppressed
in some way, they try to re-constitute for their
children elements of their original life style,
many of which may be inappropriate in the new con-
text, and hence restrict rather than nourish their
natural creativity and adaptability. Co-operation
and continuous education in a social context are
conditions of becoming human, but when the common
humanity is re-defined as members of a particular
society or subscribers to a particular cultural
system, human energy and creativity are misapplied.

George Steiner has stressed the importance of
human creativity through the imaginative power of
language, which is "the main instrument of man's
refusal to accept the world as it is" (Steiner
1975: 217).

> Man has "spoken himself free" of total
> organic constraint. Language is a con-
> stant creation of alternative worlds"
> (ibid.: 234. "Through language, we
> contract what I have called "alterni-
> ties of being". To the extent that
> every individual speaker uses an
> idiolect, the problem of Babel is quite
> simply, that of human individuation
> (ibid.: 473).

Cultures are products of human individuation, but
they are re-interpreted, translated, by every
individual and every generation. Cultural variety
does not have to be nurtured: it is an inevitable
outcome of human creativity. What has to be cult-
ivated is an environment in which people can grow
and interact. When this is neglected, in an econ-
omically and socially divided community, "the
agonistic functions of speech ... outweigh the
functions of genuine communication ... Social
classes, racial ghettoes speak at rather than to
each other" (ibid.: 32).

In contrast to this negative use of human individ-
uation, Steiner quotes John Donne:

> When love with one another so interin-
> animates two soules
> The abler soule which thence doth flow
> Defects of loneliness controules.
>
> It tells of a dialectic of fusion in
> which identity survives altered but
> also strengthened and redefined by
> virtue of reciprocity. There is anni-
> hilation of self in the other conscious-
> ness and recognition of self in a
> mirroring motion
>
> Donne's phrase "defects of loneliness"
> is acutely suggestive of the condition
> of feeling and intellect which accom-
> panies the stress of personal invention
> (ibid.: 452-3).

John Donne's words and George Steiner's comments
refer to the kind of individuality in community

and cosmic consciousness that the Venda of
Southern Africa sought to attain through social
interaction guided by musical symbols. They were
not concerned with the preservation or promotion
of their culture. Their indigenous education
system, informal and formal, was directed towards
the maintenance of general human values and of a
social life and political economy which allowed
individuals to flourish and use their innate
creative capacities for their own self-satisfaction
and the benefit of the community at large.
Dances, songs, music, mimes and myth were some of
the means by which these values were imparted and
people's security ensured. But they were not ends
in themselves, except in so far that some perfor-
mances helped to generate the transcendental
experiences that were proof to individual Venda of
the reality of the spiritual self, which was the
link between the eternal world of nature and the
ancestral spirits and the transitory cultural
forms of the contemporary society. Affective cul-
ture could therefore be an important aid to cosmic
consciousness, but the bodily experience was also
rationalized within the educational and religious
systems, which emphasized the principles of an
open society.

In sharp contrast to the Vendas' concern for human
values and human welfare, South African whites
were obsessed with the maintenance of their cul-
ture - by which of course they meant their politi-
cal and cultural hegemony. And in order to do
this they legislated for cultural apartheid, which
they euphemistically called "separate development"
The preservation of indigenous African cultures
and the promotion of a multicultural society were
the justification they offered for maintaining

absolute political control. Africans could sing
and dance and tell stories; they could have an
unrivalled knowledge of the medicinal properties
of indigenous plants, and they could wear all
sorts of interesting and colourful costumes. But
they were not ready for the vote, for rights to
land and residence in any part of the country, or
for full participation in decision-making.

Music-making by black South Africans has not
always been the escapist entertainment that whites
might have liked. In the urban areas, artistic
practice continued to be as politically relevant
as it was in traditional societies. Because
verbal protest was outlawed, nonvocal and non-
verbal symbols provided important means of commun-
icating a sense of political solidarity and con-
solidating Africanist tendencies and the concept
of Black Consciousness, which emerged in the 1970s
as a powerful political movement. Although the
arts often reflect the social, economic and symb-
olic life of the communities in which they are
created, they can also be used to take the reali-
ties of individual feeling and experience and,
with available conventions, transcend context and
create new and imaginative transformations of
current patterns of thought. Like cultural trad-
itions, the arts as cultural systems have no
intrinsic value; but their qualities of play and
fantasy, and their exploration of the possibili-
ties of symbols, allow them to be used for social
and intellectual experimentation in ways that can
touch the emotions and engage the whole body. The
Ghanaian musician, Papa Oyeah McKenzie, once des-
cribed this process of discovery with the words,
"we feel before we understand".

"Practical" culture can be seen as a product of
the collective use of innate artistic capacities
which all normal human organisms possess. The
emotional and intellectual development of every
individual is enhanced by these capacities, and
artistic practice must therefore have a central
place in human life. I do not claim that the arts
are the motor of change, or that they have a
problem-solving function. I am concerned with
their cognitive functions, and I suggest that art-
istic *practice* is an indispensable tool for
heightening and transforming consciousness. Since
adherence to cultural conventions can restrict
cognitive exploration, experience of contrasting
artistic styles, appreciated as the expression of
individuals, can help people to feel and think in
new ways because their "performance" requires a
re-orientation of the body.

CONTRADICTIONS OF MULTICULTURAL EDUCATION

Those who advocate "multicultural" education in
the United Kingdom, Australia, and elsewhere, seem
to be motivated by the best of intentions and
inspired by a liberal tradition which seeks to
ensure that the state takes positive action to
protect and promote the heritage and well-being of
all its citizens. They would probably be sur-
prised to learn that their plans and their
rhetoric are very similar to those of the White
South African government, which in the 1950s
established segregated Bantu Education as part of
its policy of apartheid. The concept of "multi-
culturalism" must therefore be approached with
extreme caution, especially in the United Kingdom
where there is a strong undercurrent of racism:

direct or indirect promotion of alien life styles
could seriously inhibit the life chances of young
British citizens by encouraging them to think of
themselves in terms of the country of their ances-
tors rather than their country of adoption and
residence. I can be proud of my grandmother's
Polish Jewish ancestry without feeling the need to
speak Polish and be a Jew; and my wife does not
deny her Moslem and Indian heritage by declining
to put herself and our daughters into purdah. She
and other Black South Africans saw "Western" edu-
cation as a means of escaping from the oppression
of apartheid: they took it for granted that the
history, political science, and religious educa-
tion would be ethnocentric; but they valued
instruction in "universal" skills such as medicine,
mathematics, chemistry, and engineering. They saw
education in the vernacular or culturally oriented
education, as a deliberate attempt to suppress
their talents and social mobility.

One of the problems about the idea of multicult-
ural education is its misrepresentation of the
concept of culture. Strictly speaking, "multicul-
tural education" means separate education, because
different *systems* of education cannot be combined;
that is, the educational distinctiveness of each
cultural system is automatically eliminated as
soon as they are presented within a single educa-
tional system. One can, for instance, teach
French or Greek history within the English educa-
tion system, and one can teach about French or
Greek culture. But this does not make it multi-
cultural education. It remains English education,
geared towards a particular technology, particular
means of production, power systems and political
formations. If "multicultural education" is to

mean anything, it must mean educating people from
different cultural backgrounds in the ways appro-
priate to their cultures. Thus people of Pakis
tani, Indian and Caribbean origin living in
England should be educated as if they were going
to live in Pakistan, India, or the Caribbean.
This might be appropriate if they were planning to
return soon to those countries or to live in
ghettoes in the UK; but if they are to be active
citizens of the UK, it is putting them at a dis-
advantage, in much the same way that segregated
Bantu Education has restricted the development of
South African Blacks.

In another sense, all modern states are in some
respects multicultural and in others monocultural,
and the problems of ethnic minorities, or "dis-
crete cultural units" as they are now called in
the USA, are basically problems of power and of
equality of opportunity. England, for example, is
monocultural in language, government, and social
institutions. But even before Caribbean and Asian
immigrants formed a substantial part of its popu-
lation, it was in fact multicultural: differences
between the lifestyles of people in the north and
south of the country, between classes and between
rich and poor, were as great as between societies
that anthropologists would describe as having
different cultures.

The practice of multicultural education is further
complicated by the problem of defining who needs
it. The South African government's planned multi-
culturalism imposed a new kind of cultural hegemony
by refusing to incorporate blacks, on the grounds
that their indigenous cultures must be respected
and preserved. Significantly, the cultures of

substantial Greek, Portuguese, Lebanese and Jewish
minorities were not considered to need separate
status and so were fused into the dominant white
culture. Thus when there is talk of a multicult-
ural society, we need to know what are the politi-
cal motives for denying that a state is effect-
ively monocultural, or that at least the subscrib-
ers to the dominant cultural system are determined
to maintain their hegemony over others. In many
cases a stated concern for the political promotion
of culture is an evasion or denial of the real
issues of equality of power, wealth and personal
opportunity, combined with the common misconcep-
tion of culture as something fixed or static, and
the failure to recognize the innate intelligence
and potential of ordinary human beings.

Insofar as we emphasize people's ethnic or cult-
ural allegiances as a basis for association, learn-
ing and action, we deny some of their rights as
persons. If the term "multicultural society"
helps us to appreciate more keenly the cultures of
wealth and poverty, class and religion, occupation
and unemployment, equality and inequality, male-
ness and femaleness, adulthood and childhood, then
it could sensitize us to the problems and respons-
ibilities of developing *human* resources in every
part of the world. But if the concept of a multi-
cultural society becomes a platform for a policy
of identifying sections of national populations in
terms of their countries of origin, and promoting
contextless and often outmoded cultural traditions,
it can only create serious problems of identity
and division within a generation, and could easily
transplant the ancient rivalries, tensions and con-
tests of Europe and Asia to countries which already
have enough of their own social and cultural

problems.

MULTICULTURALISM AND THE BETRAYAL OF ART

The notion of multiculturalism in arts education
implicity denies both the individuality and trans-
cendental universality of the arts. It is as
unhelpful to say that Wagner and Strauss were
products of German culture as it was arrogant of
German missionaries to think that they were
intellectually and morally superior to their
African neighbours because undoubtedly great indi-
viduals like Bach, Beethoven, Goethe, and Schiller
happened to have been Germans. Similarly English-
men are just as likely, or not, to appreciate
Stockhausen as his fellow Germans. The absurdity
of "multicultural" arts education was brought home
to me forcibly when an African scholar complained
about the captions to some of my photographs of
Venda musicians. "How would you react to portraits
of Bach, Mozart or Liszt", he said, "if the cap-
tions read: 'A German musician playing a two-
manual organ', 'An Austrian composer', or 'A Hun-
garian playing the piano'?".

I doubt if many would advocate a separatist (and
almost racist) policy by which the state would
promote Caribbean music for people of Caribbean
origin, Indian music for those of Indian origin,
and so on. It is rather the English who need to
know Caribbean and Indian music, and vice versa.
But even that aim would be misconceived; for it is
still dividing the world's music into the music of
individual composers and the music of cultures or
ethnic groups, which is a veiled insult to indi-
vidual Caribbean and Indian musicians. The idea

that unwritten music is not composed by individuals is as wrong as the myth that African music is "spontaneous". The Tiwi of Northern Australia think and talk about songs and dances composed by particular individuals, just as the Balinese refer to composers and specific compositions rather than to Balinese music. Similarly, I appreciate the music of Schubert and Mozart primarily as beautiful music, rather than as specimens of Austrian or Viennese culture.

Ethnomusicological research has revealed not only that recognized individual composers and performers exist in societies with traditions of unwritten music, but that their identity is widely known and that the music is discussed in terms of *individual* contributions to creation and performance, and not in cultural terms. Europeans have tended to talk about other people's music (and European folk music) in cultural terms and their own music in terms of composers and particular performers, because they have not known or believed that a similar situation could be possible in a society without a written tradition. It is therefore very important that any promotion of studies of World musics should be carried out in terms of compositions, composers, performances, musical styles and traditions, and not in terms of nationalities and cultures.

The tendency to interpret artistic experience in terms of the nationality and cultural background of its makers and receivers can be as grossly misleading as the idea that the arts will easily enhance our understanding of cultures and vice versa. For instance, certain types of organized multinational and multicultural activities tend

not to breed in different groups "respect for each
others' traditions: Poles, Hungarians, English,
Irish, Chinese and Indians, etc. go away more con-
vinced than ever before that their own cultural
products are superior to others" and that they
have little or nothing to learn. The atmosphere
is rather like that of the Olympic Games, where
nations take the credit for the performances of
individuals.

This is the paradox of the relationship between
Art and Life. The arts have brought people
together and helped to generate ideas and feelings
that were important for cultural development. But
it is through personal experience that aesthetic
energy achieves its greatest impact, both in the
production of artistic forms and in the transform-
ation of behaviour. There is always a problem of
balance between the universality of artistic
energy and cognition and the uniqueness of differ-
ent cultural expressions of these capabilities.
We have to work for the basic human right to art-
istic experience, and trust that through practice
of their own particular artistic systems individ-
uals will be able to transcend cultural conven-
tions and speak and listen to each other.

MUSIC AND INDIVIDUAL DEVELOPMENT

The power of music rests in "acts of performance"
by composers, performers and listeners, in the
processes of making music and making sense of music
rather than in the cultural products of those pro-
cesses, and in the linking of musical experiences
to other sets of ideas and social experiences.
The value of the arts in a society depends on how

TAE-B*

they are defined and used. But the most politica-
lly effective use of music *as music* is *not* to use
it for political or any particular social purposes,
but to use it in the most general sense for the
education of human emotions, the liberation of the
senses, and the expansion of consciousness and
social relations.

The need to recognize and study musics of the
world but at the same time not to entrench ethnic
boundaries, requires us to break the habit of
thinking that outside the countries of origin,
Chinese music is primarily for descendants of
Chinese, Indian music for people of Indian origin,
and so on. To limit people to studies of "their
own" music, particularly in countries where ethnic
divisions are often visible to the indigenous
inhabitants, is to hold them back from full parti-
cipation in the community at large, and perhaps to
deprive them of opportunities for educational
development.

Percy Grainger summed up the kind of situation
that music education should inculcate in all of us
as long ago as 1934:

> It seems to me that the commonsense
> view of music is to approach all the
> world's available music with an open
> mind, just as we approach the world's
> literature or painting or philosophy.
> It seems to me that we should be will-
> ing, even eager, to hear everything we
> can of all kinds of music, from what-
> ever era, in order that *we may find
> out from experience whether or not it
> carries any spiritual message for us*

as individuals

Percy Grainger's idea that all the world should
hear all the world's music was not a plea for some
kind of superficial United Nations Assembly of
Music. He recognized that music was not a univer-
sal language but that individuals could respond
intuitively to unfamiliar idioms, so that there
might be a chance for more human beings to be up-
lifted by music. If people in a particular
society appear to be tune deaf, it is not because
they are inherently unmusical. It is because the
lack of opportunity or certain institutional res-
trictions have prevented them from exercising
their innate capacities. Perhaps those capacities
could be released if they had the opportunity to
hear other musics, just as the musical experience
and practice of trained musicians can be enhanced
by encounters with other musical systems.

Some people argue that it is impossible for an
Englishman to understand African, Indian, and
other non-English musics. This seems to me to be
as arrogant, racist, and ignorant of the power of
artistic intuition as the view of many white
settlers in Africa, who claimed that blacks could
not possibly appreciate and perform properly
Handel's *Messiah*, English part-songs, or Lutheran
hymns. Musical traditions are probably the most
esoteric of all cultural products, but the
experience of ethnomusicologists, and the growing
popularity of non-European musics in Europe and
America and of "Western" music in the Third World,
suggest that the cultural barriers are somewhat
illusory, externally imposed, and concerned more
with the verbal rationalization and explanation of
music and association of it with specific social

events, than with the music itself. The flexi-
bility and adaptability of music as a symbol
system are such that there are as many variations
of interpretation and understanding *amongst*
Englishmen, Africans and Indians, as there are
between them. Different musical systems often
coincide with cultural boundaries; and sub-
divisions of musical style, musical activities and
experiences are labelled and discussed with the
general language of the culture. But a shared
mode of discourse does not provide members of
different classes, families and occupational
groups with common feelings and mutual understand-
ing any more than French culture gives all French
people the same personality.

Because music is concerned with feelings which are
primarily individual and rooted in the body, its
structural and sensuous elements resonate more
with individuals' cognitive and emotional sets
than with their cultural sentiments, although its
external manner and expression are rooted in his-
torical circumstances. This is why the English
could still enjoy Beethoven when at war with the
Germans, and why it often makes more sense to
relate the output of a composer to music from
another society or to someone from the past, than
to his/her immediate musical neighbour.

When the words and labels of a cultural tradition
are put aside and "form in tonal motion" is
allowed to speak for itself, there is a good
chance that English, Africans, and Indians will
experience similar feelings, especially if they
perform the music. Because their bodies have a
common repertory of somatic states and cognitive
functions, musical symbols can be inherently

effective and enable their users to share trans-
cendence of time, place and culture. They are
effective as symbols because their production
involves bodies in similar patterns of movements
in space and time, with corresponding physiologi-
cal responses, so that their inherent meaning is,
as it were, forced upon performers by the very
process of doing them.

The nature of music-making is such that it is one
of the most effective modes of communication for
educating the emotions, enhancing human creativity,
and generating political awareness through har-
monious social interaction. But it must be
allowed to work as music, and through individual
human beings. Musical experience must not be
cluttered up with cultural chauvinism. Who knows
what musical style will trigger off an interest in
music in someone who has hitherto been anaesthe-
tized by the restrictions of a particular cultural
tradition? Grainger's "universalist outlook" on
music is feasible because human beings have the
mental equipment to feel beyond the cultural trap-
pings of different worlds of music to the common
humanity which inspired them.

The primary responsibility of the state is not
towards the abstract cultural products of past
collectivities but towards the future human poten-
tial of its individual citizens. In my experience
in the UK and the USA and elsewhere, I have found
that the pursuit of multiculturalism and its
associated discourse too often point not towards a
new world of peace, conviviality, prosperity,
social justice and harmony, in which people's
intellects and senses will be stretched to their
highest pitch, but to new ghettoes of desperate

mediocrity which will enable even fewer people to dominate the masses of the world. Not all aspects of all cultural traditions and products are of equal value: my own culture of origin, in particular, is drastically in need of overhaul. We will improve the situation not by entrenching positions of the past, but by sharing in common enterprises with our neighbours in whatever parts of the world we choose to live. In the field of music education in particular, we have to be careful that the current craze for multiculturalism does not allow us to evade the responsibility of bringing to all people the most beautiful and uplifting, and often very difficult, music from all available musical traditions. It will be heard and performed out of its cultural context, but its individual performers and composers may be able to speak more clearly to other individuals and so transcend the cultural barriers that no truly artistic human being wants.

Education in the United Kingdom has a responsibility to transmit the fruits of one of the Great Traditions, a civilization that followed on from those of Africa and Asia and Latin America and happens to be influential in the world at the moment. It must not be associated specifically with ethnic groups of European origin. It is, in fact, an *amalgam* of the inventions and ideas of individuals from Egypt, Iraq, China, India, Indonesia, Persia, the Danube Valley, Greece, Rome, and many other parts of the world.

Unfortunately, Europeans failed to spread this tradition amongst themselves, because they became bogged down in futile power struggles, violence and cultures of inequality. But from the rubble

some products have remained, such as the work of
Plato, Aristotle, Euripides, Shakespeare, Virgil,
Bramante, Michelangelo, Bach, Beethoven, Darwin,
Einstein, and many other individuals. These indi-
viduals built their tower of Babel, and they
talked to God as did Confucius and Gautama and
Moses and Mohammed and George Fox and Isaiah
Shembe. They were not afraid to be like gods.
They recognized that all human beings can and
should be like godlike, and they wanted to share
their discoveries so that communities' life-styles
should enable all members to have equal life-
chances.

The Great Tradition of Europe must remain at the
core of formal education in the United Kingdom,
because it has been developed in Europe and is
appropriate for that environment. This has become
particularly relevant in the context of American
and Russian imperialism. There *are* significant
differences between Great and Little Traditions,
as *collective* achievements, and this has been an
important fact in the history of Europe and Asia,
where Little Traditions have survived partly
because of the general creativity of all human
groups and partly because of the failure of the
carriers of the Great Traditions to share their
ideas and resources. We should not be ashamed of
the fact that there have been great moments in
the cultural history of mankind, and we must
recognize that these peaks of activity cannot
easily be sustained and that it is the task of an
education system to make similar triumphs of human
effort and imagination possible at any time. Karl
Marx recognized this when he claimed that "Greek
art and literature would never be surpassed. They
had sprung from a concordance, by definition

unrepeatable, between "the childhood of the race"
and the highest levels of technical craft" (Steiner
1975: 463).

If the ingredients of childhood and technical
craft are essential for sustaining the productivity
of a Great Tradition, then a "child-like" openness
of mind and a commitment to extending technical
craft should be amongst the priorities of all
areas of the education system. The presence of
African and Indian musics could have value in the
context of the European Great Tradition because
they are novel and technically different systems
which can stimulate people's musical imagination
and extend the possibilities of craftsmanship.
If, however, they are promoted as part of a pro-
gramme of "multicultural" education, their value
is immediately debased. They are re-classified as
a Little Tradition of Europe, and the opportunity
of fruitful dialogue with the Great Traditions of
Africa and Asia is lost.

Hitherto, what Europe has learnt from Asia has
become part of the European Great Tradition, and
what Asia has learnt from Europe has become part
of Indian, Chinese, Japanese, or Indonesian Great
Traditions. It is not the task of formal educa-
tion systems to transmit Little Traditions, as
distinct from knowledge about them and awareness
of their presence. In the context of contemporary
British society, Indipop clearly has more signifi-
cance than *Khyal* or *Kathak*, and a policy of multi-
cultural education could entrench this division.
With an open-minded system of music education
appropriate for the Great Tradition of Europe,
Khyal and *Kathak*, as well as Indipop, would
receive proper attention, not because there are

British citizens of Indian origin living in the
United Kingdom, but because these artistic styles
should be valued in their own right, as products
of one of the Great Traditions of the World.

REFERENCES

Steiner, George. (1975). *After Babel: aspects of
 language and translation*. Oxford Press.
Tylor, Edward Burnett. (1958). *The origins of
 culture*. New York: Harper Torchbooks. Origi-
 nally published in 1871 as Chapters 1-10 of
 Primitive Culture.

Artistic Creativity

VICTOR HEYFRON

INTRODUCTION

What conditions must be satisfied before we can
meaningfully describe a person, product, or pro-
cess as creative? Philosophers caution us against
expecting a simple unequivocal answer to such
questions. Friedrich Waismann's (1951) notion of
open texturedness, i.e. the permanent possibility
of a term's impreciseness, reflects the mysterious
nature of aesthetic phenomena. The wide ranging
nature of items and practices to which the term
"creative" can be sensibly applied also makes a
straightforward definition difficult. For argu-
ably the production of any artifact can be descri-
bed as "creative" since in contrast with such
objects as trees, pebbles, and flowers, they
depend upon human agency for their being rather
than upon natural processes. But even trees,
pebbles and flowers are human creations in this
sense since the conceptual structures used to dif-
ferentiate such phenomena are also the product of
human ingenuity.

It is easy to understand the position of teachers
who wish to jettison the term from educational

contexts. They argue that the meaning of the term
is relative to each individual person using it,
and therefore is useless. However, the mistake
made by these relativists is to assume that there
is a single dimension on the basis of which
creative activities can be sharply separated from
non-creative ones. An analysis of the concept
will reveal that different activities satisfy to a
greater or lesser extent certain conditions for
the meaningful use of the term. I shall contend
as a strategy for exploring the concept that
although two different activities might on some
grounds both sensibly be described as creative, it
does not distort the meaning of the term to claim
that one activity is more creative than another.
For example, the third violinist in an orchestra
playing Beethoven's "Pastoral Symphony" is less
creative (on that account) than the conductor, who
in turn is less creative (on that account) than
the composer, in the sense that they fail to sat-
isfy more fully certain conditions for creativity.
It will be the concern of this essay to explore
these conditions.

Ray Elliott's (1971) contention that our ordinary
concept of "creativity" is strongly influenced by
the biblical myth of creation suggests a starting
point for our investigation. He writes:

> Either instantaneously or by process of
> making, God freely brought into being,
> ex nihilo or from some pre-existent
> indefinite material, a concrete,
> infinitely rich, perfectly ordered and
> beautiful world, the most wonderful of
> all created objects save man himself.
> He made it for man, not only as his

environment and to sustain him, but,
more importantly, for him to contem-
plate and wonder at, a perpetual
occasion for him to praise his Maker.

Our ordinary concept of creativeness is still dom-
inated by this myth. Further, he argues:

> The closer the analogy between any
> human activity and the mythical para-
> digm, the more confidently we attri-
> bute creativeness to the agent. This
> is why the artist's claim to creative-
> ness is unassailable. At least he
> produces a concrete, well-ordered
> object for us to contemplate, and we
> cannot wonder at its beauty without
> at the same time paying tribute to
> its maker.
> (Versions of *Creativity*, p. 142)

The "creation myth" suggests that an exploration
of artistic creativity involves reference to
(a) the "thing" produced; (b) the process by which
the created "thing" comes into being, and (c) the
nature of the value we attach to such "things" and
processes. If we can get clearer about these
aspects of creativity, then our quest for a set of
logical conditions governing its usage in differ-
ent contexts becomes more viable.

THE PRODUCT

Although we shall need to make qualifications
about precisely what *kind of object* is brought
into being by the creative act, ordinarily the

term implies making a product. We shall assume in
this section that the "thing" produced is a public-
ly identifiable object and not merely an "image"
or "idea" in someone's mind. On this view, in
contrast with a process model of creativity in
which engagement in an activity for its own sake
is seen as sufficient justification, a person must
produce something before he can be deemed to be
creative, e.g. a sculpture, design, cake, perform-
ance, or theory. John White (1972) for example,
in his article *Creativity and Education: A Philo-
sophical Analysis* insists on the primacy of a
publicly identifiable object. He argues against
the notion that creativity refers to an inner men-
tal faculty. He writes:

> "Creative" ... picks out not something
> about a person's inner processes but
> about what he publicly produces.
> (p. 135)

White maintains that the term "creative" is
inescapably normative, that its main function is
to commend persons and activities in terms of
valuable results produced. The core of his argu-
ment is that "creativity" is not a term that "has
any application of its own, unqualified". We
understand its usage only when we know the context
in which a person operates, e.g. the specific art-
istic medium, academic discipline, or practical
problem with which he is concerned. It is the
specific area of operation which indicates criteria
of value appropriate for evaluating the worth of
"things" produced. On this view, a work is
creative only insofar as it rates high on dimens-
ions peculiar to different spheres of activity.
For example, a piece of writing is creative, not

in terms of psychological processes undergone by a
child, but because the work scores high on a scale
of standards appropriate for evaluating established
literary works, e.g. Shakespeare and Dostoevsky
(to use White's examples). He writes "A creative
thinker is one whose thinking leads to a result
which conforms to criteria of value in one domain
or another". "Creative" is a medal which we pin
on public products, not the name of private pro-
cesses. (p. 136).

In contrast a process model of creativity focuses
upon the nature of the interaction between artist
and medium rather than upon a finished product.
It is concerned with what happens to a person
engaged in an activity. On this view, an activity
is valuable, and hence creative, insofar as the
experience promotes personal growth and leads to
self-realization. It stresses freedom of expres-
sion, encourages exploration, and endorses
sincerity, enjoyment and spontaneity. It is the
enrichment of the inner world of a person undergo-
ing an experience which is paramount and not
whether or not the external work produced conforms
to pre-established public standards.

Although objections can be raised against both
product and process characterizations of creativ-
ity, they do underline in their own way important
features of the concept. The first view focuses
attention on the autonomy of the art object. It
recognizes that the value of creative engagement
is not determined solely by reference to the psy-
chological nourishment gained from an experience.
A person for example might gain immense satisfac-
tion from playing a game, or engaging in a leisure
activity, or interacting with other people, and

these experiences might be described as spon-
taneous, sincere or enjoyable, but without the
production of a work in which inner processes gain
outer articulation, the experiences remain in an
undifferentiated form. The second view rightly
emphasizes the quality of experience of the
creator. It underlines the fact that even if a
product did conform to established criteria of
value, it would not be sufficient on that account
alone to describe the activity as creative. We
expect the creator to be enriched by his creative
experience, and for his perspective on life to be
transformed in some way (Ross, 1978). Arguably it
would be unwise to insist that a child regulated
his artistic practice by reference to established
criteria of value in an area (e.g. perspective in
painting) if they violated his aesthetic
intuitions.

In claiming that a product is a necessary con-
dition for creativity, I am not recommending a
slavish acceptance of established standards in
art. In fact traditional art forms which embrace
the concept of the "permanent art object" endorse
a political-social view which makes a fetish of
art as a saleable commodity. The fetish encourages
a view of art which assumes that the only worth-
while experiences in which to engage are those
which provide a financial return. On this view
art becomes instrumental to, and determined by,
factors which are other than aesthetic. The pro-
cess model is a welcome corrective to the object
dominated view.

THE ONTOLOGICAL STATUS OF THE PRODUCT

In the last section I argued that the production
of a publicly observable object is a necessary
condition for creativity. It was also contended
that there is not a sharp separation between the
mental states of an artist and the patterning of
form in a medium. The apparent conflict between
these two views prompts us to ask: What kind of
"thing" is an artistically created object? The
claim that such products are autonomous and
publicly available for the scrutiny of others
seems to equate creative work with the production
of physical objects. Although a physical material
might be contingently necessary for the creation
of a work of art, it is not logically sufficient.
For works of art unlike physical objects are not
governed by scientific laws of time, space and
causality. They are imaginative objects, and
essentially unreal. Art objects are unlike such
"things" as tin-openers, hydrogen bombs, and kid-
ney machines insofar as they do not interact with
other physical objects in the world. For example
if the painting "Déjeuner à l'herbe" catches fire,
it is the canvas and pigment which are consumed by
the fire, not the trees and characters in the
picture. Similarly, Laurence Olivier does not
interact with Ophelia: it is difficult to see how
she could catch a cold from him! Only Hamlet and
the other characters in the play are vulnerable to
contagion.

Sartre (1948) argues that the content of works of
art (e.g. the characters and action of a play, or
the landscape of a painting) are necessarily the
"correlative of an intentional act of imaginative
consciousness". In contrasting the perceptual

consciousness of an object with the imaginative,
he writes:

> We often hear it said that the artist
> first has an idea in the form of an
> image which he *realizes* on canvas.
> This mistaken notion arises from the
> fact that the painter can begin with
> a mental image which is, as such,
> incommunicable, and from the fact that
> at the end of his labours he presents
> the public with an object which anyone
> can observe. This leads us to believe
> that there occurred a transition from
> the imaginary to the real. But this
> is in no way true. That which is real
> are the results of the brush strokes,
> the stickiness of the canvas, its grain,
> the varnish spread over the colours.
> But this does not constitute the
> object of aesthetic appreciation. What
> is "beautiful" is something which
> cannot be experienced as a perception
> and which by its very nature is out of
> this world. (A picture) cannot be
> brightened by projecting a light beam
> on the canvas for instance: it is the
> canvas that is brightened and not the
> painting. The painter did not *realize*
> his image at all: he has simply con-
> structed a material analogue of such
> a kind that everyone can grasp the
> image provided he looks at the analogue.
> (*The Psychology of the Imagination*,
> p. 220).

In other words, it becomes an occasion for the
imaginative experience of the spectator.

The implication of Sartre's view is that since a
creative piece of work is essentially an imagin-
ative product or as he describes it "an external
analogue which remains an image", it is a mistake
to characterize artistic creativity exclusively in
terms of either inner processes or outer products.
The two elements are logically interdependent.
Arguably the appreciative act of the spectator is
creative since he becomes imaginatively conscious
of a material object as something which is not
physically there, e.g. he sees white pigment on a
round green shape as light shining on an apple.
Compared to the artist there is only a minimal
sense in which he is creative. He doesn't satisfy
certain other conditions which we will be con-
sidering later. Nevertheless, even in this case,
it is with reference to the publicly observable
object (e.g. the painting) that he is able to make
sense of his imaginative experience.

The characterization of the creative act as
requiring a product, albeit an imaginative one, is
important for at least two reasons. First, asses-
sment of the quality of experience that a person
has undergone requires appeal to an inter-
subjectively available phenomenon (e.g. a painting,
poem, film or novel); and secondly, the articu-
lation of a distinctive perspective presupposes a
medium in which these insights are given form.
Elsewhere (1981) I have argued that works of art
create imaginary worlds in which the incohate
longings of man are given existence, and that at
base a work registers a realm beyond the determin-
istic temporal/spatial bounds of everyday reality.

Or, at least, a realm governed by a different
logic from that which determines natural processes.
Nevertheless, the sensuous medium in which an
artist's work is embodied is significant for the
creative act because it resists the wholly fantas-
tic determinations of his arbitrary wishes and
imposes a semblance of discipline on his creations,
thereby introducing the possibility of intersub-
jective validation.

The phenomenon of "found objects" (e.g. pieces of
driftwood, Duchamp's *Urinal*) illustrates the con-
tingency of the physical product. Although the
artist does not physically make an object he
places the "found object" in an artistic context
(e.g. an art gallery) from which it is possible
for a spectator to recognize the artist's inten-
tion for an object to be apprehended in a particu-
lar way. Picasso's sculpture of a bull's head
made from a bicycle seat and a pair of bicycle
handles is a case in which the context determines
what is seen by the spectator. There is an imagin-
ative leap from the ordinary bicycle parts to the
sculpture of a bull's head.

FREEDOM AND THE CREATIVE ART

We have argued that creativity involves producing
a publicly observable object, but qualified this
claim by insisting that in artistic contexts that
which is observed is apprehended with an imagin-
ative consciousness. Although the activities of
both artist and spectator satisfy this second con-
dition, the artist is more fully creative insofar
as he satisfies a further condition, namely, that
of authorship, or responsibility for the artistic

structures which are the ground of the spectator's
aesthetic construction. The artist as spectator
fulfils both these perspectives.

The significant feature of artistic agency is its
freedom from any deterministic processes. A work
is not an inevitable result of either logical or
physical processes, and it is not the outcome of a
pre-specified sequence of events. R.G. Collingwood
(1938) focuses on this aspect of creativity when
he writes:

> To create something means to make it
> non-technically, but yet consciously
> and voluntarily. (Works of art) are
> made deliberately and responsibly by
> people who know what they are doing,
> even though they do not know in advance
> what is to come of it.
> (*The Principles of Art*, p. 133)

By "non-technically" Collingwood means the creative
act *need* not be done as a means to any preconceived
end, or according to any preconceived plan, and
cannot be done by imposing form on any pre-existing
matter. There are some implausibilities in his
theory, not least of which is his failure to do
justice to the role of the physical medium, but
his view does highlight the autonomy of the artist.
This aspect of creativity is illustrated in the
distinction between human agency and natural pro-
cesses. In nature, things like trees, flowers and
cloud formations are the inevitable outcome of
predetermined forces and in principle it is possi-
ble to anticipate the final form that organic
objects will take. But an essential difference
between human agency and natural processes is the

freedom and intentionality of the former, and the
causal determination of the latter. An artist
metaphorically causes his work to come into being.
He is a first cause. The notion of a first cause
underlies such metaphors as "gives birth to" and
"breathes life into". It is interesting to note
that "cause" is synonomous with "create" in some
contexts, e.g. he caused (created) a disturbance.
The notion of "cause" in an artistic context con-
notes the God-like quality of a "prime mover" as
suggested by the creation myth. As God created
the world "out of nothing" so the artist metaphor-
ically transcends the deterministic order of
things in the creative act. There is no ante-
cedent sequence of events leading to a pre-
specifiable end. The artist qua artist cannot
predict the final form that his creation will take.
To be able to do so would undermine one crucial
aspect of artistic activity, namely, to create a
form distinctive of his individual perspective.
We might be able to detect artistic and cultural
influences in a work and witness preliminary
explorations in a medium prior to its execution,
but none of these events logically or practically
entails the final product. Given these events the
work could always have been other than it is. It
might be possible to trace the developmental
stages of a painting after it is completed, but
these are aspects of the creative process and are
properly a part of a description of the finished
product.

A feature then of the creative act is the absence
of any rules (e.g. recipe or plan) the following
of which would lead to a prespecified end. It is
this element of freedom which is at the heart of
creativeness. When the term "creative" is applied

to certain activities (e.g. creative embroidery,
creative writing, creative flower arranging) it
suggests an increased freedom to depart from
established rule patterns governing the traditional
practice in these areas. Whereas in the artistic
domain it would be superfluous to use the term
"creative" to describe such activities as painting,
sculpture, and poetry because the freedom to intro-
duce new dimensions to the activities is accepted
as a part of what it means to be engaged in the
production of art. The freedom to open up new
ground must be a permanent possibility in any art
area. This freedom is highlighted when the des-
cription of a conventionally non-artistic activity
is prefaced by the term "creative".

It is this element of agency or authorship, namely,
the freedom to register a personal vision, which
allows us to describe one person as being more
creative than another. (Although our only reason
for doing so is to highlight logical conditions
for the use of the term). For example, a pianist
playing a musical score of Beethoven's "Pathétique"
Piano Sonata is creative insofar as he is respons-
ible for the production and interpretation of the
musical sounds. However, he is less creative than
the composer to the extent that he is not respons-
ible for the distinctive patterning of the music
which constitutes it as a rendition of the
"Pathétique" rather than the "Moonlight" Sonata.
His freedom to interpret the music is bound by the
structure created by Beethoven. The pianist has
less scope than Beethoven to exercise his freedom
of judgment and to assert his agency, and there-
fore in that sense he is less creative than the
composer. He is bound by the agency of another
person, whereas the possibilities for the composer

are infinite.

ORIGINALITY

Originality is intimately connected with the con-
cept of "creativity", but it is itself a notorious-
ly difficult term to define. We describe some-
thing as original when it is the *first* or *only one*
of its kind (for example, when we refer to the
original production of a play or an original
painting). Artistic originality means that some-
thing is significantly different from other things
of its kind. The notion of "significantly differ-
ent" begs a number of questions, but for my
present purposes it means at least the patterning
of an artist's distinctive perspective in a medium.
An artist's work is original when it represents
his own peculiar way of viewing things. In this
sense of the term, creativity can be ascribed to
the work of both child and adult artists. Dis-
tinctiveness in a work of art is not consciously
achieved, rather it comes unbidden. It is an
aspect of the whole process of artistic engagement.
Typically we describe striving for difference for
its own sake as pretentious or mannered, implying
that an artist is simply tampering with the sur-
face qualities of a work.

The importance that we attach to originality in
artistic creation is demonstrated in the oppo-
sition artists have to simply duplicating another
person's work. Copying, it seems, undermines the
integrity of the creative process in a fundamental
way. When we describe a work as a copy or a pas-
tiche we imply that it is not different from other
objects of its kind in a significantly relevant

way. We evaluate it negatively because it does
not authentically represent the view of its maker.
For example, when Tom Keating (a skilled imitator
of other artists' work) painted in the style of
Samuel Palmer it was Keating imitating Palmer's
disembodied voice. But what he said was soulless.
The outward expression is severed from the vitali-
ty of its inner life force. We deprecate this
work no matter how accomplished its execution.

A form of copying which is more acceptable in art-
istic contexts is that undertaken by technical
assistants. But although an assistant might be
responsible for the physical production of a work
of art involving considerable skill and sensitiv-
ity he is not on that account creative in the full
sense of the term. The work represents the dis-
tinctive view of another person, namely, the ori-
ginator of the design. For example, Philip King,
one of Britain's foremost sculptors, worked for
Henry Moore constructing sculptures from small
marquettes. And although King is rightly des-
cribed as a highly creative person, the appell-
ation has been achieved in relation to his own
work, not because he produced sculptures for
Henry Moore. It might be objected that there
have been in history many examples of great art-
ists copying other artists' work (e.g. Van Gogh's
copy of Millet's *The Sowers*), or that every great
artist, writer, composer, film maker has been
influenced by the work of other artists. But we
have only to observe these works to recognize that
they are unlike an ordinary copy or pastiche. The
great artist transforms the elements of another's
art and makes them distinctively his own.

We use the term "original" in an additional sense
to that which we have discussed above when we claim
that an artist has made an original contribution
to art. We do not simply mean that he has painted
a picture or composed a poem, rather we imply that
he has broken new ground and opened up new techni-
cal possibilities in his medium. For example,
Cezanne's paintings of Mt. Victoire for example do
not only reflect his distinctive perspective but
also introduce new technical conventions which are
available for other artists working in the same
medium. He provides fellow artists with a frame-
work within which they are able to express their
own individual perspective.

THE MEDIUM

Is an artistic tradition contingently necessary
for the production of an artistically creative
work? Or is it possible to produce original work
in isolation from established practices and con-
ventions? Earlier, when I urged that it is a mis-
take to separate process from product, I hinted
that the representation of a distinctive perspec-
tive demands a semantically elaborate context in
which certain elements (e.g. marks, words, move-
ments, and sounds) gain meaning and thus make it
possible for a work to be peculiar to, and repre-
sentative of, one person's unique perspective
rather than another's. Further if we wish to
argue that a distinctive perspective of an indi-
vidual is richly profound in virtue of its unique-
ness, then it must be possible for the elements of
a medium to match and exhibit this profundity.
Not just any patterning of elements will represent
an individual perspective. Patterning elements

which are significantly different, and not *simply*
different (e.g. quantitatively, temporally,
spatially and materially) requires access to a rich
artistic background. Wittgenstein (1966) pin-
points this notion when he claims that appreciat-
ing a particular piece of work involves understand-
ing a whole culture. And Gombrich (1962) argues
that an artist forges a personal style from the
range of alternatives available to him in a medium.
Originality in an artistic context presupposes
mastery of an artistic way of life whose products
are a departure from, or at least a reorganization
of, conventionally established patterns. Whereas
the virtuoso performer is unable to escape the
bonds of established conventions and the extent of
his technical proficiency.

A full appreciation of a cubist portrait by Picasso
or a film by Sam Pekinpah or a saxaphone solo by
Charlie Parker requires an awareness of the trad-
ition from which they are a departure. Anti-art
exhibits such as Duchamp's *Urinal* or Carl André's
Bricks are unintelligible without reference to the
established artistic criteria against which they
are a protest. Each age registers its own special
vision by transforming established media and
thereby creating new forms of expression. Tauto-
logically, unique vision calls for unique forms.
And unique forms presuppose a multi-layered back-
ground against which the imaginary elements of a
work can be significantly different from other
works. We recognize from the context in which an
artist operates the way he intended to pattern his
work. We are able to appreciate his work because
we share a common culture.

There is truth in the paradoxical claim that it is
possible to recognize difference only if we have a
frame of reference which allows us to compare one
thing with another (e.g. when we define ourselves
in relationship with other people by referring to
the same dimensions and noting the differences.
We refer to a cheerful or mournful expression,
brown or blonde hair, young or old age). In a
similar vein, the distinctiveness of a work and
thus its capacity to embody profound insights is
established in relation to other works. We are
able to compare one work with another in any par-
ticular medium on a number of dimensions and to
recognize what is not the case. For example, in
painting we are able to compare subject matter,
material, colour, texture, design, expressive and
representative properties. We are able to observe
from a range of alternatives in a medium not only
what has been chosen but, importantly, what has not
been chosen. The distinctiveness of a work is
achieved when the patterning of elements in a
medium coalesces with a passion which strives for
authentic release.

VALUE AND CREATIVITY

Typically, when we refer to an activity as creat-
ive we imply that on some dimension it is valuable.
I have argued previously that an activity might be
evaluated highly (a) because it conforms to cri-
teria definitive of the best work in an artistic
tradition, or (b) because it engenders valuable
states of mind in either its maker or spectator.
An adequate account of the nature of the value we
attach to art objects would reveal a connection
between these two extremes. Whatever the nature

of this value (e.g. intrinsic or instrumental) it
is a necessary condition for describing a person,
product or performance as creative. R. Woods and
R. Barrow (1975) contend that:

> If we do not write into the concept
> of creativity some reference to quality
> then the word is in fact redundant
> since every individual by the mere
> fact of being a unique personality is
> in some respect a distinctive or orig-
> inal thinker.

We can accept the argument that creative work must
have a qualitative aspect without committing our-
selves exclusively to the narrow range of criteria
which define the finest works in an area. After-
all, it is acceptable to evaluate children's
behaviour as intelligent without expecting them to
achieve the same standard in an activity as an
adult. The same argument applies to the term
"creativity". If a child's performance satisfies
certain conditions then the description is justi-
fied. Although the criteria for judging the worth
of a creative activity should be sufficiently
broad to have application to the work of any per-
son seriously engaged in making art, it is import-
ant to avoid an extreme relativist position in
which anything produced is indiscriminately accep-
ted as having merit. Identifying the merits and
defects in a person's creative work demands con-
siderable skill and sensitivity. The critical
standards we employ must relate to the point of
the activity. We must ask ourselves, what is the
nature of the value we attach to the production of
art objects in a culture? In what kind of activity
is an artist engaged when he patterns his work in

one way rather than another? At one level we are
able to provide an adequate account of his activity
in aesthetic terms (e.g. the horizontal lines in
the painting connote serenity) but it does not get
us very far. We escape circularity if we intro-
duce such notions as "expressing our feelings" or
"representing our world view", but these notions
beg a number of important questions. For example,
why does it matter whether or not we express our
feelings? What is so significant about our indi-
vidual perspective? It is with reference to the
purposes art objects fulfil in the life of a cul-
ture that appropriate standards for judging the
worth of creative activity are located.

It is simpler to identify the nature of the value
we attach to solutions of problems in our everyday
living. For example, the value of such inventions
as the turbo jet engine, the micro chip or the zip
fastener is immediately apparent. They are instru-
mental to certain utilitarian ends, i.e. they make
for an easier life. Whereas, the kind of problem
to which making a sculpture, composing a poem or
producing a film are solutions, is not clear at
all. At least, not if the problem is specified
independently of the work itself. A simple explan-
ation of why we are motivated to engage in creat-
ive activities is in terms of the pleasure we gain
from the experience. Kant (1951) argues that the
distinctive pleasure we gain from aesthetic engage-
ment is a disinterested one, and not to be confused
with the pleasure gained from satisfying material
desires. The enjoyment associated with art on this
account is peculiarly detached from our everyday
affairs. He describes aesthetic activity as "a
purposiveness without purpose". Although one
would readily agree that artistic engagement is

a prime example of an activity in which a person
engages for its own sake, it is misleading to
suppose that art is a totally autonomous area
detached from human existential concerns.

Elsewhere (1982) I have argued that the activity
of creating and appreciating works of art is made
intelligible with reference to pre-existing exis-
tential and psychological needs. I contended that
works of art enable a person to apprehend his
being as significant by exhibiting man's freedom
to elevate himself above the mundane, to dignify
suffering, and to ennoble the commonplace. When
the artist creates forms distinctive of his indi-
vidual perspective he exhibits in a concrete form
those aspects of his being-in-the-world to which
he attaches the utmost significance. Arguably the
aesthetic significance we attach to such qualities
as uniqueness, freedom, order, harmony, express-
iveness and profundity are linked to the ideals we
aspire to in our lives. It is plausible to
believe that the fact that we find these states
desirable in art presupposes a fundamental lack in
our lives in respect of these qualities. The
state of affairs which characterizes our everyday
existence may be one in which we are conscious of
arbitrariness, alienation, impersonality, con-
straint, dullness and meaninglessness. And a
feature of the value we attach to creative activ-
ity is its capacity to counteract these conditions,
albeit imaginatively in the fleeting moments in
which we are absorbed by aesthetic phenomena. It
is in the creating and appreciating of artistic
form that the potentiality for transforming our
mode of existence is realized. If we examine
creative activities we will find numerous examples
illustrating at a psychological level a connection

between creative activities and existential con-
cerns. For example, it is plausible to believe
that an author gains a power he lacks in everyday
life when he manipulates the destinies of charac-
ters and events in a novel, or a figurative sculp-
tor gains a sense of immortality when he magically
creates life in the form of a human figure in clay
(Anthony Storr, 1975; Bruno Bettleheim, 1976).

An artistic work is not successful unless it
endorses the subjectivity of its maker. It is not
detachable from the situation of a person engaged
in its production in a way, for example, that the
correctness of a mathematical proof is independent
of the psychological needs of a mathematician. A
child is not engaged in a fundamentally different
task from that of an adult artist whose work
embodies criteria definitive of the finest work in
an area. His work can achieve its legitimate end,
i.e. register his being-in-the-world, without
necessarily exhibiting all the qualities character-
istic of an adult's work. A work is creative, i.e.
serves its purpose for child or adult, if the forms
produced reflexively exhibit a fundamental free-
dom imaginatively to disengage from everyday con-
cerns.

CONCLUSIONS

The aim of this essay has been to identify con-
ditions for the meaningful use of the term
"creative" in artistic contexts. The term is
intelligible in a variety of seemingly different
artistic activities (e.g. making, performing,
appreciating) provided that we realize that there
is no *essential* meaning governing its use, the

identification of which will enable us sharply to
discriminate between creative and non-creative
activities. I have urged, following Elliott's
reference to the biblical myth of creation, that
there is a constellation of features which creative
activities share to a greater or lesser extent;
and that the closer an activity approximates to
conditions underlying the traditional concept the
more confidently do we apply the term. Everything
else being equal, an artist engaged in the produc-
tion of art (e.g. film making, composing music, or
painting pictures) satisfies more fully these con-
ditions than, say, a spectator of art. I suggest
then that typically when we use the term "creativ-
ity" in respect of artistic work, we use it to
pinpoint the presence of the following conditions:
First, some "thing" is *produced* which is publicly
observable, i.e. there is the possibility of
inter-subjective validation of its properties.
Second, it is essentially an *imaginary* "thing",
i.e. it is not subject to the basic determinations
of physical causality. Third, it is *freely* pro-
duced, i.e. it is not made to conform to a pre-
specified plan or end. Fourth, it is *original* in
the sense that it is significantly different from
other "things" of its kind. Fifth, it requires
sufficient *mastery* in an area to enable a person
to represent a distinctive perspective, but it is
not a technical skill. Sixth, it is *valuable* on
some dimension, e.g. it might be evaluated highly
against criteria enshrined in a particular domain
or because it engenders valuable states of mind in
either its maker or spectator.

Although these conditions have been separately
identified they are inextricably interrelated. It
would be difficult, for example, to understand the

TAE-C*

"value" criterion without reference to the "originality" or "mastery" conditions.

I have not attempted in this essay to provide any more than a preliminary outline of each of the six conditions. What constitutes artistic value and originality, for example, are highly controversial issues, and not easily dealt with in a short space. These questions must await a fuller consideration on a future occasion. However, it is less contentious to argue that when the term "creativity" is used in artistic contexts, it is used to pick out activities in which versions of these conditions are present.

REFERENCES

Bettleheim, Bruno. (1976). *The Uses of Enchantment*. Peregrine.

Collingwood, R.G. (1938). *The Principles of Art*. Oxford.

Elliott, R.K. (1971). "Versions of Creativity" in *Proceedings of the Philosophy of Education Society of Great Britain*. Blackwell.

Heyfron, V.M. (1981). The Relevance of Art in *The Aesthetic Imperative*, Malcolm Ross (Ed.). Pergamon.

Heyfron, V.M. (1982). The Aesthetic Dimension in *The Development of Aesthetic Experience*, Malcolm Ross (Ed.). Pergamon.

Gombrich, E. (1962). *Art and Illusion*. Phaidon.

Kant, I. (1951). *Critique of Judgment*. Tr J.H. Bernard. New York: Hafner.

Ross, M. (1978). *The Creative Arts*. Heinemann.

Sartre, J.P. (1938). *The Psychology of the Imagination*. Methuen.

Storr, A. (1951). *The Dynamics of Creativity.*
 Penguin.
Waismann, Friedrich. (1951). "Verifiability",
 Logic and Language, 1st Series, Antony Flew
 (Ed.). New York: Philosophical Library.
White, John. (1972). "Creativity and Education:
 A Philosophical Analysis" in *Education and the
 Development of Reason.* RKP.
Wittgenstein, L. (1966). Lectures and Conver-
 sations in *Aesthetics, Freud and Religious
 Belief,* Cyril Barratt (Ed.). Oxford.
Woods, R. and Barrow, R. (1975). *Introduction to
 the Philosophy of Education.* Methuen.

Aestheticism and Responsibility in Art Education

PHILIP MEESON

There are many arguments for the inclusion of art in the school curriculum. Usually they emphasize the function of art as a way of developing or training skill, often simple manual skill or dexterity or skill in what might be called problem solving activities where visual knowledge and judgment are required. Other arguments place emphasis on the development of imagination or creativity and yet others claim a vaguer purpose for art in visual knowledge, awareness or understanding or the development of feeling. Psychological theories, much in vogue during the fifties and sixties, gave rise to arguments which made art, as a manifestation of the unconscious mind, a necessary process in achieving a balanced personality or in a more mechanistic sense an adjunct to the development of cognition. More recently the particular differences between the arts have been dissolved within the notion of the aesthetic and, in the case of the visual arts, painting, sculpture and architecture, attempts have been made to identify the kind of knowledge particular to each and to set this out in such a way as to make it compatible with the learning processes, as identified and categorized in an expanding education

literature, of other more factual and propositional
subjects.

In all this argument inspired largely by the need
to justify the teaching of art in an age felt to
be increasingly alien to it there has been signif-
icantly little account taken of the meaning which
art has come to be invested with in our society.
The values which art projects, embodied in its
processes and the attitudes of mind which it
fosters are rarely overtly discussed in art educa-
tional literature so what is claimed as the purpose
of art in schools is often the outcome of a calcu-
lation about what will appeal as rational, sensible
or broadly useful to the public at large.

The simplest and most effective argument for art
in education has traditionally been that which was
effectively formulated by Henry Cole in the middle
of the last century. Cole saw art as essentially
craftsmanship belonging to the family of useful
arts and thus necessary in education in order to
develop basic manufacturing skills. This argument,
subsequently modified and elaborated by writers,
critics and artists such as John Ruskin and
William Morris and by followers of the Bauhaus
tradition together with various educational
functionalists, forms one line of today's continu-
ing argument. But it is the other line which
comes from the fine art tradition in which crafts-
manship plays little part except as technique and
in which meaning is accounted for not by reference
to usefulness but to a context of broader cultural
attitudes and beliefs that I want to discuss in
this essay.

Out of a philosophical interest in the nature of
beauty there emerged a tradition of philosophical
and critical thought at the end of the eighteenth
century which has extended to the present day.
This interest gave rise to the notion of the
aesthetic which defined an attitude of mind rather
than any particular kind of arrangement of forms
and thus turned critical attention away from
objects considered to be beautiful towards the
analysis of the principle of taste and latterly
towards the psychology of the aesthetic experience
itself. It is usual when speaking of the aesthetic
to note the emergence of the term with
A.G. Baumgarten in 1750[1] but the major figure in
the dissemination of the idea and in securing for
it a degree of intellectual legitimacy was
Immanuel Kant. Within the idealistic structure of
Kant's philosophy the aesthetic, or the principle
of judgment, forms the central term, as
Harold Osborne describes[2] "between the sensible
world of appearances and the supersensible world
of ultimate realities; between the concept of
Nature, which is the realm of law and science, and
the concept of Freedom, which is the realm of self-
imposed rational principles or "ends".

The construction of a philosophical framework
within which judgment, subsequently involving
taste and the notion of beauty, forms an essential
part led many writers and artists to see in Kant's
definition of the aesthetic a particular justifi-
cation for art. Kant, however, was not especially
concerned with art but with the construction of an
intellectual framework which might both explain
and govern man's place within both nature and
society. The description of the principle of
aesthetic judgment which Kant refined remains to

this day a central landmark in any discussion of
the aesthetic and within it two aspects stand out
above the rest. The first is the idea of detach-
ment or disinterest and the second is the notion
of "purposiveness without purpose" or that aspect
of the beautiful, going beyond the older notions
of unity in variety which might be described as
the feeling of order and design in nature which
cannot, unless we postulate a controlling Being,
be ascribed to any overall definable purpose or
end.

This idea of the aesthetic was adopted by Schiller
and developed within the context of education in
his *Letters on the Aesthetic Education of Man*
(1795). In this book Schiller argues for art,
wholly subsuming it within the idea of the
aesthetic, as the means by which man might aspire
to a higher condition of civilization. The basis
of this argument is essentially Kantian and in the
twentieth letter he places the aesthetic within a
concept of mind which clearly points towards a
view of art incorporating ideas of status and
freedom:

> The mind, then, passes from sensation
> to thought through a middle dispos-
> ition in which sensuousness and reason
> are active *at the same time*, but just
> because of this they are mutually des-
> troying their determining power and
> through their opposition producing
> negation. This middle disposition in
> which our nature is constrained
> neither physically or morally and yet
> is active in both ways, pre-eminently
> deserves to be called a free

disposition; and if we call the con-
dition of sensuous determination the
physical, and that of rational deter-
mination the logical and the normal,
we must call this condition of real
and active determinancy the *aesthetic*.[3]

Throughout the book Schiller brings together
beauty, detachment, morality, freedom, play, judg-
ment, purity, sensibility and art all within the
category of the aesthetic and thus set in train a
view of art which still largely prevails today.
Through Schiller's conflation of art and the
aesthetic the door was opened to the possibility
that, in the last analysis, it might be necessary
to conclude that whatever else art might be, what-
ever purposes or functions it might serve, its
vital principle rests on the aesthetic response
and it is in the value of this in itself and for
itself alone that any wider arguments of value and
cultural importance were subsequently based.

The first casualty of this philosophical develop-
ment was the link between art and utility. This
separation had been foreshadowed by Kant in his
division of beauty into two distinct notions;
those of free and dependent beauty. As
Harold Osborne again explains:[4]

> free beauty ... is independent of any
> conception of perfection or use, and
> dependent beauty ... is ascribed to
> things which do fall under such a con-
> cept. Only judgments relating to the
> former kind of beauty are regarded as
> "pure" aesthetic judgments. Pure or
> independent beauty belongs ... only to

things about which we judge without
any concept of perfection or useful-
ness, such things as certain natural
forms and non-representational art ...
non-vocal music, etc.

Subsequently moral considerations were to be res-
tricted within aesthetic discussion to questions
of artistic merit alone. As Oscar Wilde wrote in
the preface to *The Picture of Dorian Gray*

... the morality of art consists in
the perfect use of an imperfection
medium.

and of literature in particular:

There is no such thing as a moral or
immoral book. Books are well written
or badly written. That is all.

The idea of purity allied with disinterest and
freedom and excluding the moral became through the
nineteenth century the essential attributes of the
aesthetic and was extended to include art as well.
The notion of "art for art's sake" or aestheticism
which arose in the 1820s and which was launched as
a serious critical proposition by Theophile Gautier
in the preface to *Mademoiselle de Maupin* (1835)
contains all these attributes together with a now
customary rejection of questions or morality and
utility. Thus Gautier writes:

Nowadays there is a great affection
for morality, and it would be very
laughable, if it wasn't very boring ...
Nothing beautiful is indispensable to

life. If you suppressed the roses the
world would not materially suffer ...
Nothing is really beautiful unless it
is useless; everything useful is ugly,
for it expresses a need, and the needs
of man are ignoble and disgusting, like
his poor weak nature. The most useful
place in the house is the lavatory.

An important feature of aestheticism is the accept-
ance of music as the supreme art. A constant
theme in art criticism from Gautier to the present
day is the analogy between art and music, drawn
both by Baudelaire in his Salon of 1846 and by
Walter Pater whose apophthegm that "All art con-
stantly aspires to the condition of music"[5] is the
most memorable statement arising from this view of
art. The direction of art theory towards the
terminology of music is particularly noticeable in
the work of Whistler and indeed in the whole of
the Impressionist movement where not only is the
terminology of art and music interchangeable but
subject matter also can be expressed as effectively
by the one as by the other. Another casualty of
this aesthetic development was the link between
art and literature. As the musical analogy became
the dominant attraction within art criticism, and
for artists themselves, literature ceased to seem
in any way relevant to the concerns of the artist.
With the jettisoning of literature as a source of
artistic inspiration a further step was taken
towards the goal of social and political detach-
ment in art. As Whistler wrote in *The World* of
May 22nd 1878:[6]

Art should be independent of clap-trap -
should stand alone, and appeal to the

> artistic sense of eye and ear, with-
> out confounding this with emotions
> entirely foreign to it, as devotion,
> pity, love, patriotism, and the like.
> All these have no kind of concern with
> it; and that is why I insist on calling
> my works "arrangements" and
> "harmonies".

Ruskin attempted to resist this development and
much has been made of his concern for the state of
art in the nineteenth century, particularly in
relation to the increasing dominance of industrial
manufacturing and its disruptive effect upon
craftsmanship. But Ruskin's view of art was never
that of the practising artist, his critical method
was to establish a view of what art ought to be,
what it should communicate or mean, and then to
measure in a Procrustean way each work of art
which came before him against this view. He was
quite unwilling to take the artistic imagination
in whatever form it might manifest itself as the
starting point for enquiry and thus, as his court
case with Whistler shows, when an artist chose to
explore ideas which seemed incongruous to him,
however much they might appear to be potentially
within our normal experience (and what could be
more normal or common-place to most people then
evening descending over the Thames or a display of
fireworks?) he was obliged to reject them in
defence of what to him was a higher principle of
art. Had the meaning that art held for Ruskin
been thrust on Whistler the adjective "Whistlerian"
would not be available to us today as a way of
describing a particular effect of light or of
evoking a particular feeling associated with the
river Thames as evening falls.

The severing of the connection between art and
literature, between, that is, a familiar meaning
expressed verbally and works of art created
expressly to embody that meaning, caused artists
to look upon illustration as a lesser form of art
and prevented the mass of the public from approach-
ing art from this direction. It now became a sign
of ignorance to ask what a work of art might mean
and as art also began to turn away from the trad-
itions of the past so it became increasingly form-
alist. Thus by 1896 Bernard Berenson in his essay
on the Florentine painters remarks "The painter
can accomplish his task only by giving tactile
values to retinal impressions"[7] so putting in ques-
tion the usual criteria of critical enquiry and
art theory. The direction which art now takes is
away from expressible meaning, in a sense compat-
ible with interpretation, towards a view of art as
a function of the mechanism of mind.

The most complete expression of the aestheticist
position is to be found in the conclusion to
Walter Pater's book *The Renaissance*. In this
summary of his aesthetic beliefs Pater brings
together the major themes of nineteenth century
aesthetic philosophy and art criticism in affirm-
ation of the life of sensation. It is noticeable
that the idea of balance which is implicit in both
Kant and Schiller is now completely absent and the
aesthetic and art now become a means towards a
final triumph of sensation over reason. Art
becomes uniquely the gateway to the inner life of
the imagination, no longer having any direct bear-
ing upon the world of material reality. Whilst
Pater acknowledges in the opening passage the
importance of the physical life, this is seen as
no more than an Epicurean banquet from which we

each, individually, select our own lasting
memories and sensations. The comparison throughout
is with the flame, both illuminating and devouring
experience. "It is with this movement, with the
passage and dissolution of impressions, images,
sensations, that analysis leaves off." he writes,
"That continual vanishing away, that strange, per-
petual weaving and unweaving of ourselves".[8]

> ... Every moment some form grows per-
> fect in hand or face; some tone on the
> hills or the sea is choicer than the
> rest; some mood of passion or insight
> or intellectual excitement is irresist-
> ably real and attractive to us for
> that moment only. Not the fruit of
> experience but experience itself is
> the end. A counted number of pulses
> only is given to us of a variegated,
> dramatic life. How may we see in them
> all that is to be seen in them by the
> finest senses? How shall we pass most
> swiftly from point to point, and be
> present always at the focus where the
> greatest number of vital forces units
> in their purest energy?

> To burn always with this hard, gemlike
> flame, to maintain this ecstasy, is
> success in life. In a sense, it might
> even be said that our failure is to
> form habits: for, after all, habit is
> relative to a stereotyped world, and
> meantime it is only the roughness of
> the eye that makes any two persons,
> things, situations, seem alike. While
> all melts under our feet, we may well

grasp at any exquisite passion, or any
contribution to knowledge that seems
by a lifted horizon to set the spirit
free for a moment, or any stirring of
the senses, strange dyes, strange
colours, and curious odours, or work
of the artist's hands or the face of
one's friend. Not to discriminate
every moment some passionate attitude
in those about us, and in the very
brilliancy of their gifts some tragic
dividing of forces on their ways, is,
on this short day of frost and sun, to
sleep before evening ... We have an
interval, and then our place knows us
no more. Some spend this interval in
listlessness, some in high passions,
the wisest, at least among "the
children of this world", in art and
song.

Pater's appeal to novelty, heightened sensation,
hedonism and his association of the aesthetic with
the idea of childhood has passed into much present
day thinking about art and about art education.
It was offensive to many in Pater's day and caused
him to leave out this passage from the second
edition of *The Renaissance*. Even in art education
today such a view of art and of life has its
opponents for it sits awkwardly with contemporary
ideas about the curriculum and those managerial
exercises which require one to set down one's aims
and objectives or to formulate a rationale for
art. But perhaps the most disturbing aspect of
Pater's attitude to life and to art is his recog-
nition of transience, of the corrosive effect of
time and of habit on the pleasures of new ideas,

experiences and sensations. "Make it new" is
surely the central axiom of all art, for without
the feeling of novelty art loses its vitality,
remaining only as a minor monument by the road
where once living people trod. Equally, to live
in a state of sensual ecstasy is a dream which art
has always been looked to to support, the more so
in a world increasingly controlled by the "worldly
wise", a world which makes the idealism of Pater
seem not only naive but irresponsible and trivial.
Yet, in so far as we have any conception of pro-
gress, such a dream must surely play a part in it.

In the present century modernist art criticism
has used aestheticism as the basis for a theory of
art to which it is usual to apply the term formal-
ist. This theory has, in effect, defined art in
such a way that the spiritual in art, that which
Charles Bally describes as that "something which
communicates, so to speak, from body to body, i.e.
on the hither side of words or concepts."[9] has
been presented as a state of withdrawal or detach-
ment. Formalist art, pursuing the analogy with
music, attempts to purify art, to remove it from
the need to describe or represent directly the
appearances of nature and proposes that there is
in art a unique form of knowledge or understanding
which is experienced as "aesthetic emotion".

In *Vision and Design* Roger Fry attempted to define
"aesthetic emotion" and to construct a critical
framework within which artistic value judgments
might be made, judgments which necessarily could
not accommodate the critical standards of much
Victorian art. Fry frankly admits that his criti-
cal approach would be unlikely to attract more
than a small minority of people:

> ... the artist of the new movement is
> moving into a sphere more and more
> remote from that of the ordinary man.
> In proportion as art becomes purer the
> number of people to whom it appeals
> gets less. It cuts out all the romantic
> overtones of life which are the usual
> bait by which men are induced to accept
> a work of art. It appeals only to the
> aesthetic sensibility, and that in most
> men is comparatively weak.[10]

In defence of this argument he approvingly quotes
Bernard Shaw in advocating that "any picture which
pleased more than ten per cent of the population
should be immediately burned."[11]

In *An Essay in Aesthetics* Fry develops the argu-
ments of aestheticism to the point where key
stylistic concepts can be discerned, both describ-
ing and defining the contemporary stylistic deter-
minates of modernism, or that interpretation of
modernism which was acceptable to British artists
and art critics at the time. For example, there
is an acceptance of "child art" as relevant to a
general understanding of the significance of free-
dom and sincerity in art; the rejection of moral
responsibility and the assumption that the artistic
imagination is by nature sincere by comparison with
"the squalid incoherence" of the average business-
man's imagination. Clearness of perception, purity
and freedom, Fry claimed, are the characteristics
of the artistic imagination which he reduces
finally to a number of "design elements"; linear
rhythm, mass, space, light and shade, colour, and
an element of "planar inclination".

In a more systematic way Paul Klee also attempted
to define the essential elements of art as did
other founder members of the Bauhaus and their
analytical approach to art subsequently became
standard academic practice in the teaching of art.
Klee began his investigations by attempting to
divest himself of all prior knowledge of art and
of the world; to become, as he put it "as though
new-born, knowing nothing, absolutely nothing,
about Europe; ignoring poets and fashions, to be
almost primitive."[12] The purpose of this proced-
ure was to enable Klee to create a uniquely
personal and individual style, one which, he hoped,
would owe nothing to any influences around him.

A similar concern for the primitive as a positive
value in art informs the doctrine of "child art"
and illustrates the characteristic tendency of
modernist art theory and criticism to concentrate
on the psychological and the aesthetic rather than
broader social and cultural considerations. Thus
what has been valued in "child art", that quality
of primitiveness described variously as charm,
naivety, or naturalness which modern artists have
striven to express in their work, has its origin
in the aesthetic of modernism which similarly
places high value on "primitiveness".

The taste for the primitive, the pure and the for-
mal as against the traditional supposedly rule-
governed art of the past found a focus in the art
of children, subtly given the status of a genuine
artistic style by the term "child art".
Herbert Read in his book *Education Through Art*
used the notion of "child art" together with
aesthetic arguments derived from Schiller and the
nineteenth century tradition of aestheticism, to

which he added a large element of Freudian psy-
chology, particularly that aspect of it which
seemed to suggest a link between art, the dream
and the unconscious mind, to establish an argument
for the use of art as the instrument for the teach-
ing of all the subjects in the academic curriculum.
The point of this was not to teach art as a matter
of technique but on the assumption that art,
thought of in the undifferentiated way as expression
or language or as Read put it as a "will to form",
is a basic creative urge in man, then art should
form the starting point for all forms of learning
and for all subjects.

Central to Read's argument is the idea of the
aesthetic which now displaces art with its sugges-
tion of organized procedures and techniques allow-
ing Read to develop the main argument of the book,
that through art education the ideal of balance of
action governed by judgment and sensibility fore-
shadowed in the writings of Schiller, can be
brought about. It is easy now, of course, to dis-
miss much of *Education Through Art* as naive or
impractical and it is perhaps necessary to separate
Read's observations on art from the other elements
of the book, for he is on stronger ground when he
is discussing the art of children than he is when
laying out his pedagogical arguments. His view of
"child art" embodies the aesthetic tradition of
"art for art's sake" and is founded on the belief
that art is essentially a matter of freedom both
of the intellect and of the imagination. For Read
as for the artists who formed the main stream of
the modern movement art meant freedom, from the
debilitating influences of tradition, from arbi-
trary rules and from techniques which constrained
rather than liberated the imagination.

It is hardly surprising that Read should have been
attacked by educationists who could not have been
expected to hand over the control of education to
art teachers, but indifference to his ideas very
quickly developed amongst art teachers themselves
who found it difficult to reconcile a growing
demand within their own ranks for a kind of
academic probity to match that of the more "legiti-
mate" subjects in the curriculum with Read's
underlying anarchy. Read's ideas, strongly on the
side of freedom, came up against a resurgence of
the utilitarian tradition in art which derived
from Ruskin and Morris, recast in twentieth form
by the Bauhaus and reemerging in the form of
"basic design". As this term implies art within
this ideology is given a more purposeful aim, a
more overt function within society than within the
older "fine art" tradition. In "basic design" art
is seen not as a way of holding at bay or perhaps
reversing some of the dehumanizing effects of
modern life, but as a way of accommodating them
within art itself, although in practice many
"basic design" methods have the appearance of
being an academic reduction of modernism.

Looking back over the last hundred years, over the
emergence of modernism and the parallel emergence
of the idea of "child art", there is one clearly
apparent unifying feature, at least as far as
Britain is concerned. The dominant influence upon
art and art education throughout this period,
originating in the aesthetic movements of the nine-
teenth century, is romantic at heart and thus has
carried with it a view about art, the artist and
the place of art in society which still forms
today the starting point for discussion about art
in the context of education. Clive Bell expressed

this view in his essay "Civilization" published in 1928:[13]

> As a means to good and a means to civ-
> ility a leisured class is essential;
> that is to say, the men and women who
> are to compose that nucleus from which
> radiates civilization must have secur-
> ity, leisure, economic freedom, and
> liberty to thinkl feel and experiment.
> If the community wants civilization it
> must pay for it. It must support a
> leisured class as it supports schools
> and universities, museums and picture
> galleries. This implies inequality -
> inequality as a means to good. On
> inequality all civilizations have
> stood.

and;

> All else being equal, I should prefer
> a civilization based on liberty and
> justice: partly because it seems to me
> the existence of slaves may be damaging
> to that very élite from which civiliz-
> ation springs; partly because slaves
> too deeply degraded become incapable of
> receiving the least tincture of what the
> élite has to give. A sensitive and
> intelligent man cannot fail to be aware
> of the social conditions in which he
> lives, and the recognition of the fact
> that society depends for its existence
> on unwilling slavery will produce on
> him one of two effects: a sense of dis-
> comfort, or callousness.

Commenting on these passages Lesley Johnson writes
in *The Cultural Critics*; Bell's conclusion is dis-
turbing. His concerns were expressed solely in
terms of the sensibility of the élite, with abso-
lutely no qualms about the degradation that the
remainder of the society may be suffering. The
conditions and the quality of life of the general
population only arose as matters for consideration
in so far as they may disturb or cause distress to
the members of the élite ... Bell's writing con-
veys the impression that if oppression and degrad-
ation were out of sight, then they "would have
bothered him very little".

It would be going too far to claim that Bell's
élitist views have been a predominant influence on
art education in recent years but their presence
is clearly detectable in much art educational
debate, even though they are usually suffused with
that wider sense of social responsibility which
comes from such figures as J.S. Mill and
Matthew Arnold. Bell's views are so clearly out
of step with the broad stream of educational
debate today, even without the context of a
Marxist-Structuralist critique, that one might be
tempted to dismiss them altogether as the mere
remnants of a dying bourgeois culture. I must
confess at this point that my original intention
in writing this essay was to outline the influence
of aestheticism on art education in order to show
that through its overt claims to describe or to
express the essential nature of the artistic atti-
tude it covertly supports an irresponsible and
reactionary social position which, for want of a
better word, one must accept as élitist.

There have been many writers on art who have seen
the problem in this way; Ruskin and Morris certainly
did, but their solutions to it contain that degree
of ambivalence which one recognizes when those who
start from a position of artist or art critic
write about art education. An apparent solution
to the problem can be fabricated by making art
entirely a product of culture defined as the
expression of a predominant social experience
including within art all that can be included
under the heading of communication or expression
and then suggesting that principles revealed by a
psychological, politico-economic or linguistic
analysis of, say, the production of newspapers or
glossy magazines are essentially the same as those
which will unlock the meaning of significant works
of art. Indeed, what has hitherto been considered
the essential criterion of artistic significance,
whether or not a work sustains a high level of
continuous aesthetic contemplation, is made within
much socially orientated criticism a matter of
little significance against the view that aesthetic
contemplation itself and the values it rests upon
are essentially determined by the prevailing norms
of social discourse.

A counter thesis to this view, which I include
merely to sketch in the rough outline of the argu-
ment, is provided by Elizabeth Bird in *Idealogy
and Cultural Production*.[14] Bird notes the diffi-
culty of approaching value judgments about art
from the angle of sociology and in arguing for
aesthetic neutrality on the part of the sociologist
she advocates that the sociologist should "not
attempt to evaluate the art which he or she is
studying and that includes not seeking to rank art
in aesthetic terms"; and secondly by extension of

this principle "the sociologist should not study
art at all, but confine him or herself to the
study of the objective facts". She goes on to
suggest that, nevertheless, to carry out any socio-
logical study of art entails the selection of
works of art to study, and this in turn entails the
making of aesthetic judgments. She goes on to say
that:

> Works of art, like other cultural
> products, persist over time, and far
> outlive the economic structures in
> which they were produced. This per-
> sistence is problematic for the pro-
> ponents of straight reflection theory
> who maintain that culture directly
> reflects the economic relations of the
> base. It is less problematic if we
> accept that cultural products are not
> just commodities, but also contain
> meanings which are constantly being
> re-interpreted. The persistent quality
> of the work of art is derived from the
> present, not the past, and is bound up
> with the process of cultural trans-
> mission, which includes the process
> whereby aesthetic values are transmitted
> via art galleries and museums, the
> educational system, reproductions, art
> historical monographs, and so on. The
> interesting question then becomes what
> qualities in the work of art are valued
> and why, which leads us back to the
> ideological components of the visual
> image.

Bird concludes that the problem of understanding
the relationship between art and society transcends
a sociological analysis alone.

The problem, however, goes deeper than Bird ack-
nowledges and has particular relevance to any con-
textual discussion of art, for the terms "interpret-
ation" and "ideological components" can be construed
as tendentious within discussion about the nature
of art. Such terms may lead us to think that
expression is central to an understanding of art or
that, given that works of art embody ideas, these
ideas might be or desirably should be explicated
by discoursive means; that is, made available for
interpretation or translation through the ordinary
modes of writing or speech. If such a line of
argument is followed the aesthetic significance of
works of art becomes dependent upon what we can
say about them rather than on their phenomenal
impact, and such a view might lead us to believe
that accurate descriptions or records of a personal
response to works of art could be effective substi-
tutes for the original works themselves.

The question of whether works of art can be spoken
of as expressing ideas has been well worked over
in the field of aesthetics and is usually left
hanging where interpretation merges with form,
forcing the acknowledgment that meaning cannot in
the last analysis be severed from the particular
form which carries it. There is always a remainder
in such an approach to art, a remainder which
repeatedly eludes our grasp; hence the temptation
to choose inferior works of art, if interpretation
is sought, whose meaning can be more readily
reduced to plain words and testable propositions
particularly if, in an attempt to "demystify" art,

TAE-D

context is the preferred starting point for analy-
sis, rather than the objective work of art itself.
Had Elizabeth Bird included within her concept of
art music as well as the visual arts the problem,
one suspects, would have immediately revealed
itself in a clearer light.

If such terms as "interpretation", "ideology", and
I would add "meaning" and "understanding" are
problematic within the discussion of art, as I
suggest they are, this may well point to the fact
that our experience of works of art is different
in kind to other kinds of experience. Works of
art require to be studied for meaning, for works
which are meaningless are not, strictly, works of
art at all. Yet whatever meaning might be ascribed
to a work of art cannot be tested for truth in the
way that statements of a propositional kind can be
so tested. Statements about works of art may be
approached in this way but here the mechanism of
language has come into play and meaning becomes as
much a matter of how language governs what we may
say as a vehicle for the intended communication of
ideas. It may be that the word "truth" should
also be added to the list of problematic terms in
art discourse for clearly what might be thought
true where demonstrable proof is available is, as
with the distinctiveness of the experience of art,
a different kind of truth from that where so much
rests on spacial, aural or visual judgment, or on
manual skill. Those judgments of balance and pro-
portion also which are typically thought to com-
prise the essence of the aesthetic are not suscept-
ible to anything in the nature of proof in a
quantifiable sense and can only be supported by an
acknowledgment of rightness which at root arises
from feeling rather than from the application of

intellect. This is not to say that intellect is
not involved in the production of works of art but
to indicate that between the world of discourse
about art and the world of practice in art there
is an area where thought merges with matter and
where communication is more a matter of "seeing the
point" or of responding to the excitement and
enthusiasm of others than of anything which might
be defined as overtly meaningful or demonstrably
correct.

The attitude of mind which desires to embrace the
materiality of things whilst at the same time
embodying those things in abstract thought is, I
suggest, the essence of artistic thinking. The
attraction and the appeal of works of art lies in
this fusion of thought and substance where an
object fabricated by the hand of man carries within
it an echo of the life and personality of its
maker. It is in this that the distinctiveness of
works of art lies, separating them out from the
generality of man-made objects and from natural
objects. It is not surprising that we place a
high value on art for to be made aware of the range
of experience and knowledge which thought together
with sensation allows us is indeed liberating and
life-enhancing.

I have made this foray into aesthetics in order to
underline the distinctiveness of artistic thinking
and also to raise the question whether, however
much we may object to the detachment and apparent
irresponsibility of aestheticism, it nevertheless
arises from a true understanding of the nature of
art. Aesthetic experience is undoubtedly a common
experience but it is also a personal and individual
experience and it is this individuality which makes

it difficult to discuss against notions of social
purpose or responsibility, or, one might add, within
the context of education.

The attractiveness of art, its liberating effect
on the imagination; its life-enhancing value
resulting from the effect of pleasure which it
induces in the mind, all this contributes to that
sense of separateness from normal day-to-day
experience which both sets up a desire to repeat
and to enlarge the pleasures derived from art and
the wish to draw oneself to those of a like mind.
Where so much of the significance of art lies
within the private and unspoken area of personal
pleasure it is not surprising that association
with like-minded people is preferred to those for
whom the pleasures of art are incomprehensible.
Such, I believe, is the origin of those élitist
attitudes which are commonly found in artistic
circles, their source, I suggest, lies within the
very nature of the artistic experience itself.
Effective art teaching will support and encourage
the development of a personal vision and in doing
this it will necessarily demand an accompanying
independence of thought on the part of the student
which, unsupported in the last analysis by anything
more than ego, will lead to those familiar charac-
teristics of temperament for which artists are
notorious.

If my analysis of the characteristics of artistic
thinking is correct then any requirement that art
should become deliberately engaged with the politi-
cal or social issues of the day, except where the
individual temperament of an artist might lead in
that direction, will seem to most artists an
irrelevance. This is not to be seen as evidence

of a corrupted consciousness or as the corrosive
effect of bourgeois culture, but rather as the
natural reaction of the artist to unwarranted
demands made by those whose understanding of art
may be somewhat limited.

Are we then committed to accepting art as a mere
minority or coterie interest? If we see art as
carrying the highest and the most desirable cult-
ural values, as Bell suggested that we do, then
the acceptance of art only as a minority interest
will seem insufficient to many and may lead us to
agree with William Morris that art were better
dead than that it should be consigned to such a
minor and peripheral part of life. It is no
longer possible, however, to claim that art alone
embodies the highest values of society; art itself
has withdrawn from this position. Such idealism
sits uneasily with the tenor of present day think-
ing. Some might point to this as clear evidence of
decadence, others as evidence of a more clear-
headed view of art. But if the support of a
social relevance is seen as of doubtful relevance
to art and cultural idealism is dismissed as dis-
tinctly passé, what is left to support the inclusion
of art in education?

If the meaning of art in education has hitherto
centred about the cultural importance of imagin-
ation and intellectual freedom, what is now
apparent is that this view is being questioned
from within the institutional world of art as well
as from the direction of social criticism. It
might be argued, therefore, that in so far as art
education has any claim to value within the curric-
ulum it should display an awareness of the conflict
between a recognition of the distinctiveness of

artistic thinking on the one hand, and the demands
of relevance and purpose extending beyond a purely
personal world of the imagination on the other.
In practical educational terms, where difficulties
are experienced in justifying the inclusion of a
subject in the curriculum this is often the result
of the context from which meaning arises being
insufficiently defined. When the context is
defined to include the observable tensions in our
society between claims of the individual against
the collective, the private against the public,
the "cultural" or "spiritual" against the economic,
the world of practice against the world of dis-
course, or the conceptual against the non-conceptual,
then art, if it wishes to be seen as having any
relevance to this debate, must incorporate within
its practices appropriate pedagogical methods.

As a guideline to how this might be done and as a
way of establishing art in the school curriculum as
something more than a mere sideline to other,
supposedly more important academic subjects, a
line of practical development suggests itself.
Within the twin poles of the private and the public
there are clearly two possible ways of formulating
a theory of art education; one which lays emphasis
on a developing personal awareness, the other on a
developing knowledge of art as defined by history
and theory. Both of these axes need to be incor-
porated in any theory of art education. By "a
developing personal awareness" I mean that area of
possible understanding centred about meaning in
relation to knowledge and experience of the world.
In this sense art fulfils a purpose similar to but
also anterior to language; it is a way of linking
experience through concrete form to actuality and
thus gives to an indifferent world of nature both

significance and meaning. In short, it is a means towards knowledge of oneself within the world.

On its own the pursuit of this line of thought in education would provide ample justification for art as it would run along that line of language, and thus of knowledge, which leads back to or which starts from the space between language proper and the world which stands over against language. But there is yet the other axis which, again, is to be found in language, leading along the line of history and convention, of traditional forms and usages along, that is, the line of art as defined by existing works of art. At the juncture of these two axes the personal world of meaning meets with culture which both amplifies it by moving the personal into the wider field of the social and refines it by enabling a dialogue to take place across time and space with other minds.

The end and purpose of this is not merely to know more about art but to construct a more substantial ground of meaning in relation to the real world; such a purpose for art or for the arts in education would seem sufficiently serious to justify their inclusion in the curriculum.

REFERENCES

[1] Baumgarten, A.G. *Aesthetica*. Frankfurt, 1750.
[2] Osborne, Harold. *Aesthetics and Art Theory*. London. Longmans 1968, p. 114.
[3] Schiller, Friedrich. *Letters on the Aesthetic Education of Man*. Routledge & Kegan Paul, London, 1954.
[4] Osborne, Harold, *op. cit.*, p. 118.

[5]Pater, Walter. *The Renaissance*. Mentor, USA,
 1959.
[6]Whistler, James McNeill. *The World*. 22nd May,
 1878.
[7]Berenson, Bernard. *Florentine Painters of the
 Renaissance*. New York & London, 1896, pp. 4 ff.
[8]Pater, Walter, *op. cit.*, p. 157.
[9]Bally, Charles. *La Langue et La Vie*. Geneva.
 Droz, 1965, quoted in Bourdieu, P. *Outline of
 a Theory of Practice*, p. 1.
[10]Fry, Roger. *Vision and Design*. Chatto & Windus,
 1920, p. 15.
[11]Fry, R., ibid., p. 63.
[12]Klee, Paul. *Artists on Art*. J. Murray, 1978,
 p. 442.
[13]Johnson, Lesley. *The Cultural Critics*.
 Routledge & Kegan Paul, 1979, pp. 91-2.
[14]Bird, Elizabeth. *Ideology and Cultural Produc-
 tion*. (Ed. Barrett, Corrigan, etc.) London,
 Croom Helm, pp. 32-48.

The Aesthetic in Education
and in Life

HAROLD OSBORNE

THE UBIQUITY OF THE AESTHETIC

We might well say of Aesthetics what St. Augustine
said of Time: "What is time? So long as no one
asks me, I feel that I know. If I have to explain
it to him who asks me, I do not know". For "is it
not true that in conversation we refer to nothing
more familiarly or knowingly than time? And
surely we understand it when we speak of it; we
understand it also when we hear another speak of
it". Yet "who can easily or briefly explain it?
Who can comprehend it even in thought or put the
answer into words?"[1] This elusiveness is reflected
in current discussions about Aesthetic Education,
where the conflict of ideas bespeaks not merely
lack of unanimity about practical methods of
achieving an agreed goal but some uncertainty about
the nature of the goal itself. Yet underlying all
the diversity I believe it is possible to discern
some general understanding that in contrast with
other spheres of mental activity Aesthetics is
centrally concerned with our direct apprehension
of things, with what used to be called "knowledge
by acquaintance" rather than conceptualized
knowledge and understanding. However different

the methods that are advocated, there are perhaps
few who would not accept that Aesthetic Education
envisages the expansion of our perceptual powers
and the cultivation of that sensibility which
belongs to direct apprehension of the world in
which we live.

If we do accept this intuition, it leads on to the
conclusion that the field of the aesthetic is not
confined to the fine arts but is pretty well exten-
sive with the whole of life and experience. It is
indeed not easy to imagine anything which does not
have its potential aesthetic aspect, positive or
negative. Sensibility may be called into play in
our enjoyment of the beauties of nature, the tran-
quilities or grandeurs of landscape, the unexpected
forms of the microscopic, the grace of animal move-
ment, the elegance of dress, the refinement or
vulgarity of our most intimate environment. It
also enters into our appreciation of the beauty,
elegance and perfection of intellectual constructs,
such as those in mathematics and the sciences for
example. There is nothing strained or novel about
this extension of the scope of the aesthetic,
which goes back indeed to the first introduction
of the term by Alexander Gottlieb Baumgarten[2] and
its adoption by Immanuel Kant in his Third
Critique. I would like here to quote part of what
was said on this matter by Edward Bullough, who is
remembered now chiefly for his introduction of
"physical distance" as an aesthetic principle but
who created new enthusiasm by his lectures on
Aesthetics in Cambridge from 1907. In "The Modern
Conception of Aesthetics" he said in the somewhat
dated language of his day:

Our whole life is, indeed, saturated
with this aesthetic charm, which, how-
ever despised by some and neglected by
most, yet exhales an aroma so ethereal
that it hardly obtrudes upon our atten-
tion, though we may at once become
sensible of its loss. Its most evident
expression it finds in those external
conditions which we consciously induce
in order to enforce it upon our sensi-
bility, in those things of our daily
existence which Pater mentioned: our
houses, our rooms, our furniture, our
tools: even ourselves, in the exter-
nalities of personal manner and bear-
ing, we endeavour to invest with that
special attractiveness to which we
cannot apply any other epithet but
"aesthetic". Yet all these are but
external conditions. They either sat-
isfy some inward craving for aesthetic
satisfaction or minister to the
aesthetic expression of some inward
impulse. It is the *inward* world, of
which all these external circumstances
are but the reflection, which is essen-
tially the world of aesthetic culture.
And from this inner world, aesthetic
culture is carried over not only into
the material features of our existence,
but also transfused into our spiritual
needs and strivings. Thus aesthetic
considerations enter into educational
questions, religious convictions,
intellectual pursuits, into our own
conduct and individual acts and the way
we evaluate the actions of our fellow-

creatures. Our whole psychic life is
permeated with this mysterious
aesthetic culture, and our general
attitude towards experience, our com-
plete outlook upon life in general, is
not infrequently more of an aesthetic
than of a practical, scientific or
ethical nature.[3]

It will be germane to the point I hope to make in
this paper if I may expatiate a little further on
this idea of aesthetic culture, including areas
where the aesthetic and what is commonly thought of
as the moral seem to merge and coincide. My con-
tention will be that when we speak of the aesthetic
in education we are concerned not so much with one
subject among others, a particular region of
knowledge which can be confined to so many hours
within the weekly teaching curriculum, but rather
to an attitude of mind and a mode of awareness
which permeates broadly throughout our mental out-
look and performance. To this outlook the follow-
ing considerations are pertinent.

(a) The desire to do whatever it is that one does
as well as it can be done and not just well enough
to get by in order to satisfy immediate practical
requirements is aesthetic rather than moral in its
origin. This "pride in production", as it has
been called, is something supererogatory, something
in excess of obligations imposed by economic and
practical considerations.[4] As an aesthetic factor
in human performance, and a particularly powerful
motive in fine craftsmanship, it is far from being
a recent development but is now recognized by
anthropologists to have existed from the earliest
known epochs of human productivity. In their book

Prehistoric Societies (1965) Graham Clark and
Stuart Piggott, for example, find evidence in the
Lower Palaeolithic Age for what they call "the
cult of excellence, the determination to make
things as perfect as they could be made, even if
at a purely utilitarian level such perfection
might seem excessive ..." Although in modern
industrial societies economically regulated by the
profit motive it is tending to be suppressed, and
in some Communist countries it is already regarded
as superfluous, this "cult of excellence" still
persists in its own right as a motive alongside
the desire for reward and renown in the sphere of
sport, in the domain of the fine arts and in the
pure sciences. On this matter Bullough, again,
writes: "Aesthetic consciousness discovers that
innumerable acts are daily done, not for the sake
of practical utility nor in conscious observance
of ethical postulates, but because the doing of
them was accompanied by that peculiar sense of
enjoyment in doing them well, with all the strength,
perfection and grace that could be imparted to
them".

(b) The leaders and originators of the new
sciences of cosmology and particle physics, which
together with molecular biology have wrought a
veritable Copernican revolution in the imaginative
outlook of our age, have shown themselves highly
sensitive to the inspirational and heuristic impor-
tance of intellectual beauty, a special kind of
perfection. Poincaré, who was something of a
pioneer in this respect, claimed that new insights
in mathematics such as his own Fuchsian functions
and his realization of the connection between the
transformations he used in the Fuchsian series and
non-Euclidean geometries, emerged from what he

called the "subliminal self" and that this was
guided not only by intellectual considerations but
much more by "the feeling of mathematical beauty,
of the harmony of numbers and forms and of geo-
metric elegance. It is a true aesthetic feeling
which all mathematicians recognize ... the useful
combinations are precisely the most beautiful".
"God used beautiful mathematics in creating the
world", said Paul Dirac, and added: "It is more
important to have beauty in one's equations than to
have them fit experiment ... It seems that if one
is working from the point of view of getting
beauty in one's equations, and if one has really a
sound insight, one is on a sure line of progress".
In the opening of his book *The Particle Play* (1979)
J.C. Polkinghorne, former Professor of Mathematical
Physics in the University of Cambridge, wrote: "It
is a recognized technique in elementary particle
physics to seek theories which are compact and
mathematically beautiful, in the expectation that
they will then prove to be the ones realized in
nature. This is a striking fact". Werner
Heisenberg once commented to Einstein: "You may
object that by speaking of simplicity and beauty I
am introducing aesthetic criteria of truth, and
frankly I admit that I am strongly attracted by
the simplicity and beauty of the mathematical
schemes which nature presents us. You must have
felt this too ..."[5]

Few men in any age become great creative artists:
far far more can appreciate and enjoy the art they
create. So too in the sciences. Instead of teach-
ing mathematics and physics as a body of set rules
and stagnated knowledge to be copied into the note-
book and memorized by rote, might it not be con-
gruent with the educational ideal, one wonders, to

imbue the beginner with something of the excitement
and thrill of discovery, enable him to share the
creative experience of the founders and awaken
sensibilities for the intellectual beauty and per-
fection of the theories which have often preceded
experimental discovery. To plant the seeds of
such sensibility must be a source of supreme satis-
faction to a teacher.[6]

(c) To broach a different territory - there are
ideals of conduct to which we all subscribe
although we do not recognize a duty to practise
them ourselves on any and every occasion. Courage,
loyalty, heroism, self-sacrifice, tenderness,
sincerity, etc., are "virtues" which command the
approbation of society but which go beyond the dic-
tates of moral obligation. We admire and approve
persons who display these virtues. But if we feel
a duty to implement them ourselves, it is a duty
to *ourselves*, to the aesthetic ideal of personality
which we have set before ourselves as a standard
to which to conform. For no man has else a duty
to go beyond the demands of moral obligation,
though we may admire those who do. It is allied
to the self-discipline which supports the formation
of mature personality.

(d) Aesthetic considerations relating to stature
and style play an important and may even play a
preponderant role in our appraisals of other
people, whether it be those of our contemporaries
with whom we have direct contact or, even more,
public and historical personages. We feel differ-
ently towards a rogue on the grand scale than we
feel towards a timid, mean, sly, slinking petty
criminal. We may even experience a sort of reluc-
tant admiration for a heroic and exuberant

transgressor. Whether we accept his attitudes or
not, we rate an uncompromising moral rebel higher
in terms of human personality than a humdrum,
routine, self-righteous conformist. H.G. Wells
was once described as "small, sickly, common, sel-
fish, vain, angry ..." True or false, the impact
of such descriptions is almost entirely aesthetic
and, as every novelist knows, they are even more
telling than purely moral ones. Sensibility for
this sort of assessment is a skill that can be
cultivated rather than an item of knowledge that
can be categorized in a psychological textbook. In
the last resort it evades verbal formulation. Yet
it is a by no means negligible part of a man's
equipment in life. When Henry James wrote "We
care what happens to people only in proportion as
we know what people are"[7] it was this sort of
knowing he had in mind.

(e) It has been a topic of discussion among moral
philosophers whether moral or aesthetic values
prevail when a conflict arises between them.
There are, of course, persons, of whom Oscar Wilde
is often taken as typical, who have claimed that
aesthetic considerations are always paramount in
their own sphere and that if moral values impinge,
it is just too bad for moral values. The super-
ficial answer has been that moral values have the
greater compulsive force in every sphere and that
in case of conflict they must prevail. A man will
be allowed to say: "I am not interested in the
arts. Natural beauties leave me cold. Good taste,
tact, consideration for others if you like, in so
far as these things smooth the path of life. But
only in so far as they do not interfere with more
important things. The main concern is to do one's
duty in all things, carry on one's job in the

world as efficiently as can be done. I don't
really care about any of the rest". We allow a
man to get away with this. We may not like such a
man, but we do not condemn. But let a man say he
is indifferent to moral duty and our reaction is
quite different. If a man says: "Provided I get
from life the maximum accrual of personal satis-
faction, physical, mental and aesthetic, I don't
care about the rest", our answer then is: "But you
ought to care". We condemn anyone for being that
kind of man, for living in accordance with an
attitude of disregard for moral obligations. To
say "It is immoral" is condemnation.

That is the immediate reaction. But from time to
time there have been attempts to achieve a recon-
ciliation by seeking an aesthetic basis for the
ethical ultimate. Very briefly the argument runs
as follows, as set forth for example in
R.W. Beardsley's *Art and Morality* (1971). Moral
systems are either deontological or utilitarian
and moral considerations are discussed either in
terms of a *summum bonum*, a maximum accumulation of
satisfaction, or in terms of ultimate obligation.
In so far as the *summum bonum* is taken at the indi-
vidual level it automatically loses its moral
character and becomes calculating selfishness.
Therefore the moral goal is usually understood to
be the *summum bonum* of the community, whether the
restricted community in which each man lives or
the whole of mankind, including perhaps generations
still to come. If this is accepted, the question
inevitably arises: "Why should I, this individual
person I am, pursue the *summum bonum* of others,
any others, to the likely detriment of my own
greatest satisfaction?" There is no answer except:
"That is your duty". This is an answer which

cannot be argued or proved. Given a general
principle, reason can deduce subordinate moral
principles from it or can justify particular
actions in the light of it. But reason cannot
justify the general principle except by deduction
from a more general principle. You can only prove
obligation by deduction from a higher obligation.
If you seek justification for the highest, most
ultimate principle in the moral field, this justi-
fication can only be aesthetic. The aesthetic is
that which we accept for what it is and which no
argument can confirm or refute. We see and we
approve. Or if we fail to see, we must look again
more attentively. We cannot argue.

Or consider again. Suppose someone accepts on
whatever grounds that it is *right* for him to
further the *summum bonum* of others. Then when
this conflicts with his own inclinations he will
ask: "But why should I do what I believe to be
right?" It will be answered that obligation is
logically implicit in rightness. If someone
believes that X is right, he also believes that he
is under an obligation to do X. The two are simply
different ways of saying the same thing. But see-
ing what is right logically may be a very weak
kind of motive for doing what is right except for
the dry intellectual kind of characters from whom
philosophers are made. The more usual type of
person is likely to say: "Well if I believe that I
ought to do X, I may still know very well that I
don't want to do X, indeed I may have a strong
inclination not to do X and I may believe that my
doing X is likely to have consequences highly
unpleasant for me and therefore detrimental to my
maximum of personal satisfaction. So I don't do
X".

On lines such as these it may be argued that the
only ultimate justification for moral obligation
is aesthetic, the valuation of something for its
own sake. And that only this provides any powerful
motivation for moral behaviour. There have been
hints of such an aesthetic grounding of ethics in
Shaftesbury and Peirce. The most eminent recent
attempt to construct a complete moral philosophy
of life on aesthetic principles may be found in
La couronne d'herbes (1975), a book written by
Etienne Souriau in old age and replete with the
mature wisdom of age.

It will certainly occur to many readers at this
point that to expatiate on "the ubiquity of the
aesthetic", however that is interpreted, can offer
little help or consolation to the hard-pressed
educationist whose task it is to fit Aesthetic
Education into a curriculum. Whatever is coexten-
sive with life and experience must permeate all
branches of education. And so indeed it is. As
has been said, we apply aesthetic descriptions not
only to material things, works of art and the
beauties of nature, but to scientific theories,
mathematical theorems, philosophic systems, and so
on. Aesthetic sensibility enters into our percep-
tions of other people and ourselves. And it is
important that this ubiquity should remain well to
the fore in discussions and planning of Aesthetic
Education. Nevertheless the traditional association
with the fine arts - music, literature, the visual
and performing arts - continues to be justified
for practical purposes. Aesthetic appreciation
represents a frame of mind and an attitude of
attention, a mental stance which can be inculcated
and cultivated by precept and example as can any
other skill, but which cannot be taught and learned

by rote. Works of art are artifacts which, what-
ever other values they may serve (and these are
many and various), have this one thing in common
that they exist expressly to be used as vehicles
for evoking and sustaining aesthetic awareness at
a high level, while in great works of art is
crystallized and encapsulated the experience of
those men and women whose sensibility was most
richly developed in some chosen field. Therefore
all in all they furnish the most suitable - though
certainly not the only - material for introducing
most students to the skills of aesthetic apprecia-
tion and the practice of aesthetic perception.
But it must always be remembered that there are
people, young and old, whose natural endowment of
sensibility tends in other directions.

It is common form to emphasize the non-utilitarian
character of aesthetic perception. In daily life
our interest is directed upon the practical impli-
cations of our impressions for object recognition
and subsequent action, while all else tends to
pass unobserved. But when we take up an aesthetic
attitude towards anything we shelve practical
interests and strive to actualize its appearance
as fully as possible for its own sake alone. This
is the kernel of truth in the eighteenth-century
doctrine of "disinterested interest". But even
this truth is susceptible of one-sidedness and
exaggeration. There is aesthetic value also in
the economic adaptation of means to end, of the
part to the whole and of the suitability of a
thing for the function it fulfils without super-
fluity or lack. Indeed "appropriateness", in the
sense of *aptum* and *decorum*, was a central idea of
much medieval aesthetics and penetrated into
modern aesthetics by way of Kant's concept of

"purposiveness without purpose". Perhaps even
more characteristic, however, is the fact that in
our aesthetic commerce with the environment we do
not conceptualize. To conceptualize, that is to
put into verbal form, is to reduce the content of
an experience to what it has in common with a wide
class of similar experiences.[8] In aesthetic
commerce, however, it is the aim to retain the
full vigour of the perceptual experience, striving
to render it ever more vivid and complete without
emasculating its impact by categorization. This
is why by its very nature aesthetic experience can-
not be put into words. Aesthetic thinking is non-
verbal thinking. For language is a mode of com-
munication among men, a "way of life", as
Wittgenstein called it, by means of concepts.
Concepts are common objects whereas perceptual
experience is private and unique. Furthermore in
aesthetic apprehension we do not remain content
with piecemeal observation, relating together by
reason and understanding the sharply defined "bits"
or elements of a construct, but aspire to the sim-
ultaneous awareness of a complex but perceptually
unified whole.

The difference between aesthetic and practical
perception was described by Roger Fry as follows:
"We were given our eyes to see things, not to look
at them. Life takes care that we all learn the
lesson thoroughly, so that at a very early age we
have acquired a very considerable ignorance of
visual appearances. We have learned the meaning-
for-life of appearances so well that we understand
them, as it were, in shorthand. The subtlest
differences of appearances that have a utility
value still continue to be appreciated, while
large and important visual characters, provided

they are useless for life, will pass unnoticed ...
In the practical vision we have no more concern
after we have read the label on the object; vision
ceases the moment it has served its biological
function". Although for our outlook today Fry
tended to emphasize too exclusively the aesthetic
aspect of the visual arts at the expense of other
values they embody, he was pre-eminent among
critics in his understanding of aesthetic vision
and the following account of a Chinese bowl has
not been bettered:

> This (i.e. aesthetic vision) is at
> once more intense and more detached
> from the passions of the instinctive
> life than either of the kinds of vision
> hitherto discussed (i.e. practical
> vision and the vision of the collector
> of curios). Those who indulge in this
> vision are entirely absorbed in appre-
> hending the relation of forms and
> colour to one another, as they cohere
> within the object. Suppose, for
> example, that we are looking at a Sung
> bowl; we apprehend gradually the shape
> of the outside contour, the perfect
> sequence of the curves, and the subtle
> modifications of a certain type of
> curve which it shows; we also feel the
> relation of the concave curves of the
> inside to the outside contour; we
> realize that the precise thickness of
> the walls is consistent with the par-
> ticular kind of matter of which it is
> made, its appearance of density and
> resistance; and finally we recognize,
> perhaps, how satisfactory for the

display of all these plastic qualities
are the colour and the dull lustre of
the glaze ... But in all this no element
of curiosity, no reference to actual
life, comes in; our apprehension is
unconditioned by considerations of space
or time; it is irrelevant to us to know
whether the bowl was made seven hundred
years ago in China, or in New York yes-
terday. We may, of course, at any
moment switch off from the aesthetic
vision, and become interested in all
sorts of quasi biological feelings; we
may inquire whether it is genuine or
not, whether it is worth the sum given
for it, and so forth; but in proportion
as we do this we change the focus of our
vision; we are more likely to examine
the bottom of the bowl for traces of
marks than to look at the bowl itself".[9]

From all that has been said it will be apparent
that *how* a thing is taught may be even more import-
ant from an aesthetic point of view than what it
is that is taught. The fine arts offer the most
suitable material for a full cultivation of sensi-
bility in most cases. Yet not only the capacity
but the direction of sensibility differs notably
from person to person. There are people who are
impervious to the arts or to some of them, but
have sensibility for beauty and fineness in some
other field. Clive Bell, a fine critic of the
visual arts, confessed that he could barely recog-
nize a musical melody. And even the arts can be
taught in a manner which discourages sensibility.
There was a generation of art historians and
experts in *Kunstwissenschaft*, fortunately by way

of becoming obsolete, who could tell everything
about a work of art, including everything that
other people had ever said about it, but were
incapable of looking at any work of art with what
Fry would have called aesthetic vision. Perhaps
there is still a danger that literature be taught
in this way with the memorizing of poetical frag-
ments and biographical facts falsely elevated to a
central position. The main task is the cultivation
in whatever field of that skill which we have
called aesthetic apprehension and the acquisition
of aesthetic culture.

THE VALUE OF THE AESTHETIC

The exercise of aesthetic sensibility is a skill
to be cultivated and trained. I want to suggest
here some reasons why this cultivation is worth
while.

It is common form to emphasize that aesthetic
attention is a form of perception-for-its-own-sake,
freed from the practical interests that dominate
perception in ordinary life. Sometimes we look at
flowers or sunsets in this way, listen to the sing-
ing of birds, the soughing of the wind in the
trees, the rippling of a stream, but not the
shrill of a telephone bell or the rasp of an elec-
tric drill. The ancient Chinese kept crickets in
expensively wrought cages attached to the girdle
for the pleasure of listening to the sound of
their chirping. Chinese connoisseurs cultivated
a sensibility for the feel of jade and the Japanese
in their *kodo* game tested their discrimination for
olfactory sensations. These are examples of per-
ception for its own sake and not for the sake of

drawing practical inferences from it. Works of
art present more complex objects for attention,
organic wholes which challenge and extend our
powers of percipience. But in their case too
appreciation - the aesthetic act - finds its ful-
filment and completion in the perception itself
without ulterior purpose. In contrast with every-
day habits our awareness of aesthetic objects - or,
one might equally well say, our aesthetic involve-
ment with anything at all - is non-utilitarian.

"Why, then", the student may well ask, "why go to
the trouble of cultivating this recondite form of
sensibility at all?" And the question is a reason-
able one. It should be taken seriously and needs
a serious answer. Life is too short for the
realization of all our potentialities and as a
person standing at the threshold of adulthood must
perforce choose a path, it is better to choose
deliberately than at haphazard, on impulse.

What, then, is the value of cultivating a mode of
apprehension which is admittedly remote from prac-
tical interests? There is, of course, no validity
in the simple inference that because practical
concerns such as object-recognition and decisions
about action and behaviour are recessive in
aesthetic perception, therefore aesthetic percep-
tion has no intrinsic value of its own. It might
indeed be the case - as many people have assumed
it to be - that the exercise of aesthetic sensi-
bility in the appreciation of works of art is the
source of special pleasure to a minority of people
who are so inclined, a luxury indulgence but ulti-
mately dispensable. Yet art in one form or another
is pretty well universal among men. And in most
advanced societies aesthetic activity is accorded

a high degree of cultural value by general consent
including the consent of many people who do not
themselves share an inclination for the arts, while
artists, the makers of objects intended for the
exercise of aesthetic contemplation, enjoy recog-
nition and general respect. Large sums of money
are paid for artifacts which have none of the
usual practical values, public museums are main-
tained to house them, and so on. It is my purpose
here to offer an explanation and justification of
this apparent paradox, and the explanation will
fall into two parts: (1) the value of art apprecia-
tion for the individual; and (2) the value for
society and the progress of mankind.

Aesthetic Solitude

Our lives are lived in a public world, stamped and
circumscribed by the forms and traditions of the
society into which we are incorporated. Through
language we are integrated into the life and
thoughts, the hopes and aspirations, the prejudices
and assumptions of those with whom we have to do -
and the rapid technological advances in communi-
cation media are continually widening the circle
of those who constitute the "society" of each one
of us. All our overt thinking, whether shared
through spoken language or verbalized internally
within ourselves, is carried on in terms of con-
cepts, which are public objects, common coin.
Once experience has been conceptualized by putting
it into language it is public, but at the same
time it is shorn of immediately and reduced to
those features which are common to a whole class
of experiences. By the clothing of language
experience is etiolated, bleached and diminished,
transmogrified into the intellectual counters of

discursive discourse which, like monetary instru-
ments, are voided of intrinsic value. Our mental
world is a public, social world to an extent which
we seldom realize.

From this immersion of the individual into the
social, aesthetic experience offers a way of
escape. Through it a man may find a path leading
back into himself. In contrast to our public per-
sonalities it is confined to the immediate impres-
sions which are private to each one of us, not
transmuted into public, intersubjective categories.
It cannot be verbalized. It can be communicated to
others only with the impression of gesture, though
it is the most concrete and precise of all
experience. The reactions of other people may be
similar to ours or different, but they are in
either case irrelevant at least until we pass
again into the public, social world of linguistic
expression and deprived experience. Aesthetic
engrossment creates a world of its own and it is a
realm of solitude. But this solitude is not lone-
liness, not isolation in the midst of a shared
world. It is a solitude that is integral to each
man's concern with his own spiritual development
and in this respect it has something in common with
induced meditation and the cultivation of religious
experience. We attend a concert and make one of
an audience, each member of which enjoys an
experience that is his alone, bringing new rich-
ness, depth and meaning into his personal world.
By sharpening sensibility and expanding awareness
aesthetic experience resists the encroachment of
socialization, combats the temptation to super-
ficiality which lurks in all of us, enlarges self-
knowledge and activates the deepest levels of our
individual contacts with the environment amidst

which our lives unroll.

Among primitive peoples individuality is relatively
undifferentiated. Primitive man is a unit who in
conjunction with other units gives expression to
the inherited traditions and customs of his tribe.
He may have character of his own: one man is brave,
another timid; one is reliable, another sly; one
persevering and another irresolute; and so on.
But to speak of personality would be out of place.
In higher societies too there are many people who
live by routine, are lost and unhappy when the
familiar routine breaks down. But by and large it
is a feature of civilization and progress that they
have encouraged the emergence of more complex and
more integrated personality. Personality involves
enrichment and depth of what is called the "inner
life", and those populations which stand in the
forefront of technological progress have not always
led the way in the development of this. In our own
population today we are witnessing a recession of
personality bound up with a formless fear and loss
of confidence which manifests itself in a retreat
from purpose and an urge to merge the individual
into the group as a means of shelving responsibility
and decision. Loneliness is abhorrent and the
young often feel lost, empty and bewildered. With
the mistrust of inner experience the range of per-
sonality is contracting and this shows itself in
such phenomena as the recourse to group psychology
or to exotic practices of meditation without the
powers of patience and self-discipline which, as
Oriental peoples well know, can alone render these
practices potent. This is the challenge which
education faces today. The goal is the expansion
and invigoration of personality. By commerce with
the great artistic heritage, which knows neither

age nor senescence, we can share the experience of
men who have achieved outstandingly delicate sensi-
bility combined with exceptional concordance of
attitude and insight. In a chaotic and untidy
world the fine arts afford intense and luminous
awareness of tracts of imaginative experience
moulded by an ordered beauty as convincing as the
mathematical beauty of the conceptualized sciences.
This is reassuring. For many people today it may
well be the only ultimate reassurance.

The art which has the widest reach and diffusion
today is undoubtedly the art of the novel and I
shall conclude this section with a few animad-
versions on this art. In *The Test of Time* (1982),
a book which should be compulsory reading,
Anthony Savile wrote: "it is one central aim of
the arts to provide us with imaginative models for
thinking about aspects of the world, which are
worked out and tested against the detail of indi-
vidual cases". (p. 146) Moreover, by enabling us
to envisage new forms of affective response the
novel can enhance our sensibility, broaden our
sympathetic understanding, and, as he says: "To
come by new modes of feeling is to understand the
world in new ways ..." (p. 98). But it is not
only understanding that we need. Understanding is
not the final goal. The direct need today is for
a conviction at the profoundest level of our being
that life has meaning, that behind the apparent
chaos the world shows harmony, pattern, order. And
like other artists, great novelists present their
created world as a world infused and unified by
pattern because this is how they themselves have
seen the world.

In *Moments of Being: Unpublished Autobiographical Writings* (ed. Jeanne Schulkind, 1978) Virginia Woolf said:

> Perhaps this is the strongest pleasure
> known to me. It is the rapture I get
> when in writing I seem to be discovering
> what belongs to what; making a scene
> come right; making a character come
> together. From this I reach what I
> might call a philosophy; at any rate
> it is a constant idea of mine; that
> behind the cotton wool is hidden a
> pattern; that we - I mean all human
> beings - are connected with this; that
> the whole world is a work of art; that
> we are parts of the work of art.

Iris Murdoch wrote in *The Sovereignty of the Good* 1971:

> Good art reveals what we are usually
> too selfish and too timid to recognize,
> the minute and absolutely random detail
> of the world, and reveals it together
> with a sense of unity and form. This
> form often seems to us mysterious
> because it resists the easy patterns
> of phantasy, whereas there is nothing
> mysterious about the forms of bad art
> since they are the recognizable and
> familiar rat-runs of selfish daydream.
> Good art shows us how difficult it is
> to be objective by showing us how
> different the world looks to an objec-
> tive vision.

While this stresses the affinity between the
presentation of patterned coherence with an objec-
tive outlook, other novelists have connected
coherence with the faithful presentation of their
personal character, aware that the two must merge.
In a letter to N.N. Strakhow about *Anna Karenina*
Tolstoi said that everything he wrote there was
guided by "the need of collecting ideas which,
linked together, would be the expression of myself,
though each individual idea, expressed separately
in words, loses its meaning, is horribly debased
when only one of the links, of which it forms a
part, is taken by itself".

Such statements are reminiscent of the medieval
concept of intellectual or "divine" beauty as the
imposition of order upon chaos and testify to a
sentiment analogous to that which underlay the con-
stant comparison of God's creation with the work
created by an artist.[10] It is important that we
develop the skill to read great novels not simply
as entertainment literature and not only as an
expansion of everyday experience - though they may
be that too - but with appreciation for the sense
of unity and meaning in the world and for the
sense of profundity in objective vision which
meant so much to the writers. There is a world-
view implicit also in the writings of
Samuel Beckett, Alain Robbe-Grillet,
Nathalie Sarraute, Jorge Luis Borges. We make con-
tact with great writers not to be converted to a
world-view other than our own but in order to
experience concretely what it would be like to
hold such world-views as are embedded in their
works. It is for the teacher to direct his
students' feet upon this path.

An Evolutionary Picture

I believe that the importance to society, and
indeed to mankind as a whole, of cultivating and
maintaining our aesthetic faculties is best under-
stood within the framework of an evolutionary pic-
ture and I will briefly summarize the relevant
facts and argument.

The hominoids, the ancestors of man and the anthro-
poid apes, are thought to have branched off from
the other primates some 35 to 50 million years ago.
The hominids, founders of the genetic lineage
whose only surviving representative is modern man,
branched off from the other hominoids some 8 to 12
million years ago, with a brain capacity averaging
perhaps some 350 cubic centimetres. An advanced
form of hominid, Australopithecus, with brain
capacity of 450 to 500 cc, roughly comparable to
that of the chimpanzees, gorillas and orangs, seems
to have appeared rather abruptly under 4 million
years ago. Then, a little under 2 million years
ago and also rather abruptly, appeared *homo
habilis*, regarded as the first distinctively human-
oid creature. At more or less the same time or
very little later the fossil record points to the
emergence of several types of *homo erectus*, includ-
ing Peking Man and Java Man, with brain capacity
ranging from little more than that of Austral-
opithecus to little less than that of modern man.
The earliest ancestors of modern man, *homo sapiens*,
flourished in Asia, Africa and Europe with a brain
capacity of about 1400 cc from some quarter of a
million years ago, while modern man, *homo sapiens
sapiens*, with average brain capacity of about
1500 cc came on to the scene only about 40 or 50
thousand years ago. Man differs from other animals

in that the brain of the human child triples in
size during the first post-natal years and impor-
tant faculties come to maturation subsequently - a
basically significant fact for man's educability.

What leaps to the eye is the incredibly short time
in evolutionary terms (say 50 thousand as against
50 million years) within which man's intellectual
superiority has been achieved. Whether this is to
be attributed in part to the adoption of the erect
posture and the extension of tool-making habits is
beside the point. The second, even more astounding
feature is the still more rapid advance made by
homo sapiens sapiens, modern man, from the primi-
tive creature of Palaeolithic times to contemporary
man with powers of destruction that amaze and
terrify even himself and an increase in techno-
logical mastery which has not been linked to a
corresponding physiological development. Its
source lies rather in what is known as cultural
evolution, exogenetic not endogenetic heredity.
We know beyond any reasonable possibility of doubt
that acquired characteristics, whether bodily con-
formations or skills, are not inherited. Even
profound modifications brought about during an
organism's lifetime cannot be imprinted on the
genome. The DNA cannot be taught. The skills of
mankind are not mediated through the chromosomes
and genes but passed on by precept and example and
by deliberate indoctrination. With the acquisition
of speech and writing and with the gradual emer-
gence of more complex social institutions the
laboriously discovered skills and know-how of the
human race are passed on cumulatively from gener-
ation to generation so that the individuals of
successive generations need not start again always
from scratch using only the native abilities they

TAE-E

were born with, but build upon the stored wisdom
and accumulated skills of all past generations,
the inherited tradition. This is what is meant by
education and learning in the profoundest sense.
Effective tradition is the dominant key to man's
progress, and it is education that makes the
tradition effective.

But there exists an obvious danger that with the
increase of man's power over nature and the conse-
quent relaxation of pressure upon his native capa-
cities, evolved in the interest of comfort and
survival, these would tend to languish and begin to
atrophy. There is more than adequate evidence for
such occurrence both historically and today, parti-
cularly perhaps the sympathetic and organizational
capacities which cement social cohesion. Degener-
ation as well as progress has its place in the
evolutionary picture. As some safeguard against
this regression the human mind is endowed not only
with a lively impulse to learn and explore, as a
domestic cat will fussily and meticulously explore
any new environment before settling down, but also
with a persistent drive to exercise and improve,
for their own sakes and independently of foresee-
able practical benefits, the basic faculties which
were originally evolved for utilitarian purposes.
There is, of course, an inherent human laziness
which too easily leads to premature satisfaction
and the thought: "After all these generations we
know our environment as well as we need to know it:
now let us settle down like the cat and go comfort-
ably to sleep". It is the devotion of the scient-
ists that is our main salvation against this force
of inertia. The drive to exercise and enlarge the
basic mental powers for their own sake may be
active only in a small minority of men; yet it is

subscribed to by the majority so long as society
continues to foster as important cultural values
those pursuits, from sport to cosmology, from fine
art to Zen meditation, whose motivation consists
in the non-utilitarian exercise of inborn facul-
ties. All in all, then, there is no good reason
to believe that this process of exogenetic evolution
by the "inheritance" through education of slowly
acquired skills and knowhow has come to an end.
Rather we may see some indication that mankind
today stands at a new threshold with the prospect
already dimly in view of possible new powers to
control endogenetic evolution by the physiological
manipulation of the genome rather than simply by
eugenic methods poorly understood. This too
creates a profound alarm with a sense of inadequacy
if mankind is faced with the necessity to choose a
direction where all ahead is dark.

It is the consciousness that the development of
man's own spiritual nature lags behind his progress
in the technological field that causes doubt and
anxiety about his ability to use these new powers,
possessed or in prospect, with wisdom and responsi-
bility. Man stands abashed before his own techni-
cal achievements, aware that progress in the enrich-
ment of his own nature has not kept step. There
is a sense of unconfessed fear and inadequacy not
only in face of the new powers of universal destruc-
tion. And these feelings, deeply embedded if sel-
dom ventilated, pervade the minds of the younger
generations most profoundly. It is this which
gives the leaders of education a responsibility
such as has perhaps never existed before.

Education today has two major tasks, both of which
are necessary for the furtherance of man's

exogenetic evolution and the maintenance of pro-
gress already achieved. One is the transmission
to each new generation of those acquired skills
which are conducive to the perpetuation of man-
kind's dominance in the world. These include the
basic skills which are demanded from all members
of advanced societies - language, reading, writing,
elementary calculation, civilized deportment and
powers of self-discipline to rein or direct the
inborn impulses to selfishness and aggression on
the one hand, benevolence and altruism on the
other. In addition to this, education in one form
or another is responsible for equipping the young
with the diversified skills which fit each person
to perform a particular function in society -
doctor, lawyer, engineer, nurse, mother, etc. The
second manor task, which is more directly linked
to the improvement and enrichment of man's own
nature, is no less urgent. It concerns what I
have described as the non-practical exercise for
their own sake of faculties evolved in the first
place for utilitarian needs. The stimulus behind
mathematics, logic and theoretical psychology is
the exercise of reason for its own sake, not any
practical advantage which might be expected to
accrue from these studies but the sheer desire to
understand our own inner nature and the cosmos in
which we exist. The pure sciences combine this
motive with the satisfaction of an ineradicable
curiosity. There is no practical benefit to be
expected from the speculations of Cosmology as to
the origin and ultimate fate of the universe; and
if recent discoveries in Microbiology do encourage
hopes of important utilitarian results, this is
incidental to the compelling drive towards dis-
covery which is the main motive power of research.
It may be possible to derive lessons for the

problems of the present from history and archaeol-
ogy, but if so this is still a minor reason for
their pursuit. The cultivation of aesthetic sensi-
bility comes into the same category and from one
point of view is the most basic of all. It is both
the most difficult to pin down and the most wide-
ranging in its ramifications. Though it is often
attended with pleasure - as indeed is the success-
ful exercise of any developed faculty - this is
not an adequate justification or a main reason for
its cultivation. There are other more facile
pleasures and it is not expected to bring other
extrinsic benefits corresponding to the labour of
cultivation. It represents the intensification
and amplification of the direct perceptual contact
which underlies all our cognitive contact with the
environment and it is cultivated for its own sake,
for the satisfaction of a self-sufficient and
autonomous skill.

Contrary to the naïvely humanistic idealism which
would have all men born with equal capacities, the
fact is that individuals differ ineradicably both
in the quality of their inborn faculties and in
the fields of interest to which these faculties
are spontaneously directed. Despite the egali-
tarian ideologies and practice of "socialist"
countries, inborn inequalities happily persist.
An experimental psychologist has written: "The
equalization of certain external conditions has
had practically no effect whatsoever on this
inequality of talents and abilities. Clearly,
genetics sets a limit to what can be accomplished
by environmental manipulation. Much the same is
true of personality. The major dimensions of
personality have been found to be as strongly
inherited as intelligence; and these personality

factors powerfully influence much of human con-
duct".[11] Sensibility is more unevenly distributed
even than intelligence, both in degree and in
direction. Some students will show a quick and
ready sensibility for one of the arts but not for
others. Some persons have sensibility for natural
rather than artistic beauties, some for the intri-
cacies and intimacies of human relations. Edu-
cation must recognize the existence of these
differences and must take into account the inherent
nature of every individual. This sounds like an
impossible task and it is perhaps the most serious
problem that faces the educationist today. But we
know that differences both in capacity and in
direction are inborn to an extent not previously
understood and attempts to force all into the same
mould can only lead to frustration and inefficiency.
In practice compromise will be necessary. But it
is well to have in mind where compromise begins
and ends and in what it consists.

REFERENCES

[1] Augustine. *Confessions*, X1, 14.
[2] See *Baumgarten's Reflections on Poetry*. Ed. by
 Karl Aschenbrenner and William B. Holther
 (1954).
[3] See *Aesthetics. Lectures and Essays by
 Edward Bullough*. Ed. by Elizabeth M. Wilkinson
 (1957).
[4] See my Preface to *The Oxford Companion to the
 Decorative Arts* (1975).
[5] Henri Poincaré: *Science et Méthode* (1908). Eng.
 Trans. G'B'Halstead (1958). P.A.M. Dirac,
 "The Evolution of the Physicist's Picture of
 Nature", *Scientific American*, May 1963.
 J.C. Polkinghorne: *The Particle Play* (1979),

p. 2. Werner Heisenberg: *Physics and Beyond* (1971).

[6]Beauty is not restricted to the most advanced mathematics. In *A Mathematician's Confession* G.H. Hardy declared that the proof that the root of 2 is an irrational number is one of the most beautiful things in mathematics.

[7]See the essay "Anthony Trollope" in *Partial Portraits* (1888).

[8]I have dealt with this point more fully in an article "The Cultivation of Sensibility in Art Education" contributed to the *Journal of Philosophy of Education*, Vol.18, No 1, 1984.

[9]The quotations are from an essay entitled "The Artist's Vision" published in *Vision and Design* (1920).

[10]See, for example, Basil of Caesarea (Homilia in Hexaëm., 111), commenting on *Genesis*, 1. 31: xx "'And God saw that his work was beautiful.' This does not mean that the work pleased his sight and that its beauty affected him as it affects us; but that that is beautiful which, in accordance with the principles of art, is complete and serves its purpose well".

[11]The quotation is from an article by H.J. Eysenck entitled "The Limits of Manipulation", published in *Encounter*, December 1983.

Creative Development at 14+

RICHARD PRING

INTRODUCTION

As recently as May 1984 quite radical proposals
were announced for a new kind of educational pro-
gramme for young people leaving school at 17.
What is now referred to as "pre-vocational educa-
tion" will, it is estimated, benefit 100,000 young
people each year. At the end of their course they
will be awarded the Certificate of Pre-vocational
Education (CPVE) - unless that is, a new name is
found for it. The proposed programme for CPVE
reflects a considerable shift in educational and
curriculum thinking from that which is built into
most schools' and colleges' courses. Indeed, in
conception the innovations are quite revolutionary.
But whether or not they will be so in practice is
another matter, for many features of the new pro-
posals, though exciting enough in general terms,
lack the detailed description and analysis that
would enable us to evaluate them objectively.

The difficulties I want to examine can be illustra-
ted through the place of the arts in the new pro-
posals. The programme will consist of a common
core, vocational studies and additional studies.

The common core is divided into ten areas. These
are:

 personal and career development;
 communication;
 numeracy;
 science and technology;
 industrial, social, and economic studies;
 information technology;
 skills for learning, decision making, and
 adaptability;
 practical skills;
 social skills;
 creative development.

One needs to see this content against other
features of the new proposals which are not spelt
out in terms of content, but which concentrate more
on processes and teaching strategies - in referen-
ces, for example, to a negotiated and experiential
basis for learning, to guidance and counselling,
to profiling, and to criterion referenced assess-
ments. But, even so, such content could be inter-
preted rather narrowly as a preparation of young
people for an adult world, especially a world of
work, as it is conceived by teachers and trainers
who may pay little regard to the broader educational
needs of the young people we have in mind. On the
other hand, the content could be interpreted gener-
ously. And the place of the arts in the programme,
as this is translated from general terms into cur-
riculum detail, will in my view be the touchstone.
In courses that are seen to be pre-vocational and
that "are demonstrably relevant to the needs of
young people as emerging adults and prospective
employees", where will be the place for music,
art, and drama? How will "creative development" be

interpreted?

In what follows I shall give the background to
these developments and finally pose questions that
those who teach the arts ought to be asking about
their own contribution.

CONTEXT

Only 14% of the 16-year-olds at one local compre-
hensive school found employment last year; the
previous year it had been 33%. This rapid change
in employment prospects for 16-year-olds is not
untypical of the country as a whole - although
there will be variations from region to region.

The sort of employment eventually available is
changing too. In the last 10 years, one million
unskilled jobs have disappeared from the economy.
In the next 10 years, a further million will go.
Simultaneously there is a shift from craft-based
to technician-based industries, requiring a more
highly educated workforce. These industrial
changes are reflected in the decline of traditional
forms of apprenticeships; 40% of those who left
school in the early 1960s became apprenticed but
by 1980 it was only 20%. The one area of expansion
is the service industries, which require a greater
emphasis upon personal qualities than upon academic
qualifications.

In brief, therefore, there are radical changes in
the context in which schools are preparing young
people for the adult world and schools are having
to face problems of a kind they have never had to
face before - and at a speed that challenges their

capacity to respond appropriately. Key questions
are:

(a) How might schools prepare young people psy-
 chologically for an unpredictable future, in
 which the traditional routes to a stable
 employment have disappeared?

(b) How might young people be motivated to learn
 when the relevance of the curriculum is much
 less clear?

(c) How might an alternative programme be pro-
 vided for young people that better serves
 the economic needs of the community?

COURSE CHANGES

For some time courses that are offered at school
and college have reflected these changes in the
social context in which they are placed. Young
people staying at school or college beyond the age
of 16, who are neither able to pursue A level
courses nor willing to enter for vocationally
specific courses, have needed some provision.
To meet this need there has been a growth of "pre-
vocational" courses. And this has had its effect
upon the curriculum pre-16 - both negatively and
positively. Negatively, the task of motivating
young people is more difficult; the prospect of a
better job as a result of improved examination
grades is fast disappearing. Relevance is the key
word - though relevance to the world as the young
person sees it or to the world as the adult sees
it is rarely clear. Positively, the principles
of pre-vocational education" - for example, more
experience-based learning, a stress upon guidance

and counselling, profiling - are beginning to percolate down the school. The following classifications are necessarily crude and simplistic but they reflect the changes taking place.

(i) Old or traditional structures

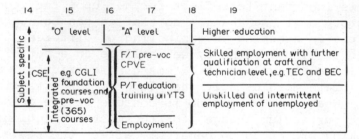

(ii) New and developing structures

The only relatively unchanged feature is that of the top 20% (approx.) in attainment, namely, academic "O" level courses leading to "A" level, and thence to higher education.

Below the top 20% we see:

(a) a shift at 14 to 16 towards more integrated
 and vocationally oriented courses;

(b) a shift at 16 from employment to full-time
 education or to training schemes;

(c) a replacement at 16/17 of traditional craft
 and technician courses by the national youth
 training scheme;

(d) an expansion of pre-vocational full-time
 courses at school and college.

What does not appear on this outline are the "all
through" 14 to 18 vocational courses now being
planned through the initiative of the MSC.

It is important to reflect further upon the recent
history of these changes so that we can be aware
of the interesting intermingling of different trad-
itions. Thus, perhaps, we shall be in a better
position to evaluate the "emerging curriculum" and
to locate more clearly the place of the arts within
it. What we must not do is confuse course change
with curriculum change, for the most revolutionary
looking proposals on paper may affect the style,
quality and indeed content of learning very little.

First, the CPVE is in direct line of descent from
the kind of curriculum outlined in the Further
Education Unit's (FEU) publication *A Basis for
Choice* (ABC). ABC set out broad criteria against
which the growth of post 16 courses for non - "A"
level students might be evaluated.

The recommended courses should have 60% Common
Core studies (spelt out in terms of aims and

objectives that stressed a range of skills, abili-
ties and qualities that transcended traditional
subject boundaries) and 20% vocational orientation
and job specific experience respectively. The ABC
principles for what have now become known as "pre-
vocational courses" were adopted by City and
Guilds of London Institute (CGLI) for its own pop-
ular 365 course and became the model for the DES
recommendations for a new examination at 17+, the
Certificate of Pre-vocational Education (CPVE).
What is being recommended is a more integrated
(rather than subject specific) organization or the
curriculum with an emphasis upon personal prepar-
ation for a rather unpredictable future.

It was argued, however, that many of the principles
embodied in ABC and incorporated into post-16
qualifications apply with equal force to what
happens before 16. Therefore, many secondary
schools are beginning to examine their curriculum
in order to achieve a more coherently planned
curriculum from 14 to 17 or 18.

The curriculum principles behind the common core
are reflected in a statement of aims, which are
then spelt out in more specific objectives. The
language of specific objectives may indeed colour
the educational thinking, but it should not dis-
tract us too much from the integrated approach to
an educational process which has at its centre a
concern for the personal and social development of
young people - the ability to form satisfactory
personal relationships, the development of a stable
set of moral principles, an increased social and
political awareness, a sense of responsibility.
There is, of course, a place for traditional sub-
jects, but their value and place will be subordinate

to aims which transcend subject boundaries.

However, what is missing is any concern for the
arts. A curriculum that is essentially student
centred, with a stress upon experience based learn-
ing, negotiated learning, profiling of experience
and achievement, and relevance to the aspirations
of the student, seems to have no place for the
aesthetic (notwithstanding the mention of that
word in objective 3.8 of the core curriculum out-
lined in the appendix of *A Basis for Choice*). To
what extent will the addition of "creative develop-
ment" to the list of content of CPVE affect that
initial omission? Have we not, despite all the
indications of student centredness, a curriculum
development which, in its concern for relevance,
interprets that term in a purely utilitarian way,
determined still by a rather narrow view of what
"the world of work" requires?

Secondly, parallel with these developments in
schools and colleges have been changes in the
structure and provision of training. The Manpower
Services Commission (MSC) launched in 1982 its New
Training Initiative (NTI), a major component of
which is the Youth Training Scheme (YTS). The YTS
will provide the basis of a national training pro-
gramme, and the MSC will become the "national
training authority", more responsive (it is
claimed) to the training needs of industry and of
the economy as a whole. This national training
programme, as it is emerging, will (i) be mainly
employer led (since employers are said to know the
training needs); (ii) be based for the most part
in practical work; (iii) have a compulsory off-the-
job training/education component; (iv) provide
development of skills and abilities that will be

properly recorded and accredited; and (v) provide
an integrated programme of qualifications at differ-
ent levels and in different broad occupational
groupings. A complex system of monitoring the
quality of the various schemes is still being
explored.

Thirdly, these quite distinct, though parallel,
developments (YTS and CPVE) do to some extent come
together in the Technical and Vocational Education
Initiative (TVEI). This scheme is financed by MSC
but administered by the local education authori-
ties. Announced in November 1982, it provides for
curriculum developments 14 to 18 that will have a
technical and vocational bias, promote equal oppor-
tunities for boys and girls, and be linked for all
participants to different systems of accreditation.
Fourteen pilot schemes started in September 1983,
and a further 46 have commenced in September 1984.
Earlier pronouncements indicated that these schemes
would be narrowly technical and vocational for the
middle range of ability - indeed, firmly within the
tradition in which YTS schemes, described above,
were conceived. In reality, however the schemes
are developing according to the more broadly con-
ceived educational principles outlined in *A Basis
for Choice*. What then might be concluded? First,
sixteen is, for the large majority of young people,
no longer the normal age for completing education.
The jobs are not available and in effect the age
of entering employment is being raised to 18.
Secondly, there is a development of a more practi-
cally based curriculum for many youngsters that
will (in theory at least) relate more closely to
their personal needs and to those of the wider
society. Thirdly, the system of assessment is
coming to reflect these changes-for example, a

growing interest in graded tests that will indicate
more precisely what pupils can do. Fourthly,
there is an increased influence upon what happens
in schools and colleges from a new and, as yet
untried, national training authority, namely
the MSC.

THE DEVELOPING CURRICULUM

In the introductory section of this paper, I listed
the components of the suggested common core of
CPVE, and I pointed to the more integrated course
structure that was envisaged. But I also pointed
out that such course structures are still to be
translated into curriculum terms and that they can
be translated generously or narrowly depending on
the educational and training tradition through
which the development will take place. But that
is not easy to forecast.

And there's the rub, for there is little within
existing curriculum traditions from which one can
easily draw in order to make educational sense of
the new demands upon schools and colleges. It is
as though we need to rethink, at a more fundamental
level than hitherto, what it *means* to educate a
group of youngsters who would not normally be
remaining in either full-time education or part-
time training and whom, by and large, the educa-
tional service has systematically failed. What
kind of curriculum content, what kind of teacher/
student relationships, what kind of teaching
strategies will make sense to young people when
the direct relationship of that programme to get-
ting a job has been removed? Perhaps at long last
we must take seriously the definition of education

as the "initiation into intrinsically worthwhile
activities". But what would these activities be,
and how would they connect up with the interests
and concerns of a group of young people that is
increasingly disillusioned about its future?

As Geoff Stanton, the Secretary of the working
group that wrote ABC, has argued, curriculum
development has largely emerged from two quite
different traditions. First, there is the trad-
ition embodied within distinct academic discipli-
nes - the handing on, albeit in an adapted way, of
the concepts, principles, ways of thinking that
are embodied within particular intellectual
disciplines such as geography, mathematics, or
chemistry. Even such innovative projects as
"Geography for the Young School Leaver" were
rooted in a tradition of geographical research,
enquiry, and teaching that provided a context and
a set of shared experience and meanings from which
change could be initiated. Secondly, there is the
tradition located in further education in which
the curriculum is based upon an analysis of social,
especially employment needs. CGLI and BTEC
courses start with an identification of skills
that young people will need who want to pursue
certain careers. Even "communication" is, at its
most sophisticated, based upon an analysis of
language needs within, say, engineering and within
the wider context of social and political life.
Neither traditions however provides an adequate
foundation for the curriculum changes and develop-
ment needed to meet the problems as I have identi-
fied them earlier. On the one hand, the "disin-
tegrated", subject-specific curriculum of trad-
itional schooling does not meet the requirements
of a group of students whose interests lie not

within the academic world represented by those
subjects but within the kind of programme which
focuses upon their personal and social development
as *they* recognize it. On the other hand, the trad-
ition of further education, in which young people
are provided with the skills required for specific
jobs or industries, is no longer relevant where it
is impossible to predict what those industries or
jobs will be in four or five years time. To place
at the centre of one's programme ·the personal
development of young people, though necessarily
within the context of a world requiring particular
forms of social and political awareness, requires
a fairly fundamental review of what education for
these young people is about and what place within
it remains for traditional subject areas. The
place of the arts in such a programme will have to
be thought through as a contribution to the per-
sonal development of young people - a refinement
of feeling, a critical appraisal of received forms
of experiencing - who are facing an unpredictable
future and for whom the systematic study and prac-
tice of music, painting, or dance has meant very
little in the past.

At times the emerging curriculum seems firmly
entrenched within the tradition of further educa-
tion. Specific learning objectives are spelt out
by teachers and trainers, rarely negotiated with
the learner; relevance to the world of work
receives frequent mention; and City and Guilds and
BTEC provide the secretariat for the new CPVE. On
the other hand, the essentially student centredness
of the proposals emerges in the stress upon chang-
ing teaching and assessment styles - the importance
of experience-based learning, the more negotiated
programmes, the profiling of experience and

achievements, the systematic guidance and counsel-
ling of students and the concentration upon the
development of personal and social qualities and
skills.

Personal development however - the development of
a sense of dignity and self respect, the acquis-
ition of a defensible and stable set of values
with which to face the decisions and choices in
adult life, the growing sense of responsibility for
what one does, the development of respect for and
understanding of others, the ability to relate to
others at work or in leisure in an enriching and
constructive manner, the finding of significance
in the activities one pursues, the extension of
one's capacity to communicate with different kinds
of people, the intelligent grasp of social and
political issues that impinge upon ones life, the
active participation in institutions and groups
that affect ones life, the development of moral
and spiritual ideals that sustain one in life -
personal development defined in those terms must
be at the centre of any programme that claims to
educate persons. But it raises questions *vis-a-
vis* a particular age group about the relevance of
particular curriculum contents, learning objectives,
teaching styles and methods. How might all this
be spelt out into detail? For unless it is, we
are in danger of failing a generation of young
people yet again - building up hopes under a new
training initiative for rewards and work that will
not transpire, and thus creating a disillusioned
generation, alienated from the social institutions
which govern their lives. Indeed, we see this
already happening.

The emerging curriculum, therefore, in its broad outlines picks out the following as a basis for further development:

(a) *Experience based learning*, in which there will be more serious attention paid to the experience the young people bring with them into the school or college and a more systematic reflection upon that. This will of course include work experience, but in YTS schemes and TVEI importance is often attached to the social experiences provided by residential weeks together.

(b) A more *negotiated programme* in which the learner plays an active part in fixing learning objectives, entering into a form of contract with the teacher.

(c) Greater *community involvement*, with personnel and facilities within the community being drawn upon to enrich the educational provision and with an extension of the location of the programme into the local community.

(d) *Guidance and Counselling* as an integral part of helping young people to find their way through the complex world of courses, training schemes, and personal decisions that they cannot avoid.

(e) *Profiling* as a way of providing a more complete and generous picture of what the child has achieved and can do - contributed to, as part of the curriculum, by the young person.

(f) A greater concentration upon the *communication* function of language in its various forms - in listening, talking, arguing,

debating, reading or writing - with an increasingly critical appraisal of the media in its various forms.

(g) The capacity, and appropriate attitudes, to approach new problems with confidence - *problem solving skills* are a bit elusive, but (it is claimed) there are general strategies for tackling problems and certainly there are relevant attitudes.

(h) *personal and social skills* which, though not to be confused with the personal qualities essential for moral growth, do facilitate the social interactions which young people are necessarily involved in with friends, acquaintances, employers, teachers, and so on.

(i) *social and political awareness and competence*, for whatever their ultimate destiny in employment or unemployment, young people have an entitlement within a democracy to that knowledge and practical "know-how" that will enable them to participate in the communities that affect their welfare.

(j) technological understanding, especially *information technology* seems, too, to be essential in a world so affected by the growth of technology, especially the micro-chip. But it is not so much a profound understanding of the technology that is required, but a sufficient grasp of it to see the personal and social implications.

If we examine these different aspects of a more person-centred curriculum, we can see the urgent need there is for staff development (in adopting

different teaching styles and relationships) and
for institutional change in schools and colleges
that are organized very largely on a departmental
basis.

IMPLICATIONS FOR THE ARTS

We have a responsibility to ensure that the many
young people, who remain in full-time education or
part-time training beyond 16, have an educational
experience that meets their particular needs.
This requires a more fundamental reappraisal of
the curriculum, even before 16, than most people
are aware of. What sort of people, displaying
what sort of knowledge and personal qualities,
ought the educational training systems to be
developing?

The difficulty in answering these questions lies
partly in the inadequacy of existing curriculum
traditions for providing ready-made answers. It
is so easy for curriculum answers to be given
which are simply extensions of existing practices
either in school or in further education.

What then are the questions that those working in
the arts ought to be asking? Too often the arts
are seen within the existing changes as a useful
leisure time activity - lumped with hobbies and
games as increasingly important to fill the non-
serious time when the young people are not working.
But the distinction between work and leisure is
increasingly a false one. The aim of education
must surely be the gradual involvement of young
people in the serious business of living - not
simply earning a living, but engaging critically

with the ideas and institutions that affect the
quality of life, pursuing activities that have for
the person an intrinsic worth, engaged creatively
in giving form to his or her own environment. Art
at its best should never be seen as a leisure time
activity. It is a serious activity, that engages
the imagination and critical faculties and thereby
bestows dignity and self respect upon the artist -
whether or not it earns a living. As a serious
activity at the very heart of personal development,
it must play a central role in the emerging curric-
ulum. In so doing, it must be the vehicle through
which, in its various forms, it enables young
people to explore and to make sense of the unpred-
ictable future they are entering into. Without
this central and significant contribution of the
arts, we are likely to see the much more utili-
tarian tradition of curriculum development assume
control, with clearcut divisions between the world
of work and the world of leisure and with specific
skill objectives that leave the core of "the per-
son" untouched and that fails to face up to the
deep and social needs of an increasingly dis-
gruntled and alienated generation.

The Aesthetic in the Curriculum

LOUIS ARNAUD REID

I

My subject is "The Aesthetic in the Curriculum".
Let me begin by making a verbal, but important
distinction. The subject is the "aesthetic", not
"aesthetics" in the curriculum. "Aesthetics" as I
take it here, is *about* the aesthetic: it is the
philosophy of the aesthetic, the aesthetic as part
of human experience. I shall be talking about this
aspect of human experience as it bears on the
school curriculum, talking in a more or less phil-
osophical way. The verbal point is important: I
have seen it said, even in some "official" reports,
that aesthetics should be part of the curriculum.
This is confusing. I certainly don't want to
exclude, at any stage, some relevant talk about
the aesthetic and the arts; some of which might be
of a very general kind and might be called "philo-
sophical". It might well come in at later stages
of school education. But it would have to arise
out of *experience* of the aesthetic, which is
central.

The word "experience" links with a topic much dis-
cussed in recent years. HMI has proposed eight
"areas of experience" as constituting the whole
curriculum: spiritual, ethical, physical, aesthetic

133

and creative, scientific, mathematical, linguistic, social and political. In the curriculum part of my lectures at the University of London Institute of Education, I lectured on "Ways of Knowledge and Experience" (later the title of a book). Partly influenced by my lectures, Paul Hirst developed his own, very different, account of the Forms of Knowledge - originally, mathematics, physical sciences, human sciences, history, literature and the fine arts, philosophy. The list has been modified from time to time. (The biological sciences are not mentioned.)

I do not intend to discuss these particular proposals now. But if we assume, as I think we may, that at least one main aim of education is the cultivation and development of knowledge and understanding, it is important to ask some specific questions about the nature of the knowledge and understanding as it operates in different subjects (or areas of experience) in the curriculum. The knowledge and understanding acquired in mathematics is, concretely speaking, a different *way* of knowledge and understanding from that of history, biology, geography ... the arts. Or if you prefer, each is different in concrete *form*. What each way, or form, is, cannot be fully understood in its concreteness without first-hand inside experience of studying it or perhaps teaching it. But behind this specific and particular understanding there are more fundamental questions, second-order questions, of a philosophical kind, of radically different, basically different, *kinds* of understanding, knowledge and experience. It is not the direct business of the practitioners in mathematics, the sciences, history ... the arts, to interest themselves in these fundamental philosophical

questions. And in the past, at least, there has
been some reluctance on the part of the prac-
titioners to do so. There has been, and perhaps
still is quite a strong resistance of some his-
torians and some scientists, to the philosophy of
history of the philosophy of science respectively.
But it seems to me very important that *teachers* of
these or other subjects should not show this resis-
tance. Certain aspects of theory of knowledge are
basic to philosophy of education.

 II
So, before I can turn to the more particular ques-
tions of the aesthetic and the arts in the curricu-
lum, I shall have to spend a little time on more
general questions of kinds of knowledge, and, par-
ticularly, of the different relations of different
kinds of knowledge, to personal experience.

I will begin by a dogmatic "educational" statement.
The *learning* of, and in, any "subject" whatsoever,
should be a personal *learning experience*, an
engagement, an involvement in whatever is being
learnt. If, instead, it is as it too often is,
merely the "getting up" of "knowledge", to be
thankfully forgotten as soon as the examination is
over, the educational value of "learning" that
subject has been minimal. As I have just said,
this is true of the learning of any subject whatso-
ever. But "subjects", or areas of learning, are
different, and the bearing of them on the character
and person of the learner will vary too.

If we speak, in education, of coming to know and
understand as a main aim of education, we can, I
think, discern two main emphases: the knowing and
understanding of the factual and the conceptual,
and the knowing and understanding of values.

These, I repeat, are emphases, stresses, and not watertight compartments. Values are involved in coming to know and understand the factual and conceptual: and values themselves do not float about in the empty air, but arise out of the factual and conceptual. That someone shows compassion, that Cezanne painted *Mont Saint-Victoire*, are facts; and we say that they are "good", or that it is good that they did. But the *distinction* is clear.

Involved with these two emphases are three other emphases, or three different kinds of knowing and understanding. They are knowing-how, knowing-that (or about), and what may be called "acquaintance-knowledge". The first, knowing-how, is basic to the others: we could not think or act without knowing how to. I will assume this here but shall not discuss it. Acquaintance-knowledge and knowledge-that correspond respectively with *Kennen* and *Wissen* in German, or *Connaître* and *Savoir* in French.

As my reiteration of the word "emphasis" suggests, acquaintance-knowledge and knowledge-that are not, as they actually occur in everyday life, shut off from one another in watertight compartments. They overlap. But the stress, as two broadly contrasted ways of knowing, is different. The stress, in acquaintance-knowledge, is on the direct impact on personal experience, the experience of a whole person, the cognitive, conative and the affective aspects of experience very closely related, functioning together, with repercussions, reverberations on body and mind functioning as a whole. We can think here of the total reactions of meeting and knowing another person, or of admiring his compassion, or courage in the face of difficulties,

or of integrity as against speciousness. We "cog-
nise" these, but not simply with detached recog-
nition of these qualities. We respond actively;
there may be impulses to emulate the admired
qualities: we feel, sometimes with emotion, these
qualities in the other person. Or in the direct
confrontation with a great work of art there is a
total response. Our "knowing" of the work as
directly apprehended is a holistic response. If
we take it seriously we give it close attention,
an attention in which recognition of its formal
qualities, its composition, its unity in variety,
its expressiveness, perhaps its depth, perhaps its
charm, are all indivisibly (though distinguishable)
aspects of one created thing. And these qualities
are discerned, certainly "cognitively", but with a
cognition which is fused with our active partici-
pation in its characters, and, above all, *felt-
together* in a single though very complex intuition
in which there is a special kind of joy, peculiar
and special to that individual thing. I am not
suggesting that here there is a sort of grand
emotional wallow. The response when it is developed
and mature (and after, perhaps, repeated returns
to the same great work), is a highly discriminat-
ing perception. For the duration of the single
experience, the *thinking* which distinguishes the
various interacting qualities of the work, and
which is, as I have been suggesting, a feeling and
active participation as well, may be followed, at
another time of reflection afterwards, by a great
deal of thinking, often analytic in emphasis. The
study of a Bach fugue is a case in point. The
fugue is a highly complex structure which needs
careful and long analysis for full understanding.
This is done at another time from the actual
musical performance (or an actual listening to the

music). But the study done at another time, and
in the background rather than in the focus of con-
sciousness, comes to clarify and illuminate the
performance (or the listening), so that the total
meaning - the artistic meaning - of the work is
enhanced and unified.

The total, complex, very-personally-involved,
experiences which occur in acquaintance knowledge,
stand in contrast to "knowledge-that (or about)" -
though as I have suggested, knowledge-about
enhances aesthetic understanding. If we consider
the *objectives* of thinking in mathematics, the
sciences, geography, they are conceptual-intellect-
ual knowledge and understanding of the facts. This
can require a great deal of high abstraction,
which is in strong contrast to the emphasis in
acquaintance-knowledge. If you stand at a
crossing-gate, and with a kind of naïve and glorious
thrill watch the approaching express thundering by,
the experience is reverberating and total. The
"motion" of the train is the *whole* thing. It is
what Bergson called *Durée Reéle*. If on the other
hand you are studying the progress of the train as
motion to be recorded and formulated as a concep-
tion, you have to reduce the motion of the train,
the *durée reéle*, to a spatial diagram. You have
to reduce the "real" motion of the train to, per-
haps, a line where a body, b, is at a time, t^1
at point, p^1 and "later" (or further along the spa-
tial line) at another point, p^2, at "time" t^2 ...
This is very necessary for certain purposes: but it
is, from another point of view, a caricature of
movement. You know movement in one sense by a to-
tal experience of the moving train; but in quite a
different sense by means of the spatial diagram.
Mathematics and logic are pure abstractions.

Empirical science is, necessarily, abstraction
from concrete experience. And, generally, science
is an abstract conceptual construction, a complex
conceptual system enabling us to understand the
world in a way in which we can deal with it
intellectually, and, very often, in high tech-
nology, practically. Knowing-that is expressed in
highly complex systems of propositions. This is
what I have called the "objective" of scientific
thinking, the clarified system of propositional
statements giving us objective, relatively feeling-
free knowledge *about* the world. It is matter-of-
fact oriented, and though of course science is
valuable in many ways, and has its own values of
objectivity and implication, the concentration is
on objective impersonal truth.

This is one side; and of course in describing it
thus I am not in any way at all depreciating its
importance - which would be merely silly. Nor if
one points out that a main *objective* of science is
a kind of impersonal objective truth, and not,
finally, the individual and personal satisfaction
and enjoyment of, say, the great discoverers of
science, is one saying that "science", taken in
its total perspective, does not satisfy a great
human need, and afford a very deep *human* satisfac-
tion. I will not say that all great scientists
are "great" human beings (any more than all great
artists are "great" human beings). But scientific
passion and integrity, and the profound joy of the
search for intellectual comprehension of the struc-
ture of the world, rank among values of the very
highest sort. (Perhaps it is an arbitrary specu-
lation; but maybe, in the realm of human values,
the single-minded search for scientific truth, and
the great joy of it, may be *more* "important",

humanly speaking, than the attainment of impersonal
objectives. But I agree that this is arbitrary
and probably much too simple.)

These observations do draw attention to the one-
sidedness of thinking of science merely in terms
of its impersonal objectives, expressed in systems
of propositional statements. Science is not merely
the attainment of its impersonal objectives. It
is a living human enterprise in which there is joy
(as well as frustration). And I want to say now
(coming to the point after what I hope have been
relevant wanderings) that this joy is *aesthetic*
joy. Polanyi remarks that the joy of mathematics
is purely aesthetic. And I think that this term
"aesthetic" can be applied throughout the whole
range of intellectual-conceptual adventure. It is
not so much that aesthetic satisfaction, intellec-
tual "beauty", is the conscious aim of intellectual
pursuits, as that it is its natural freely-given
reward. The job is done well, a wonderful illumi-
nation and clarity is the outcome; it is a
"beautiful" solution. And it is interesting to
note that Henry Moore, the artist, has said that
he is not trying to create "beauty", but to do his
particular job well. It is not self-indulgent,
self-centred hedonism that is the motive. It is
the work well done and worth doing for its own
sake: the joy is in doing, as well as in enjoying
what has been done, in self-forgetful integrity.
This is aesthetic joy.

I have been talking about the great scientists -
and, latterly, a great artist. In saying that the
aesthetic joy is not directly or consciously sought
after, but is like the bloom on the perfectly grown
ripe peach, there is a slight overstatement. As

conscious beings with memory, we know that certain
activities carried out well, do in fact ensue in
joy, and we should be deceiving ourselves if we
were unrealistic about this. We do hope for some
of this joy, and sometimes we get it. Sometimes
we do not. But the fact that, whilst knowing this
too, and that sometimes our efforts to do a good
job are rewarded by frustration and despair, we
still persist in the faith and conviction that the
enterprise exercises over us a sort of categorical
imperative - this is a vindication of our convic-
tion that it is the quality of the work which
primarily matters, and that the joy of fulfilment
is a kind of grace, something given.

III

I have suggested that the discovery, and the dis-
covering, of conceptual-intellectual order, in
science and philosophy as well as in mathematics,
yields *aesthetic* joy. This may seem to be a too-
wide extension of the word "aesthetic", which is
usually taken to mean a kind of joy we get in cer-
tain modes of sense perception, to apply to
beautiful things in nature or art. And of course
the etymology of the word does relate to the
senses (though Aristotle says that morally right
actions are determined by a sort of "aesthetic"
perception). But a very generally accepted account
is that when *anything* (often, but not necessarily,
a sense object) is attended to "for its own sake"
or for itself, and is sufficiently interesting to
hold our attention, that "anything" becomes an
aesthetic object. We are not interested in it
because it increases our knowledge about things,
or because it is useful, or because it has economic
value, or for any extraneous reason or cause, but
because it is itself, and holds our attention and
gives us a certain joy. The joy, aesthetic joy,

arises out of this attention to the qualities of
the thing, very often to its intrinsically pleasing
form. It is very important to keep in mind this
attention to the qualities or forms of the object,
for the aesthetic joy arises out of this attention
to them and is, as I suggested, a delight which
belongs to this sort of objective attention and is
not something which can be cultivated as an isola-
ted feeling on its own.

The range of things which can yield this aesthetic
joy is not infinite; for there is so much in this
world that is aesthetically *dis*pleasing. But the
positive range is unlimited. I have mentioned the
aesthetic joys of mathematics and science, which
are the outcome of the hard work of thinking. But
the natural world, and the world of man's makings,
offer so much that if we lived for a million years
we should never come to the end of them. Of the
ordinary world, Rupert Brooke, in *The Great Lover*,
writes of some of the many things which need no
hard work to win their enjoyment, but are there
for the giving - *if* we have the sensibility to
become aware of them:

> These have I loved: White plates and
> cups, clean-gleaming,
> Ringed with blue lines; and feathery,
> faery dust;
> Wet roofs, beneath the lamp-light; the
> strong crust
> Of friendly bread; and many-tasting
> food;
> And radiant raindrops couching in cool
> flowers;
> And flowers themselves, that sway
> through sunny hours,

Dreaming of moths that drink them under
 the moon;
Then, the cool kindliness of sheets,
 that soon
Smooth away trouble; and the rough male
 kiss
Of blankets; grainy wood; live hair
 that is
Shining and free; blue-massing clouds;
 the keen
Unpassioned beauty of a great machine ...

The enjoyment of all these things is good in
itself; and a life that is full of it is a life
full of unlimited potential delights, so that an
ageing man, Thomas Hardy, looking back as if life
has ended, can write in his poem "Afterwards":

When the Present has latched its
 postern behind my tremulous stay,
And the May month flaps its glad green
 leaves like wings,
Delicate-filmed as new-spun silk, will
 the neighbours say,
"He was a man who used to notice such
 things"?

If it be the dusk when, like an eyelid's
 soundless blink,
The dew-fall hawk comes crossing the
 shades to alight
Upon the wind-warped upland thorn, a
 gazer may think,
"To him this must have been a familiar
 sight".

If, when hearing that I have been
 stilled at last, they stand at the
 door,
Watching the full-starred heavens that
 winter sees,
Will this thought rise in those who will
 meet my face no more,
"He was one who had an eye for such
 mysteries"?

The "education" of children "to notice such things"
cannot be a formal thing, with rules, but rather a
sympathetic encouragement by parents and teachers
as much by their own attitudes and "noticing"
interests as anything else. In the routine bring-
ing up, and the school teaching of children, it is
too often sadly lacking. But where it is present
it is an initiation into what here in this context
it may sound a little pompous to call "aesthetic
education".

Is it pompous to speak of "aesthetic education" in
the teaching of some, possibly all, subjects of
the curriculum? Is it simply wrong, or confused,
or exaggerated, or over-simple? It depends, of
course, on what you mean. It would be a bit of all
these, I think, if it meant that teaching mathe-
matics or science, or geography or history ... is
just "aesthetic education", that is to say just
identified with "aesthetic education". In all
these subjects the first thing is learning to under-
stand their various facts and the concepts which
are the keys to the understanding of them. This
is objectively directed, and implies hard work
which is not, in itself, of an "aesthetic" kind.
The primary aim is to learn mathematics, or
physics, or history or whatever it may be.

Teaching the subjects is in the first place aiming
at some objective knowledge, knowledge of and
knowledge about. And for the learner who is
really trying to learn, and with some success,
there is a natural and proper satisfaction in the
achievement. But in the learning and in the
measure of understanding, there can be, quite
inseparably from all the rest, a joy in coming to
understand the form and structure in a field of
study, a development from what at first may have
seemed to have been a bewilderment of confusion by
the formidable challenge of its complexities, to a
grasp of relationships and *form*. In every field
of knowledge and experience the deep desire to
find form in the welter of what may at first seem
to be confusion and chaos, is one of the most
fundamental facts about intelligent human nature.
And the delight in form, the discovery of relative
cosmos from relative chaos, so fundamental, is, I
am suggesting, an *aesthetic* delight. The discovery
of, and the delight in form, whether it be mathe-
matics, biology, history ... is what I am calling
"aesthetic" delight. And I suggest that in any
good teaching of anything, the cultivation of the
sense of, and the delight in, this form is one of
the strongest motivations in the learning of any-
thing. If this happens, the teaching will *involve*
aesthetic enjoyment in this sense, enjoyment which
comes through and is the reward of these factual-
conceptual studies. Studying science or history
cannot, as I have said, be identified with
"aesthetic education": but good teaching will con-
tain this element which is inseparable from it.

I am, of course, incompetent to say what in detail
teachers of the various subjects would have to say
about the aesthetic aspects of teaching their

several subjects. I suppose it would be right to
say that in mathematics and in some aspects of
science the "beauty" would be of systems of con-
cepts. Other, empirical, aspects of science
involve sense experience, and here there are two
different aspects: strictly objective scientific
observation, the direct scientific focus, and, dis-
tinct from that (and sometimes separable from it)
an aesthetic enjoyment of what one perceives through
the senses. This could apply to astronomy,
geology ... the biology of plants and animals,
anatomy, physiology, chemistry. In biology, for
example, there is a potentiality of endless delight
in simply looking at flowers, trees, animals large
or small, the patterns of their colours and shapes,
their anatomy and physiology functioning as alive
or perhaps in good working models. One can look
at "such mysteries" as Hardy perhaps did, without
much scientific learning, naïvely. But the informed
understanding, seeing the same things, can see them
differently, seeing further, and moved to further
study and understanding, and to deeper enjoyment.
The aesthetic enjoyment is distinguishable from
the factual knowledge and the conceptual under-
standing but inseparable from it, both as a motive
for further pursuit and as a reward. Fact and
value, conceptually distinct, are indivisibly
united in existential experience. The "head" and
the "heart" are at one. There is a fullness in
this education which is much more than knowing and
understanding "that something is the case". It
has a blessedness all its own.

IV

I have touched on some facets of the aesthetic,
"natural" aesthetic experiences as well as
aesthetic elements in the learning of subjects out-
side the arts. In these, I have said, the focus

is on learning the subject (and its knowledge-that)
and not primarily on aesthetic experience and
enjoyment. In art education itself, aesthetic per-
ception and enjoyment *is*, contrariwise, at least
one part of the *main* aim or objective. I say "one
part". For art education, like the other "sub-
jects", has two sides. One side is that just
mentioned, the cultivation of aesthetic perception
and enjoyment of art, both in the process of making
art, and in the apprehension of given works of
art. This is essential throughout: and one way in
which it happens is simply by extending the
experiences - seeing, hearing ... more art. But,
as from the beginning we are intelligent, thinking,
language-using human beings, the *study* of art (and
in serious education we are concerned with *study*)
is much wider than the simple enjoyment. Art
education is not just enjoying the making of arti-
facts or enjoying artifacts presented to us -
though of course it includes it. Art education as
a *study* contains analysis, criticism, sense of the
context and period of works of art, some historical
awareness. At different stages of school education,
with which we are mainly concerned here, this will
of course take different forms. What young
children can "take" and understand is obviously
not at all the same as what a maturing adolescent
can accept and absorb. In what follows this is
assumed throughout.

If we do keep this last point firmly in mind,
perhaps my insistence in what follows, that we
must understand as clearly as possible what art is
in its most developed and mature manifestations,
will be seen to be essential. Aristotle somewhere
says that in order to understand *anything*, we have
to look at it at its most developed and "best". This

is profoundly true. Such art as children make is
not yet developed and mature. But, if we are to
use the term "art" of children's work responsibly,
we must not use "art" in a sense which bears little
relation to its use in any discourse on mature art.

It is very necessary to stress this, because there
has been a great deal of talk and writing of
"childrens' art", as though there is a special
brand of "art" which is "childrens' art". The con-
fusion partly arises from a verbal ambiguity. It
can be sensibly enough said that "childrens' art"
is the art that children (particularly young
children) "do". This is, as an "extensional"
statement, in itself unobjectionable. But even
here there is concealed an assumption which is
highly questionable. It is that everything
children do in the way of drawing, painting,
modelling, etc. is thereby "childrens' art". But
on any serious account of art this is not so, as
I shall try to develop in the briefest sketch of
some essential conditions for anything to be called
"art", even in a minimum and undeveloped sense.
Again, and not unconnected with the use of the
term "art", there is much-acceptable-talk of the
instrumental effects of what is called "art-making"
upon children's growth and development. It helps
them to come to terms with the perceptual world.
Drawing improves the quality of observation and
understanding. It teaches children to analyse
objects: drawing can be involved with one's feel-
ings about things; it can be a means of reorganizing
ideas and responses or of transforming them into
new images. This, although it is largely concerned
with the general development of young children, is
quite true. Some of it is art, and it can be a
beginning of art education. But an older tradition,

beneficial in its day, still lingers on, inherited
from Rousseau, Froebel and others, that children
grow up naturally like flowers, that they should
not only be allowed to express themselves freely
(which is quite right), but that parents and
teachers should never intervene, or check, or even
suggest. Apart from this (though related to it)
there is still lingering the notion that what art
is, is "self-expression". I do not doubt that in
some (and I am inclined to say much) art and art-
making there is an element of self-expression, and
of expression of other kinds. But I think that
the emphasis on "self", and "expression of one's
personality", rather than on the discovery of
meanings which are *not* oneself, is unhealthy and a
bad influence. Again I do not doubt that an out-
going sentiment in art-making is a very important
factor in the development of personality. But it
is the added grace, and not the self-centred focal
aim.

All this (and other factors too), has resulted in
a very "bitty" approach to at any-rate visual art
education. There has been a lack of fundamental
philosophical approach to art education. If one
looks over the syllabus proposals put out by many
art departments, they tend to be vague and some-
times idiosyncratic. Of course individual teachers
must teach each in his or her own way. But the
absence of fundamental guiding lines in the train-
ing of art teachers (until very recently), or per-
haps more basically, the absence of any introduc-
tion to the conceptual understanding of the
aesthetic and art, has tended to leave excellent
teachers floating in a sort of half-vacuum. (I
have briefly commented on this in my article, "Art
Teaching and the Conceptual Understanding of Art"

in *Bedford Way Papers*, No. 14.[1] And it may be an
illustration of what I have just been saying, that
the very *title* of my contribution was thought, by
one or more referees to which the whole volume was
submitted, to be not quite relevant to the main
theme of art education!)

V

If I now turn to state - much too briefly -
several essential features of art making and art
appreciation, features essential to anything which
can properly be called mature "art", it is because
I believe that it has an important bearing on the
art education of children of school age. If some
of the work of children is to be fairly called
"art", I would expect it to include some or all of
these features in embryo at least. But of course
the question whether this or that piece of a child's
work does contain artistic elements, or whether it
is or is not, "art", would have to be judged on
individual cases. This would often be a difficult
critical question: certainly I am not trying to
give general answers to particular questions here.

I will not do more than mention here various
general writings, psychological or philosophical,
on "creativity", by Guilford, Hudson, Wallas ...
Elliot, White and others. It is said that since
we know little or nothing of the inner processes
of creation, we can note only general conditions,
such as preparation, incubation, "inspiration",
verification. Alternatively it is said that we
must concentrate on the product not the process,
and that the product must be new and "valuable".
To conform with the "valuable" criterion we should
have to rule out tests of mere ingenuity like
novel uses for a brick, or *merely* "divergent" as
opposed to "convergent" thinking. And it is

certainly true that absolute creation would be the
sort of creation described in Genesis: "and God
created all things out of nothing". and human
beings are not God! If they are creators at all
their's must be creaturely creation.

Is there then "creaturely" creation? I think there
is, and that, in spite of the sickeningly overused
word "creative", in the arts there is genuine
creation, and that some significant things can be
said about it - though in the centre there is a
mystery.

Each work of art is "new", not in the trifling
sense in which each raindrop or each tick of the
clock is new, but significantly and importantly
(that is "valuably") new because it is a new indi-
vidual creation with a form which requires a
special act of experientially aesthetic attention
in order to understand it *as* an individual with
its own internally structured content.

There are two approaches from which one can view
the significant newness of new creation. One is
the approach of the creative artist, the other
that of the receiver of art (the spectator,
listener, etc.).

First, the artist's approach. I suggest that the
effort to make art is, *inter alia*, an effort to
discover new meaning, meaning-embodied in a medium.
It is discovered through working in that medium in,
metaphorically speaking, a sort of dialogue
between artist and medium. The artist never knows
beforehand exactly the structure he is going to
make and has no fixed rules to guide him towards
this individual piece of making. Of course he has

had previous experience of making, and a knowledge-
of and knowledge-how of techniques potentially
anticipatory; he had, too, habits and stylistic
tendencies. But as to exactly how he is going to
use these, and as to the potentialities of the
medium in which he is working, he has but vague
and tentative feelings and ideas. There is
neither a prefigured plan, derived or deduced from
some given intelligible scheme, nor a final plan
operating teleologically towards which he can work.
The final form of the particular painting, or
poem, or sonata ... not only *is* not known before-
hand by the creating artist: it *cannot* be known
beforehand, because the form of a work of art as
individual is not a *general* form or general pattern
or structure into which the work will, as it were,
fit, or be moulded by. The form of a particular
and individual work is organically dependent on
its parts as, in complementary fashion, the
artistically-aesthetic meaning of the parts cannot
be fully understood aesthetically except as
functioning in aesthetically-organic relation to
all the other parts and to the whole. There are,
of course general artistic forms which have general
names - the sonnet, the fugue ...; and the artist
can say beforehand that he is going to make some-
thing in a particular form of that general kind.
But the "form", spoken of quite legitimately in
that way, is the form in quite a different sense
from the individual form of *this* work, which is
creatively built up in a temporal process and does
not exist as an artistic form until the actual
building-up is complete. (There is form as a
general concept, and form as existential.)

And this, if it "comes off", as in genuine works
of art (major or minor) is something which can

truly be called "creation". In good and great art
something genuinely new, genuinely new and impor-
tant, is brought into the world: and in a sense it
remains new - or if that is thought too paradoxi-
cal, unique and individual, long after it was first
made. In a sense, if it is good or great, it has
something of a timeless quality and is forever -
though in chronological time the physical part of
it may decay or disappear, and through chance it
may be lost to human memory, forgotten.

I have said that in creating art there is no pre-
conceived plan of the *exact* complex which is to be
made - though there may be plenty of floating
ideas, exploratory feelings and desires. If there
were a more or less exact plan beforehand (as
sometimes seems to be suggested in stories about
Leonardo or Mozart, who had vast experience of
working in their media, and vast imaginations),
the work would already have been created. Of
course every artist begins with certain talents
and established habits of work: and he senses
certain elements required for his future product.
But (to repeat) he does not yet know its individual
form. He discovers in creating. The plan becomes
formulated in and through the process of making.
"He formulates his plan at the same time as he
sees what is required to complete the process he
started ... He must generate a necessitated
product which is not necessitated by anything
given to the creator with which he can generate it.
In short, the creator must act as an agent which
is a cause without a prior cause, a cause which
causes itself".[2] This sounds thoroughly
irrational; and many people do call art
"irrational". I agree that the progressive dis-
covery through working in a medium, which is art,

is mysterious, and if "rational" means something
like "logically deduced", art-making is not
rational in that sense. But, as Polanyi often
said, "We *know* far more than we can say". And if
(in science as well as in art, though in a dif-
ferent way) the tacit cognitive processes which we
do not directly know or fully understand, can
issue in the perfect harmony and order of the
great works of art - of poetry, drama, music,
painting ... it is monstrous, I think, to say that
art is an "irrational" thing. There are "ration-
alities" of different kinds.

> Reason has moons, but moons not hers,
> Lie mirror'd on her sea,
> Confounding her astronomers,
> But, O! delighting me.

Carl Hausman, whom I have just quoted, has many
illuminating things to say about this mysterious
thing, artistic creation. One of them, which I
cannot stay here to expound as it deserves, and
can only hint at, is an application of the
Platonic, and later Christian-theological, ideas
of *Agape* and *Eros*, to art-creation.[3] *Agape* in
Christian theology and religion means the outgoing
love of God directed towards all persons, sinner
and saint alike, and is "uncaused" in the sense
that the love is not evoked by any good or attrac-
tive qualities in the persons loved but is concern
for their good and well-being. *Eros*, on the other
hand, is "caused" love, caused by the qualities in
the beloved, dependent on the beloved for fulfil-
ment. (The denotation of Eros is much wider than
the erotic in the sexual sense.)

Hausman's application of these concepts to the
creation of art is interesting and important. The
idea that creative acts may be driven by love in
the sense of *Eros* should not seem surprising. The
artist, though he has often to endure anguish and
painful effort, has a passionate love for his work,
and when he achieves his work, he can be overcome
with a joy like the joy of consummated love. But
the kind of love which operates in artistic creation
cannot be adequately described exclusively in terms
of Eros. The basis of the dynamic thrust of Eros
is the attraction of the perfection which is
desired. The desire is for the attractive nature
of the end of the process. But in the creation of
art, the nature of the end desired is not known
beforehand: and if it were known beforehand the
process of making art would not be creative, but
simply determined by its initial direction, without
varying as the working proceeds. As predetermined,
there would be no novelty in the intelligible
structure of the outcome.

Eros by itself is then not enough to account for
the creative and self-determining character of art.
Hausman (drawing some of his ideas from
A.N. Whitehead's *Adventures of Ideas*, and *Process
of Reality*) points out that the telos or end of
the art process itself changes; hence it could not
*pre*structure the process. At the beginning of the
creative process, as we have seen, the artist
envisages only a vague and at best partially deter-
minate end. I spoke earlier in a metaphor of a
sort of "dialogue" between the artist and his
medium through which he discovers new meaning: and
this is an essential factor in art making. It is
one side. Another factor in the dynamism of the
artistic process is the outgoing drive of *Agape*.

As Hausman points out: "The creative act is not
wholly uncontrolled. If there is serendipity, it
is not sheer accident. The creator must not only
exercise critical judgment in deciding what to
accept and reject when possibilities occur to him,
but he must also form, refine and integrate these,
even if he knows only with a degree of imprecision
what the final integration will be. And most
important, he must assume responsibility for what
he brings into being ..." The motive finally is
not of *Eros*, seeking to fulfil itself by attaining
a previsualized, predetermined goal, but is a kind
of offering of itself by permitting creation to
grow in its own terms. The artist both seeks, and
gives himself to, creation. The concern is not
finally for self-fulfilment but for the creature,
the art which is yet to be. This concern is, I
believe, an artist's moral responsibility. It
requires its own very special kind of moral integ-
rity; and the integrity of the art can hardly be
had without it.

All this is meant to be merely an indication of
some essential features of art creation at its
maturer levels. It may seem absurdly remote and
completely irrelevant to what might happen in a
primary school art room. In one sense it is so,
or would be so, if it were supposed that the
"philosophy" of anything is the kind of thing that
can be directly "applied" to particular and practi-
cal problems of this or that piece of art or of
educative teaching. But philosophy is not like
that: if basic philosophical understanding of a
complex concept like art can at all affect practice
in art education, it can only do so by being
assimilated and absorbed into the understanding
mind, so that, without necessarily thinking about

it consciously, an understanding teacher will see
things rather differently than he or she would
otherwise, and therefore may act intuitively
rather differently in particular situations. There
are all kinds of ways *into* "art" - emotion, self-
expression, technical facility, accurate drawing,
schematic insights ... But genuine art, whether
at earlier, or later, stages, is much more than
simply these. And of course the teacher knows
about the internal relations between "process" and
"product".

That children from the earliest stages should, as
far as is practicable, be given plenty of oppor-
tunities to explore and experiment in various media
and in different art-forms, is intrinsically of
great importance. In the society into which we
are rapidly moving (for one reason or another) -
one of greater leisure - it is, if possible, of
greater importance than ever. The recent
Gulbenkian Report, *The Arts in Higher Education*,
discusses how, in other cultures, the various arts
have been part and parcel of the life of the com-
munity. In our own, urban, culture, the "high"
arts have tended to be cut off from the common
people, a divisiveness which has eaten into the
quality of life of the masses, and has not only
cut them off from the best that has been achieved
in the past and in the present, but has impover-
ished popular art itself. The élite and the popu-
lar tend to be separated off from one another,
looking at each other across barriers. (This can
penetrate too the sentiments of the so-called
Avant garde, amounting to a rejection of context
and tradition, overstated in a remark of
Claes Oldenburg who wants "an art that starts from
nothing"). I am suggesting then that it is

important in itself to let children be guided
early into the experience of artistic exploration,
both for itself, and because if they gain some
insights early into the essential thing which is
art they will be the more likely not only to take
part in (hopefully) the increasing enterprises of
community arts, but to contribute to it much more
fruitfully.

But though exploratory experience in art making is
vital, it is only one essential in art education.
Critical, discriminating appreciation and under-
standing of the works of established artists is
another, which must complement the present far too
exclusive tendency to put self-expression in the
centre of the picture. As Richard T. Kelsall
writes of art education in the Primary School:
"Critical study would be characterized by the
ability of pupils to make judgments on their own
work, as well as that of others; and to do this
within a knowledgeable historical and cultural
frame of reference. What is called for is a
strengthening of the educational rôle of galleries,
museums and professional artists together with an
acceptance of the idea that critical study is not
something that can be popped into the curriculum
during adolescent years, but which needs to be
experienced by children throughout their art edu-
cation in appropriate forms so that it may be
developed and extended from the infant school
onward".[4] Kelsall emphasizes the importance of
language and its crucial part in the development
of discriminating aesthetic perception. In
experiment he found not only that development and
expansion of vocabulary commensurately altered and
improved perceptual abilities and understandings,
but that (in comparison with a control group) the

children's picture making improved. Generally, the
"children appeared to be giving more attention to
the colours and shapes and other sensory aspects
of the work and rather less attention to the sub-
ject matter at the post-test stage compared with
the pre-test stage".

A paper by John Steers in the same journal appo-
sitely complementary to Kelsall's, asks the same
kinds of question about art education in the
Secondary sphere. He complains similarly of the
too-exclusive concern in art departments with the
production of art objects, and the too-little
allowance that is made "for the development of
critical awareness or an understanding of the cul-
tural heritage of this country or of mankind as a
whole".[5] Again, "There is little obvious sequence
in art education generally, or specifically in the
secondary school. At every stage there is a tend-
ency to ask pupils to start again at the beginning
and to ignore previous hard won experience". It
is "a confused subject area generally lacking
direction and purpose". In contrast, he says (as
I have here in a different way) that "there are
fundamental art experiences that are equally valid
at all stages of pupil development: the content
does not differ, the level of understanding and
depth of involvement does". The structure of
Steer's research is much too complex to outline
here. But the results are positive and support
the feasibility and desirability of a more compre-
hensive conception of art education.

VI

And history? What about History of Art?
Anthony Dyson, a leader in this field of art
education, writes illuminatingly on the subject in
"Art History in Schools: a Comprehensive Strategy"

(as well as in other papers). Dyson observes that
the study of the history of art in British education
"may best be represented as the apex of a pyramid,
floating baseless".[6]

There are several bad misconceptions about history
of art and its relation to art education. One,
overdominated by the limited conception of art
education as simply encouraging children to make
their own art-objects, rejects art history as
"irrelevant" - except perhaps in so far as an
example from past history can help in this piece
of practical making. Examples are to be picked
out from "history" to help, now. This (or the
assumption behind it) is nonsense. Picking out an
example from "history" has nothing to do with
history, or with the context in history of the
example(s) chosen. It ignores the essentially
chronological factor of history.

Another, opposite, misconception is that history
is *just* chronology. Chronology is an irradicable
factor in our conception of history; but it is
only *one* factor in the history of human enterprise.
That learning history is just learning dates and
periods and committing them to memory is a common
image - and not one confined altogether to the *hoi
polloi*. There is no doubt that some teaching of
art history has been not unlike that.

There is another, and much more considerable,
objection to the teaching of history of art in
schools (except perhaps for a few specialists who
will take examinations in it as a "subject"), an
objection which tends to isolate it from the direct
study of the practice and appreciation of art. It
is that history of art is too difficult and

technical - a study of styles, iconography, etc. -
altogether remote for ordinary school consumption.
This is, as I say, a considerable objection, and
if the teaching of art history were simply identi-
cal with this advanced study, it would be a very
strong objection. One of the merits of
Anthony Dyson's writing is that he seriously
addresses himself to the problem of "the devising
of courses in primary schools and in the lower
levels of secondary education which will enrich
the learning of all pupils, the majority of whom
will never aspire to examination success in the
history of art". He discusses "what may be
achieved in an ordinary classroom with the aid of
a pile of postcard reproductions and photographs,
a few colour transparencies, and a collection of
everyday objects".

"The contemplation of a group of Cubist portraits,
however eloquently supported by a teacher's commen-
tary, may mean little to pupils whose looking and
questioning has left them unprepared for a diffi-
cult feat of perceptual gymnastics, and probably
unsympathetic towards images for which there may
be no niche in their interest and experience. The
way towards the appreciation of such images may
need to be paved by a thorough consideration of
their essential animating principles. In the case
of the Cubist portraits, one such principle might
be that of distortion; and it is suggested that,
long before a Cubist portrait can be comprehended
as a Cubist portrait, the formal principle of dis-
tortion (among other important characteristics)
will need to be appraised, explored and understood
by pupils". "What is important ... is that a
sense of human shaping, of chronology, of location
and of cultural inflection be gained - almost by

contagion: a realization that an art object is the
work of human hand and mind, the evidence of a par-
ticular moment of history, the product of a certain
geographical region and the expression of a cul-
ture". Again, in teaching the time element, one
might compare a photograph of a greengrocer's stall
with one of a Byzantine mosaic: or a Cubist head
and a Renaissance portrait: or Wembley Stadium and
the Roman Colosseum. Questions arising might be:
When might each item have been made? Recently?
Long ago? About how long ago?

The very common image, the chronological image, of
history can be very misleading. It is an image of
lists of names, dates, chronological tables, of
things belonging to a long-gone past, not of great
interest except to those who have a *penchant* for
poking into the past, a past cut off irrevocably
from the present. But, though the fact that in the
nature of things there is a sequence in time of
before and after is of course undeniable, it is a
mistake to think that chronology, or the *recording*
or chronicling of events, is more than a necessary
and convenient abstraction from the living thing,
the course of human events, which is history.

We have to distinguish two different things with
the same name, the *concrete* history which is the
sequential happening of human affairs *as* they
happen, and *written* history which is, properly, the
imaginative account of those happenings based on
such evidences and records as remain to us. Both
of these have to do with what may be called "real"
time, or in Bergson's language, *Durée Reéle*. Con-
crete history is *durée reéle* in the sense that it
is the time of the concrete human happenings as
they occurred. Written history attempts to capture

this imaginatively. Bergson's own homely example
of "real time" is the experience of raising your
arm. This "real time" is known directly in
experience. Let me here recall my earlier comment.
When, as a physicist or mathematician you try to
record and measure time, you have to draw a static
diagram, a line with points p^1, p^2 ... through
which a body b is supposed to pass at time t^1 and
t^2 etc. Bergson develops this in an interesting
metaphysics into which I cannot go here. But the
point now is that the recording and measuring,
though they may tell you something important, can
be very misleading if they induce you to believe
that in the diagram of the static line with points
you can grasp the essential essence of time, which
is the *movement and sequence* which you can only
know in the intuition of direct experience.

The *concrete* "history" of art is what actually
happens in "real" time, the lived time of the
artists who actually participated in it. The
written history of art tries to take us imagin-
atively into that life. (Gombrich's *The Story of
Art* would be an example of this.) Such written
history is sensitive to the sequence of events, and
may sometimes use chronological devices and dia-
grams as *aides mémoires*. But its aim is to recap-
ture *durée reéle* for the imagination.

There is, I think, a significant difference between
ordinary political or social history, and the his-
tory of art, and one very important for art educa-
tion. Concretely speaking, archaeological,
political, social history belong to the *durée reéle*
of the past. Written history, aiming at as true
an imaginative account of the past as it can
achieve, makes use of relics - a flint axehead, a

broken shard ... a suit of armour, an old manu-
script ... relics which remain now from the past.
With the aid of these, written history constructs
its pictures. The relics can be enjoyed, often
aesthetically, as imagined parts of the picture.
But the prime object of the historical exercise is
not aesthetic as such, but, as far as possible,
historical truth. Primarily, the relics are
"evidences", and their aesthetic value the added
grace. In history of art it is rather different.
We do not naturally think of the corpus of the
works of art which have come down to us from the
past as "relics" (though in a sense they are
relics, and if physical, usually corroded by time).
Again they may be "evidence"; but we do not think
of them primarily as this. Baroque music, Durham
Cathedral, Giotto's frescoes, "Tintern Abbey" ...
are presented to us, now, as art, architecture,
poetry, and there is the focus of attention upon
them, upon works of art as such. That is one,
sure, irreducible aspect of our experience of them.
But it is one aspect only, however important, and
if it were all, our understanding and our fullest
enjoyment of them would be strictly limited. For
though they are here, now, they also belong to the
past, and to the *durée reéle* of the past. And
since art is not only a present aesthetic object,
but humanly intentional meaning-embodied, the
imaginative recognition and understanding of the
historical context of works of art, as in their
durée reéle, is internal to their fuller apprecia-
tion.

In this fuller appreciation we do two distinguish-
able things at the same time, indivisibly. The
sense of history, time, situation, sequence, is
not cut off, divided, from our present direct

contemplation. We see the content, present in its
form and direct appeal: and we see it (if we have
the knowledge and historical insight) as belonging
to its period. Our better understanding comes from
the union of the two things. Take the historical
sense away, or suppose it absent altogether, and
our artistic understanding is much impoverished.
The relation between historical sense and fullest
appreciation is not external (history being con-
signed to the past) but internal. Historical study
and insight is not an addition of information; it
is an intrinsic part of full enjoyment and under-
standing. As I have already suggested, a work of
art is not merely an aesthetic object (though it
is that): it is the expressive embodiment made by
the artist, living in and necessarily conditioned
by his period: in enjoying his art we are at the
same time enjoying an art of his period - if we
have acquired the insight to do so. And teaching
the history of art well is inseparable from teach-
ing the understanding enjoyment of art itself.

> Time present and time past
> Are both perhaps present in time future,
> And time future contained in time past.

I am saying, then, that arts education, if it is
to be given, and received, *as a serious study and
as part of the core of any liberal education*, must
contain three main elements. First, it must offer
opportunities for practical explorative work in
several arts media, with such technical or other
help as required. Secondly, it must initiate into
the critical appreciation of given works of art.
Thirdly, and integral with this, is some study -
appropriate to the different age ranges - of the
history of the arts.

REFERENCES

[1]Bedford Way Papers No. 14, (Institute of Education, University of London).

[2]Hausman, Carl R. A Discourse on Novelty and Creation, Martinus Nijhoff, 1975.

[3]Hausman, Carl R. "Eros and Agape in Creative Evolution: A Piercean Insight", *Process Studies*, Volume 4 (Spring), 1975.

[4]Kelsall, Richard T. "Towards Critical Study in the Primary School", *Journal of Art and Design*, Volume 2, No. 3, 1983.

[5]Steers, John. "The Structure and Content of Art Teaching in the Secondary School", *Journal of Art and Design*, Volume 2, No. 3, 1983.

[6]Dyson, Anthony. "Art History in Schools: a comprehensive strategy", *Journal of Art and Design*, Volume 1, No. 1, 1982.

The Smock-coated Researcher

MALCOLM ROSS

> I find indeed that many of the effects
> of nature can be accounted for in a
> two-fold way, that is to say by a con-
> sideration of efficient causes and
> again independently by a consideration
> of final causes ... Both explanations
> are good ... And writers who take
> these diverse routes should not speak
> ill of each other ... The best plan
> would be to join the two ways of
> thinking.
>
> (Leibniz, quoted by Oliver Sacks in
> "Awakenings")

I recently gave a seminar to a group of students
researching education, on the theme *Art as a
Research Paradigm*. I set out to suggest that the
arts and the arts process, might offer educational
insights and perspectives significantly different
from and complementary to those provided by the
more traditional "scientific" approach. I pointed
to a range of artistic or arts-related activities
which the researcher might usefully engage in as
ways of knowing, as investigative methods.

167

1. The artist as maker of art-works was clearly
 concerned to arrive at a kind of truth about
 human experience, and to communicate to and
 share that truth with others. The creative
 process out of which the art product emerges
 is surely one of investigation and enquiry,
 though the techniques involved and the criteria
 and methods of evaluation adopted are different
 from those we normally associate with science.

2. Critical discourse is similarly a species of
 research, the object of which is not simply to
 establish norms of good taste but more particu-
 larly to illuminate and make more accessible
 the meaning inherent in perhaps "difficult" or
 unfamiliar works.

3. It would be a fairly straightforward matter to
 present the artistic acts of performing and
 audiencing (reading) as similarly investi-
 gative - as actions the purpose of which is to
 bring about understanding and personal develop-
 ment.

I wanted to suggest that there might be things we
wanted to know about education, there might be edu-
cational research subjects, which could be more
appropriately approached from the artistic point
of view than by means of quantification, measure-
ment and objective testing. And I was not only
thinking of the artistic dimension of education
itself - of researching the arts - where the
deployment of scientific research methods and
techniques of assessment are often so glaringly
misconceived; I was thinking of the arts as a way
of researching educational phenomena hitherto
deemed the exclusive preserve of what a colleague

has called the "white-coated researcher".

Although my talk was, on the whole, generously
received, there was clearly some dismay around,
not least because most of those present were
currently taking some pains to learn and acquire
the very skills and disciplines the efficiency of
which I was in some degree challenging. In par-
ticular they expressed their doubts about an
approach that I had described as open and meander-
ing; one which specified no particular objectives
at the outset and predicted no specific outcomes.
How, they asked, could there be "purposeless"
enquiry? I grant that not all artists approach
their work in an open, purposeless way - of course
many artists have the clearest idea what they want
to investigate. However it did seem reasonable to
me to claim that creative work, by definition,
proceeds in ignorance of the final outcome, and
that, for many artists (and here of course I'm not
simply thinking of painters and sculptors, but of
writers, poets, musicians, dancers, playwrights)
it suffices to have at the beginning of a working
session nothing more concrete to go on than an
obscure yet compelling desire to engage formatively
with a medium. Such an approach inevitably implies
a readiness to remain open to the possibilities
inherent in the process of enquiry. It also means
being prepared for false starts and, indeed, to
abandon the work because no aesthetic motive for
pursuing it has surfaced. So often, in artistic
activity, one only grasps the direction of the
work at the very end of the process, recognizing
what the quest has been only at the moment of its
apprehension. Conducting research on this basis
struck many in my audience as impracticable if not
futile. It offended their perception of research

as a logical, gradual and essentially incrementa⹏
process.

Then there was the bogey of "objectivity". If we
allow that there might be something to be said for
a rambling line of enquiry that uncovers its pur-
pose in the actual process of investigation, how
do we validate the results and in what sense could
the findings be said to be reliable? I proposed
that the notion of subjectivity in the arts was
over-worked. That there was clearly a sense in
which amongst those familiar with certain branches
or periods of art there was a considerable degree
of consensus over what was valid and what was not.
That, allowing for personal preferences and his-
torical shifts of taste over time, there were
grounds for believing that the arts appealed to
certain "universals" in the human condition and
that reasonable levels of agreement could be
reached between experts about what was significant
and what was not. Collective value-judgments are
made and accepted in many problematic areas of
human experience, where scientific tests and
access to hard information are either not possible
or simply inappropriate. Trial by Jury is one
instance of this practice - we could also cite the
system of assessing some aspects of gymnastics
(e.g. ice-skating), selecting the Summer Exhibition
at the Royal Academy, and recourse to a second
opinion in medicine. In daily domestic life we
continually check out the validity and reliability
of our judgments against the opinions of trusted
others. When authenticity, honesty, or integrity
are in question we tend to rely upon the confirm-
ing view of our disinterested friends and assoc-
iates. In circumstances such as these the mechani-
cal lie-detector, for all its apparent efficiency,

remains a dubious form of corroboration.

The other major objection to my thesis arose in
connection with communicability. In what form, I
was asked, would the research findings be communi-
cated? If they could not be communicated as veri-
fiable results encoded in a public language, how
might they be used to bring about changes and
improvements within the field being investigated?
I countered by suggesting that it is the business
of works of art to communicate by means of just
such a public language - though for the most part
non-verbally. I pointed to the rôle of artist in
times of war: to the War Poets of 1914-1918, to
the War Artists of 1939-1944, to the photographers
covering the Vietnam War, to Picasso's *Guernica*,
Goya's *The Third of May*, Britten's *War Requiem*.
There followed a discussion of the way works of
art mean, the notion that meaning in art is "mean-
ing embodied", of the essentially subversive rôle
of the arts as argued by Herbert Marcuse. Had
there been time I should have wanted to explore
the psychological basis of art as illustrated by
the writings of Anton Ehrenzweig and D.W. Winniott -
well rehearsed in Peter Fuller's book *Art and
Psychoanalysis*. And then, leaving aside the creat-
ive work of the artist, there is the interpretive
and mediating skill of the critic. These, I went
on to suggest, might be very usefully deployed to
illuminate and give access to some of the more
human and less easily quantifiable aspects of
education. Indeed, many of the new initiatives in
educational assessment - records of personal
achievement, pupil profiles, etc. - are adopting
just this interpretive stance, the object being to
give the reader access to the child's particularity,
and especially to take a positive stance towards

TAE-G

the subject. These assessments are committed to
the principle of embodiment rather than abstrac-
tion (lists of marks), to being holistic rather
than fragmentary, to belief in the value of the
child rather than to questioning his or her limit-
ations. These are all, I maintain, features of an
artistic approach.

As I have said, my proposition was received
generously, albeit with strong reservations which
I was unable properly to deal with. Not least
because I couldn't immediately cite examples of
arts-based research in education which that
audience could credit and recognize as useful in
the strictly pragmatic sense. When I suggested to
them that they might have misgivings about the real
value of what they themselves were doing there
were more than a few who wanted to agree. Many
recognized the sense of disappointment as their
initial vital ideas had to be cut down, stiffened
and filleted to meet the demands of scientific
legitimacy. Often the process itself becomes
unbearably wearisome (boredom seems to pose the
greatest threat to much doctoral research). Which
isn't to suggest of course that art work is
uninterrupted excitement and delight. Artists
know all about frustration, loss of direction and
the toilsome discipline of crafting. But once
embarked upon the search for truth that animates
the artist's research, there is usually sufficient
intrinsic motivation to see one through the troughs
and the long, forced marches. My audience ack-
nowledged much of this - but I think could reason-
ably complain that what my proposal most needed
was some specific instance. And I had nothing at
the time to offer. It has occurred to me since,
however, that some of the experimental work I have

myself been recently engaged in is indeed
"research" of an artistic kind and could possibly
have served as an illustration of one approach
with a typically arts-based philosophy informing
it. In the space remaining to me here I will offer
an account of the work in question and try to show
how research, especially arts-based research, can
itself provide a powerful educational methodology.
In describing what I have come to call my "Open
Group" work I shall try to bear in mind the
anxieties of my researcher audience over the ques-
tions of aims and purposes, objectivity and com-
munication of results. I hope to show that
specific artistic disciplines can be utilized in
respect of all three constraints.

* * * * *

Since I work at a School of Education my groups
are normally comprised of adults: young adults
(PGCE and BEd courses), older adults (Advanced
Courses and Higher Degrees). When I propose an
Open Group approach I sense I am to work very much
as a creative artist works - except that there
will be no simple equation between myself as art-
ist, and the group as my medium. Rather, my model
is that of a small, leaderless group of musicians,
composing a piece by means of a shared improvis-
ation. At the outset I try to establish certain
basic principles:

- Whilst accepting "institutional" responsi-
 bility for the group's work, I shall not
 lead, instruct, nor direct the work. It
 will, sooner or later, become a shared
 responsibility.

- That we shall be concerned to discover what
 we need to do - and then to see if and how
 we might do it.

- That we should take care of ourselves and
 have a care for the others in the group.

I should say that the Open Group is not announced
as such in any prospectus. All my courses have
rather ordinary titles: Creativity in Education,
Creative Arts, Drama in Schools and so on. When
we adopt an Open approach we have to accept the
constraint that the title of the course - its
supposed subject - puts upon us. It may be that
we decide to be as open as we can, given that what
we are researching is our need and the group's
potential within the field declared. It is my
hope one day to be able to ditch all such con-
straints - though I think my researcher audience
would be encouraged to feel that we had at least
the security of a theme or topic to focus on. But
of course what we don't do is "focus".

In conformity with what many writers on art and
artists themselves have said about the artistic
process, we begin by removing all sense of focus -
the need to isolate, define, pin down, concept-
ualize, plan. We repudiate what one of my coll-
eagues recently said to me: "What you cannot
define you cannot research". The Open Group opens
up, the assumption being that our first thoughts
are likely to be routine and predictable and ill-
informed; that we need to learn about the medium
(ourselves) before we can discover what we need to
do and might be capable of doing (the creative
impulse); that we need to respond as uninhibitedly
towards each other as we can before the structural

possibilities of the medium materialize; that in
the course of this initiation into openness or
free play we may begin to sense the promise or
possibility inherent in this collective encounter.
The process of doodling together becomes immediately
real and rich in the sense that the agenda is our-
selves; what we care to be or offer to each other -
rather than something wished upon us by a syllabus
or examination rubric. We choose how to work and
when to work, what that work shall be, whether to
pursue our idea or to abandon it, whether to accept
a temporary leader; we learn how to regulate dis-
cussion, take decisions, feedback evaluation, take
risks. We begin by exploring openness itself, dis-
covering all those things in our make-up and
experience that pin us down, locate us, perhaps
make it easier to cast or cast off the other. We
don't necessarily exchange names, or fill out
personal or professional backgrounds. We learn to
accept and to understand silence, small-talk, non-
verbal signs, evasion, assertion, anxiety,
imposition, blocking, digression, apprehension,
frustration. The agenda is real so the decisions,
the opportunities, the concern, the motivation is
real. We are talking here about first-hand, direct
engagement in live situations that are self
evidently worthwhile. A long haul from much else
that I have to do in the name of teacher training.

The fortunes of the group depend upon a range of
factors. There is the tension over the lack of
leadership, over purposelessness and doodling,
over negotiating an unfamiliar routine that allows
one simply to become one of the group, working
alongside everyone else. This tension regularly
proves a continuing source of problems and insights
as we work out our several and collective

responsibilities. In any groups there are likely
to be risk-takers and conservatives, precipitators
and responders, agitators and pacifiers, the
impatient and the diffident. There will be tend-
encies to fracture and split - into various kinds
of sub-groupings - and decisions have to be taken
about the goodness and usefulness (or otherwise)
of such tendencies. Always you work with what is
the case: whatever happens, offers, by design or
accident is the reality which locates us and with
which we engage. When good things happen you feel
blessed; when bad things happen you suffer. The
suffering is real and so the learning is real.
Though I stress the "reality" of the experience it
is worth saying that time and space, in these sit-
uations, can take on fresh and unusual values.
The clock ceases to matter and the sessions achieve
a timeless quality - the time itself becomes a
responsive medium for the intimacy that this kind
of experience develops. The space you are working
in becomes "sacred", set apart from the everyday,
protected in some important yet indefinable way.
A kind of "home". From my experience of working
in this way, a number of general points, areas of
common denomination, can be drawn out:

1. The overwhelming "finding" - i.e. what is
 found, and found to be most overwhelming - is
 a sense of enriched being, a freedom that is
 related somehow to feeling "at one" with the
 group. Love opens us up. Most participants
 report feeling personally freer, more alive,
 more sensitive, more hopeful by virtue of this
 experience. The group is experienced as "good".
 We literally find ourselves in being together.

2. Matters of deep moment and absolute importance
 are raised and shared. Individual needs are
 identified and, to a more or less successful
 degree, met. Valuable and significant work is
 done. We are illuminated, changed, trans-
 figured. We try.

3. Many participants experience guilt and anxiety,
 most particularly over a sense of self-
 indulgence and a feeling that this deep and
 demanding experience is absolutely foreign to
 and has little or no meaning for "outsiders".

4. Connected with 3 above, there is often some
 confusion and difficulty over relating what is
 happening within the group sessions to life
 outside the sessions: to life on the campus
 during the rest of the week, and to life at
 home. We are often more ourselves, or feel
 ourselves so to be, for the group than almost
 anywhere else. Life partners outside the
 group can become anxious. The experiences of
 "communitas" and "commons" become powerful
 forces in our lives.

5. The group rapidly develops a deep sense of
 attachment. This raises its own problems
 especially at the end of the course, when what
 has become a life-enhancing relationship has
 to be summarily broken up. The "findings"
 however persist, not, just as memories but as
 new being, and, after a period of unavoidable
 mourning, life goes on - enriched. The
 "special relationship" becomes a touchstone;
 what we found transforms us and our futures.

I have spelled out these general factors without
giving much idea of what actually happens in these
sessions. Each Open Group, by definition, estab-
lishes a unique identity and its own special way
of working. There is always a lot of talk. But
the talk is creative, intimate, honest - not all
the time, but for much of the time. Goodwill and
cheerfulness are the characteristic keynotes of
the groups, despite often quite acute problems,
conflicts and difficulties - no matter what
happens, the sense of the potential goodness of
the group remains. Sometimes we agree to play -
go for walks, explore town or countryside, make
music, dance, eat and drink together, listen to
each other. Sometimes the issue of "focus" is
openly raised: we ask where we are going, whether
we have yet identified our business. But these
questions rarely stick - the evolving relationship,
the rolling agenda seems to shape itself and we
come to trust ourselves, each other and the momen-
tum we have generated to carry us forward. In
some way the results of this "research" might be
thought to be ephemeral. They are not communicated
in terms of reports or quantifiable findings. The
Group itself becomes the art work, the research
outcome, and, like a musical or dramatic perfor-
mance survives only in the lives of those who par-
ticipated in it. It is formative rather than
informative. Not that the lessons learned could
not be generalized or communicated discussively in
some sense. But persuasion here waits upon parti-
cipation - which is the way of the arts.

And the end of all our exploring
Will be to arrive where we started
And know the place for the first time.
(T.S. Eliot, *Four Quartets*)

* * * * *

I have cited my work with Open Groups as an example
of research based upon the artistic paradigm. I
feel the claim to be reasonable because I find a
close parallel between the way these groups work
and the way creative artists work. The formal out-
come is less substantial than a painting or a poem,
more like the transient experience of a musical
improvisation. Nevertheless its impact can be
immensely productive, and it would be easy to
check on the validity and reliability of the claims
made for it by investigating the participants.
Attempts on some occasions to document progress
(by means of personal journals for example) have
provided illuminative criticism of the on-going
experience. Whereas my groups tend to be rather
arbitrarily constituted and to have their research
topic, albeit fairly loosely, identified by the
University, there is surely scope for similar kinds
of enterprise among groups wishing to identify
their own field or problem. Senior staff in a
school for instance might agree to work upon the
notion of "leadership"; pastoral teachers might
look at some aspect of their special concerns; a
class teacher could adopt this procedure as a way
of exploring specific human and moral issues with
a class. All such enquiries, utilizing the Open
Group approach, would constitute research teams,
and their "findings" could be assimilated directly
into their lives. We are not talking about simu-
lation or rôle-play exercises here - we are

TAE-G*

confronting actuality, our real feelings, real
behaviour, in real situations.

I am aware that I have ignored many perhaps more
obvious research rôles for the arts. In this brief
paper it has not been possible to develop these
ideas exhaustively. One of the most obvious
developments might be in the production of art work
that directly impinges and comments upon particular
situations - e.g. resident artists employed not
simply to do their own thing in schools and
colleges or to act as surrogate teachers, but to
provide those places with a reflection of them-
selves. A traditional and far from insignificant
rôle, though one the research potential of which
remains almost entirely unexplored. The arts
staff might be asked to provide just this sort of
an illuminative service for their own institution
or community. Within academic institutions such
as mine we should be prepared to make our awards
to men and women whose preferred research skills
are artistic, rather than accommodating only those
with scientific and literary skills. If, as I
maintain, the arts are a way of knowing, they are
also, surely, a way of researching. And if the
arts don't fit into our present conception of
research, it is that conception that needs changing.
The monopoly imposed by the all-pervading scient-
ific paradigm must be broken. When we ask of any
piece of research, as ask we must, "Does it add
up?" we should recognize that to be effective a
work of art must add up in its own way too, every
bit as much as the statistician's sums. Together
they might add up to a more comprehensive, more
balanced account of the real world. It isn't
simply medicine that needs to be holistic; we need
an holistic approach to research.

"Healing"
Papa would tell me,
"is not a science,
but the intuitive art
of wooing Nature"
 (W.H. Auden)

Research too needs perhaps to be more like an act
of courtship.

Can we begin to think through some of the possi-
bilities of a research methodology that embodied
the artistic or aesthetic principle? Leaving
aside the actual deployment of works of art as
ways to understanding, what other forms might our
open, creative or arts-based research take? What
research practices might be seen as appropriate
and valuable? What skills or qualities might
characterize the artist-researcher? The following,
somewhat arbitrary sketch, constitutes the beginning
answers to these questions.

In what sense or senses can the artist-researcher
deploy the skills associated with artistic making
and performing as ways of researching? If we take
making first, there is surely scope for a form of
action-research - better described as inter-action
research - that brings researcher and researched
into the simbiotic relationship of maker and
medium. The researcher seeks to reconstitute the
expressive "surface" of the subject (an individual,
a group, an institution, a process or procedure)
through interaction or reciprocation that explores
possibilities, discloses needs, fulfils promise
and establishes a new entity, respectful of the
autonomy of both partners. So, making becomes a
mode of finding, of discovery, a channel of

insight, a means of epiphany. "Results" could be
communicated through critical appraisal, through
reproductive and reprographic techniques and by
direct, face-to-face encounter with the research
"product". People could simply be invited to come
and see for themselves. It would, in other words,
be treated in exactly the same way as an artwork.
We ought, with this kind of work, to be satisfied
that the researcher deliver the creative product
and not demand a discursive account, a commentary
or paraphrase to legitimize the work. The valid-
ation process is really the responsibility in the
first place of the audience or general reader. If
an objective assessment and an interpretive account
were felt necessary - perhaps in the general
interest of accessibility of results or as a prior
condition to the conferring of an award - this
could be separately undertaken by an assessor in
the rôle of critic. With research work of this
kind the various artistic rôles would break down
in the following way:

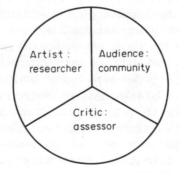

If an illuminative interpretation were required it
would be the assessor's job to provide it. We
should not demand of the artist-researcher skills

of a discursive kind.

Performance requires the interpretation of
another's "score", and its enactment or activ-
ation - i.e. its realization - in terms of the
researcher's interpretive and performance skills.
The artist-researcher might accept to test a situ-
ation, a particular approach or methodology by
directly working within it, i.e. by becoming the
agent or instrument through which the required
realization or test might be achieved. The
"scores" to be tested through enactment might be
"old" or "new". It would once again be the task
of the assessor as critic to provide an interpret-
ation, and, if necessary an appraisal, of the
researcher's performance. The attraction of this
approach lies in the light or insight a disinteres-
ted participant might shed upon a situation other-
wise contaminated by various kinds of involvement.

The "reading" of phenomena in the world as artistic
or aesthetic objects is well established in the
"found object" tradition. This actually requires
that the observer (our researcher as "audience")
treat the phenomenon in question as an art object -
as an open-textured symbol requiring imaginative
extension and apprehension. The imaginative gaze
or ear might be turned in this manner upon any
aspect or feature of the educational object world
and its expressive meaning apprehended. We are
talking here about the skills of aesthetic apprecia-
tion whereby we grasp the aesthetic significance
of objects as "affecting presences". For such
responses to become public, the researcher-as-
audience or as-reader would need to exercise the
discursive and interpretive skills of the art
critic.

I said that these were but a beginner's thoughts.
I do not doubt that many of my readers would be
able easily enough to extend and cap these notions
of mine from their own experience. It would I sus-
pect also be a simple matter to find examples of
"alternative" or so-called "naturalistic" research
that similarly challenge the restricted traditional
view and deploy some of the artistic skills I have
referred to here. None of which would either
invalidate my plea for a more holistic approach to
educational enquiry, or exhaust the possibilities
of a truly arts-based research. I will conclude
by offering a list of skills and qualities which I
would expect, in one degree or another, to charac-
terize the research techniques I have been advocat-
ing. Readers of Victor Heyfron's article on
Creativity included elsewhere in this volume will
recognize my debt to him.

1. Productivity: the artist-researcher will
 realize his/her findings
 as substantive forms,
 capable of "objective"
 appraisal.

2. Imagination: the art-research product
 will take the form of an
 "open-textured" symbol.
 It will operate iconically
 rather than discursively.
 It will be located in the
 imaginative experience of
 the maker and the reader.
 As critical appraisal it
 will operate expressively.

3. Disinterestedness: the capacity for "free"
 production and appraisal,
 that allows for the open,
 self-determination of the
 product.

4. Originality: the ability to render par-
 ticular insights, i.e. to
 present findings as the
 unique, living experience
 of particularities having
 general implications
 (rather than the reverse:
 generalities with particu-
 lar application).

5. Expressivity: having the ability to
 exploit the expressive
 potential of the chosen
 research medium.

6. Signification: the ability to sense
 intuitively the problem
 or need that is to give
 point and significance to
 the expressive act, and
 to represent it effect-
 ively.

My white-coated friends might call this kind of
thing "Research in a Smock." For my part, I take
heart from these lines of the poet John Donne:

 "... though truth and falsehood bee
 Near twins, yet truth a little older is;
 Be busy to seeke her, believe me this,
 He's not of none, nor worst, that

seekes the best,
To adore or scorne an image or protest,
May all be bad; doubt wisely; in
 strange way
To stand inquiring right, is not to
 stray;
To sleepe, or runne wrong, is. On a
 huge hill,
Cragged and steep, Truth stands, and
 hee that will
Reach her, about must and about must goe;
And what the hills suddenness resists,
 winne so."

 (Satyre III)

Utilitarianism, the Arts
and Education

ALAN SIMPSON

The two assumptions that underlie this paper are
so commonplace as to be platitudinous: one is that
utilitarianism dominates education as it does our
society in general, and the other is that the arts
are non-utilitarian, or as Wilde said, "All art is
quite useless".[1] Although there is nothing partic-
ularly new in the view I wish to put forward,
nevertheless I believe it needs to be constantly
reiterated and reinforced. Philosophical state-
ments about education belong to the "ought"
category rather than the "is" category; they are
largely a matter of advocacy of value-judgments.

I should first make clear my use of the word
"utilitarianism". Two uses are distinguished by
Barrow;[2]

(i) The "vulgar", which is the ordinary sense in
which something is useful in achieving some
desired end.

(ii) The "technical" sense, which is "grounded on
the premiss that what matters ideally is a
world in which everyone is happy".[3] There-
fore we must try to minimize states of
unhappiness and all practical and moral

187

questions must be resolved according to the
contribution to general happiness.

Perhaps I should mention a third more limited use,
but one which I do not intend to employ; that
which applies "utilitarianism" strictly to the
philosophies of Bentham and Mill.

Barrow distances himself from the vulgar everyday
use of "utilitarianism", from that employed by
MacIntyre, whose paper "Against Utilitarianism"[4]
he claims to be "not recognizably against utili-
tarianism at all"[5] and, for that matter, from any-
body else who, according to his view, gets it
wrong. Whilst admitting that words are quite
often misused and misunderstood, I am afraid I
cannot accept Barrow's distinction entirely, for
common usage may sometimes be trivial, but is as
often quite consistent with his account of utili-
tarianism. We generally speak of means and ends
as "useful" "worthwhile", "good" etc. with approval
and with the expectation that they will bring some
measure of satisfaction or happiness, or go some
way to create the conditions in which people might
be happy. Barrow gives the example of teaching
children to become mechanics or pastrycooks as
utilitarian in the loose sense, neither of which
is necessarily justifiable according to his use of
the term. This may be so, but it is difficult to
see what is wrong with them for mechanics and
pastrycooks contribute to general material welfare
and may be very happy people. Therefore I intend
to use "utilitarianism" in the normal way of
referring to things, particularly our actions, in
terms of means to ends which are generally desir-
able; even to use the term in its broadest sense
may still imply and be encompassed by the overall

notion of progression to the possibility of the
eventual outcome of happiness, and I contend that
this is quite consistent with Barrow's use of the
word.

Utilitarianism - the practical, well-intentioned
view of things - is remarkedly powerful and self-
fulfilling and is in the well-nigh impregnable
position of being so thoroughly embedded in con-
temporary language and thought that it is part, in
the Wittgensteinian sense, of our form of life.
It is so powerful because in so many ways it can-
not be denied. We can only ensure the continuing
existence of ourselves as social beings by agree-
ments in practice and by some sense of community,
and in particular by some sense of communal wel-
fare. We must, as moral beings, judge our actions
by their outcomes. At the most fundamental level,
to have any coherent awareness, i.e. to have any
"experience" at all, we must categorize and con-
ceptualize from our interminable battery of sense
impressions. These basic processes are utili-
tarian - for recognition and for use; is something
dangerous or innocuous, eatable or non-eatable,
how does it relate to us? The most primitive
animal forms must rely upon categorization, even
if it is merely in the form of a genetically pro-
grammed stimulus reaction, but it is continuous
with the sophisticated cognitive conceptualization
that underlies articulate thought and language.[6]
In other words, our ability to make sense of
experience entails a mode of perception that is
essentially utilitarian in the broad sense.

At the level of animal survival, like the proverb-
ial desert-island castaway, we must use objects
and skills, and develop new skills, in order to

live. However, having achieved sufficient mastery
over his environment that he can exist in reason-
able comfort, the prudent castaway neither lays
waste his resources in a mad craze of production
nor in gluttonous consumption, but refines his
means of living; like Crusoe, he finds ways to
enrich his living and thereby retains his sanity.
It is not unreasonable to claim that he retains
his humanity through developing his own micro-
culture. On the other hand, the less fortunate
castaway, either because of the poverty of his
environment, or also because of his own poverty,
i.e. his ignorance or lack of resourcefulness and
imagination, is reduced to brute existence and
may regress to an animal state entirely dominated
by practical needs. In either case he might still
be "happy".

My contention is that utilitarianism, when it is
allowed to dominate society and education, is vul-
nerable to being reductive and ultimately
inadequate. In this paper I shall attempt to
point out some of its dangers, to indicate how it
is antithetical particularly, but not only, to the
arts in education, and to suggest the central
values of the arts in education: the aesthetic
dimension.

MacIntyre[7] identifies three main aspects of utili-
tarianism which I wish to repeat and re-emphasize
here.

(i) The means-end view: everything we do is
 evaluated in terms of its consequencies.
 Each action is instrumental to some desir-
 able end - What is that for? What good is
 it? What use is that?

(ii) There is the implication, as these typical
 questions imply, that consequences are
 assessed on some scale of public usefulness,
 satisfaction, or "goodness": everything
 must come before the bar of public utility.

(iii) These "good" outcomes rely on a notion of
 an overall community of interests: the wel-
 fare of society at large.

The most noteworthy aspect of the criterion of
utility is the vagueness with which it is met.
"Good" outcomes are rarely identified with any
specificity, indeed they are most often tacitly
assumed to be self-evident as in "happiness". It
is patently obvious and reasonable that in any
society, institutions will be valued in terms of
their relevance and usefulness within the social
system. They require general acceptability, there-
fore they are justified in terms which suggest the
widest support; public "interests" and "needs",
whether they are the needs of children, or the
interests of the community. Utilitarianism must
rely on "caring" notions such as "welfare", for
otherwise, if unexamined, it regresses to a state
in which all "uses" end up in producing a happy
society, the utility of which must, in turn, be to
produce a more happy society and so on. It is
also in danger of circularity: a happy society is
one in which we live our most useful lives in
order to produce a happy society. It is not sur-
prising that the justificatory phrases of utili-
tarianism are so persuasive; "the greatest happi-
ness of the greatest number" comforts each and
every one of us with the implication that we must
be in that lot somewhere or other, and who could
seriously deny such a statement? But "happiness"
is not something we can guarantee, nor is it

quantifiable; even if people's idea of happiness
is reduced to some banal notion such as the con-
stant acquisition of material comforts, they are
just as likely to become unutterably bored as to
be constantly happy. Salutary examples of the
dire results of hedonism are available all the way
from *The Rake's Progress* to *Dallas*. "Happiness"
becomes a portmanteau term with its ready, built-
in connotations of approval. It is interesting
that Barrow defines it negatively by saying that
a world in which we are all happy is one "in which
people are not depressed, anxious, alienated,
frustrated, burdened by a sense of guilt or
inadequacy, bored, angry or, more generally,
miserable".[8]

Phrases about the "welfare" of society, or about
the "needs" of groups that might be under-
privileged, carry such an aura of humanitarian
compassion that they are very difficult to ques-
tion. And incidentally, virtually any group can
be made to seem threatened or underprivileged if
the needs are framed in the right way; e.g. the
"bring back the grammar schools" movement is
largely concerned with the "needs" of children
who, in the majority, are by most standards privi-
leged, but who need to be "stretched" in order to
fulfil their potential (and so be happy) and thus
make their important contributions to society (and
so to general happiness). The difficulty is no
less with the clear usefulness of earning a living,
especially if it relates directly to an area of
economic or industrial need. We are told repeatedly
that the country needs technologists and that
children need maths and science in order to
function in the last decades of the 20th century.
It is nonsense to deny such claims entirely, but

their "usefulness" is so strong that it is virtu-
ally impossible to examine them in a remotely dis-
passionate manner.

To be associated with matters of urgent relevance
is something of a double-edged advantage to the
"serious" subjects for they are always at the
mercy of the demand for demonstrable utility. We
are all too familiar with the furore that breaks
out when an industrialist announces that school-
leavers entering his firm can neither spell nor
add up. Children must have the "basics", and to
be any use to society, they must be good at them.
In the Spring of 1983 I heard a most interesting
review of the large-scale testing programme in
science, which has been carried out for the APU
(Assessment and Performance Unit). The colleague
involved explained that when she was called upon
to present a report to the particular government
minister, he showed little interest in the detailed
findings but wanted her to tell him whether or not
the children were "any good" at science. Needless
to say, he decided that they were not. This
example is typical of a politician's concern over
"standards", for clearly such "concern" is in the
public interest. It is the stock-in-trade of the
utilitarianist assumption of grades of public use-
fulness; the mythical scale of which everyone -
"the public" - is aware through some form of
common-sense knowledge. The difficulty with such
deeply embedded assumptions is that of being able
to step outside them. When we are inside the
"thought-system" as Orwell so chillingly showed,
it is self-fulfilling, our expectations are con-
stantly confirmed; Winston Smith was finally happy
when he loved Big Brother.

The ends of utilitarianism are not only vague,
they are also often inadequate. They are typic-
ally characteristized by a fallacious utopianism
which alleges that certain desirable ends are
achievable permanent states, as if they were com-
modities we can possess; "law and order", "educa-
tion", "personal development", even "leisure". I
suggest that this is a corollary of the meaning of
"utility", which may be defined as follows:

> The capacity to satisfy human wants.
> This capacity may be found in goods
> or services, and the worth of such
> goods and services to the consumer is
> determined by the degree to which they
> are capable of satisfying his wants.
> While this degree cannot be objectively
> measured it is reflected in the price
> which the consumer is prepared to pay.
> And in the economic theory the theory
> of value is often equated with the
> theory of prices.[9]

The point is that the wants must be satisfied, and
satisfaction is in terms of goods that are con-
sumed. It is not a case of aspiration towards a
Platonic ideal but of using means to reach an end
that can be obtained. Thus there is the common
assumption that the possession of material goods
equates with possessing happiness, and from the
evidence of TV advertising, which influences and
is influenced by millions, this view would seem to
be confirmed. The consumer industry metaphor is
complete, everything is subject to the same pro-
cess; even holidays are planned, produced, packaged
and sold, along with all the paraphenalia that goes
with them, by the "leisure industry"! This

industry fulfils a "need" in that most people work
in order to obtain leisure and to have enough money
to enjoy it. And although we know that it is
presently not the case, it is feasible to maintain
that this could operate without causing unhappiness
or suffering to any particular group. Barrow may
protest that many people "evidently lack any real
understanding of utilitarianism",[10] but then he
can hardly insist that "the happiness of the great-
est number" means that the majority must conform
to *his* view. If "happiness" is to be available to
everyone, the concept must be one of general con-
sensus, everyone should be able to know quite
freely when he is happy, without first having to
check with what Barrow says. Unfortunately, even
though it may be a benevolent view which eschews
the possibility of harm to others, nevertheless
the popular idea of happiness is quite likely to
be that of the lowest common denominator, which
can still feed off Barrow's high ideal version.
Neither the concept "happiness" nor the qualifi-
cation "of the greatest number", carry any critical
implication about the *quality* of that happiness.

The industrial metaphor and the mistaken, mislead-
ing habits of language and thought that make all
desirable ends analogous to tangible objects, is
endemic in education. To a large extent, it tends
to pervade what politicians have to say about
"standards" and provides an easily assimilated
quantification of educational achievements; e.g.
"70% of children should achieve CSE Grade 4" or
whatever, may be presented in the kind of consumer-
economics shorthand through which we now habitually
receive so much information. More particularly it
pervades the language of educationalists them-
selves; e.g. "expression", especially "self-

expression" still tends to be spoken of as a thing
that the child obtains, which of course fulfils a
"need", which is that of "personal development",
or the satisfaction of becoming a "fully-rounded
personality" - a sort of psychological Michelin
man.

The effects of utilitarian instrumentalism are well
catalogued in the arts in education.[11] First of
all, common assumptions about "usefulness" work in
quite different ways to those associated with sub-
jects such as maths and science. Any question of
the "What use are the arts?" variety, is tendentious
and prejudiced from the start, for the whole idea
of art, or the arts, carries the corollative
notion of non-utility; the arts are autonomous,
their value is intrinsic and not tied to the con-
cept of an end.[12] As a result of this fundamental
difficulty we have the persistent dilemma of the
arts educator and the numerous contortions which
endeavour to prove that the arts are really useful
after all. Most widespread are the various justi-
fications for the arts in which the spin-off is
the production of "better-balanced" and con-
sequently more useful members of society. Fore-
most is that of psychological utility:[13] the arts
enable children to express their feelings and
emotions, (often at no greater level than "letting
off steam") and they are therefore better for it.
A stronger version emphasizes the therapeutic rôle
of the arts more fully and, of course, they *may* be
used in this way. A third, more clearly moral
approach, stresses that the arts deal in and
present "life issues" in a vivid and profound way
and that through sensitive, emotional involvement
and response, we become more sympathetic human
beings. A fourth, rather different slant, which

could conceivably gain some momentum, is that the
arts provide for ways in which people can occupy
their leisure time in satisfying (and happy) ways,
and everyone, so we are told, is going to have con-
siderably more leisure time in the future, whether
we like it or not. To move to another topical
emphasis, this time on rationality; a quite subtly
persuasive justification is that the arts develop
inventiveness in "problem solving" (as in Design
Education) which is demonstrated in semi-technical,
socially relevant projects.[14] One final example
is that of the arts' pedagogical usefulness in
interdisciplinary work in which they become
vehicles for the effective teaching of other sub-
jects. The extent to which the above justifica-
tions are brought forward varies between the
several art forms although those for Drama are
truly remarkable for their range and comprehensive-
ness; anything and everything can be taught through
Drama: as a not unsympathetic but rather weary
colleague remarked recently, "Why limit yourself
to the solar system?"

All the various instrumental claims for the arts
are not without some foundation; e.g. it may well
be that by means of emotional expression in the
arts I achieve some form of psychological develop-
ment and become a more complete, self-actualized,
happy person, and this is by no means unworthy.
Unfortunately it does not necessarily follow that
this will occur. There is plenty of empirical
evidence to show that people engaged in the arts
may well become singularly unbalanced, unhappy,
positively psychotic characters; indeed it is quite
possible to argue that involvement in the arts
will inevitably lead to dissatisfaction and frus-
tration. In other words, the stereotype "mad

artist" is no more or less ridiculous than that of the "mad scientist" - there is neither sufficient reason nor evidence to suppose that the arts unquestionably promote "mental health" or "develop" the emotions. (We might just note that these ends are typically utilitarian in their positive, human-itarian connotations and implications of self-evident value, yet it is very difficult to say just what they mean.)[15]

There remain further aspects or off-shoots of unquestioned, broadly utilitarian assumptions which plague and confuse educational thinking, to some of which I wish to draw attention. These derive from the means-end model and in particular, from assumptions that see mental processes, creative processes and educational processes as analogous to those of industrial production.[16] It may well be that logical deduction is linear, and that the mechanistic analogy is illuminating in various situations, but it is nevertheless an analogy, it does not follow that, e.g. all our creative acts must follow the *same* process. There are several examples, but the variants on "problem-solving" are especially prone to this particular form of reduction. Incidentally, examination of the whole notion of "problem-solving" is overdue; although it has been stimulating and beneficial to many practices in teaching, it has its limitations and to apply it to literally everything renders it vacuous. Secondly, it tends to direct concern only to the practical, to what we might describe as the "immediate surface". It overlooks and undervalues reflection and the perception and con-templation of experiences enjoyed for their own sake in, e.g. the arts and humanities.[17] Thirdly, it can lead to superficiality and facility: if

there isn't a problem, then one must be contrived.
Clearly these dangers are evident in Design Educa-
tion where all problems are reduced to technologi-
cal problems which are solved by *the* "design pro-
cess"; roughly, "situation and brief - specifica-
tion - solutions - realization - testing".[18]

The above approach is determinedly and behaviour-
istically "objective", but the danger of the
mechanistic analogy applies equally to a contrast-
ing, romantic, "subjective" view. Witkin[19] and
his followers identify a mysterious "sensate-
problem" whose ultimate solution is the "expressive
form". Again, the means-end view of expression
can be misleading. It is nonsense to allege that
some random stimulus will produce a "sensate-idea",
as yet embryonic, unformulated but "felt" and that
all that is required is the medium, whether words,
colours, movements, or sounds *through* which "it"
may be expressed. The notion that art objects are
transparent vehicles is fallacious. Just as the
analogy with a spiritualist "medium" is mistaken,
so that with industrial production can lead to con-
fusion; the sequence "raw material - process -
product" is not exactly paralleled by, "idea -
medium - expression". An idea is not separable
from its means of expression; I cannot first think
what I want to say in some strange wordless form
of gut-feelings and, secondly, say it. I can only
think of what I want to say in words. Of course I
can consider alternatives, I can put my idea,
statement or message in other words, I can also
think or imagine, using visual images and also
sounds; I have learned to do so. Because I read
music and sing in a choir, I can "think" musically,
but my thinking is crude compared to that of the
choir's director, although it is likely to be more

sophisticated than that of someone with no musical
skill or experience whatsoever. If "ideas" of
whatever kind were independent of the means of
expressing them it would be perfectly feasible for
me to claim that my dog has some great ideas and
if only I could teach him to speak (paint, dance,
etc.) he would be a great poet (painter, dancer ...)

So far I have tried to point out some of the
inadequacies of utilitarianism in its strict sense,
in its broad use, and in notions that are readily
associated or confused with it. These may be
summarized as follows:

1. The aim of general happiness is comforting but
so open that it is vulnerable to the widest
interpretation and easy incorporation of
virtually any instrumentalism.

2. Crucially, it does not logically carry a
critical dimension about the quality of
happiness, and utilitarians are obliged to
graft on moralizing recommendations which pur-
port to democratic interest.

3. "Happiness" and related ends such as "welfare",
"public interest", or in education, "personal
development", even "self expression", are
vague and intangible but yet have such "good"
connotations that they are often difficult to
question.

4. Some curriculum subjects carry a similar, near-
impregnable aura of "usefulness", whilst the
reverse is the case with the arts.

5. The instrumental, means-end model leads to
 various justifications for the arts in educa-
 tion which, alone, are difficult to substan-
 tiate but easy to dismantle.

6. The means-end emphasis comfortably embraces
 and fortifies views that see, e.g. educational
 development, and the expressive or creative
 process, in terms analogous to that of mechani-
 cal production.

On the other hand, as I acknowledged initially,
our lives are inevitably, and in all manner of
ways, dominated by practical concerns. It may well
be that a great deal of what we do, from the most
simple to the most complex, is founded on the
pleasure-pain principle which itself is fundamental
to utilitarianism. In its "technical" sense, util-
itarianism is eminently defensible on moral grounds
because of its necessary implications of consider-
ation and compassion, for its cheerful, benevolent
aim is "to promote happiness with equal concern
for the happiness of all."[20] And perhaps we could
do worse than turn the world into one vast Disney-
land. Secondly, we must concede that we employ
the term and the whole notion of "usefulness" in
the broad sense and that we are bound to do so if
our lives are not to become intolerable. From
day-to-day we must make thousands of instantaneous,
pragmatic decisions as well as more carefully con-
sidered ones, if we are not to utterly waste our
energies and collapse into disorder. Thirdly, it
may be argued that the whole concept of value is
essentially utilitarian. When we maintain that
something is worth doing for itself, this is just
another way of saying that we gain a great deal of,
e.g. satisfaction, intellectual stimulus, enrichment

of knowledge, vivacity of perception, or simply,
pleasure, from the experience. The utilitarianist
insists that the only intrinsic value is pleasure,
however, as the foregoing examples indicate, the
argument is difficult to counter only if we are
content to use "pleasure" as a portmanteau word.

Even so, the distinctions between instrumental and
autonomous arguments are not always so stark as
might be supposed. A difficulty that shrouds many
debates about areas of the curriculum applies to
education as a whole. The question, "What use is
education?" is utilitarianist, as is the assertion
that everyone needs education. To maintain that
education is worthwhile in itself is to take an
autonomist position, but what is it to insist that
education is, or should be, worthwhile for every-
one? Here I merely wish to point out, while recog-
nizing de-schooling arguments, etc. that common-
place assumptions about universal, egalitarian
education have developed very recently and are
imbued with both utilitarianism (whether "pure" or
not) and autonomism, and with complex entanglements
of the two, such that it might be fruitless and
misconceived to try always to separate them and,
incidentally, to assume that educational debate
about value should only be in terms of this
dichotomy. My complaint in this paper is that
utilitarianism is currently so dominant that its
impact on education as a whole is that of distor-
tion and reduction,[21] and that its effects on the
arts are signally subversive and debilitating.

Before turning to some fundamentally important
aspects of the arts in education, I wish to discuss
briefly the notion of intrinsic value. Although
if we push this line too far we end up in solipsism,

I suggest that it is helpful to assume that we can
only properly conceive of the peculiar nature of
the intrinsic qualities of some pursuit, discipline
or activity, by virtue of being, or having been,
"on the inside".[22] In his sound criticism of
White's category distinctions[23] Barrow refers to
the category of "appreciation of works of art" and
agrees that "you cannot explain what appreciating
art is like to those who do not appreciate it" and
he goes on, "But then no more can you explain what
enjoying cricket is like to those who do not play
it".[24] Similarly, in the film *Born Yesterday*
Broderick Crawford was "outside" in his rôle of
coarse, bullying, self-made man, both worldly-wise
and ignorant and his perception of "education" was
limited to the end of obtaining social entrée. In
itself, education was useless, it was the by-product
of acceptability into influential society that he
valued. (By no means a fallacious or uncommon
view, if the health of the "public school" system
is anything to go by.) However, as the education
of his "dumb broad", Billie Holliday, progressed, it
was not just that she saw him and his world in an
entirely new light but that communication between
them became more and more at odds and he could not
comprehend what was happening nor why. The con-
cepts and critical outlook she was bringing to bear
just did not make sense to him. A further point is
that a particularly despicable aspect of the char-
acter played by Crawford was that he *used* people:
lawyers, Congressmen, even the girl for whom he
had genuine affection was to have been instrumental
in his schemes. Such an attitude appals us for,
as Kant stressed, people are not *things* we use but
they are *persons* "because their nature already
marks them out as ends in themselves."[25] The
analogy is limited but perhaps it is useful in

illuminating the frustrations, misunderstandings
and misinterpretations to which those of us who
try to propound the intrinsic value of the arts in
education, are subject. Thus the dedicated utili-
tarianist has difficulty with the whole notion of
intrinsic value except in so far as it is reduced
to pleasure, which of course is the means to happi-
ness. There are many examples of the consequencies,
but two may suffice; one is to trivialize the arts
into decorative, silly appendages; the other, more
concerned and serious, is to attempt to turn them
into a profound moral force with the resounding
claim that the arts deal with "life issues".

There is a danger that in attacking the inadequacies
of one or more views, of implying that there is
only one true answer, one real value; albeit a
metaphysical reality. I do not subscribe to the
fallacy of the tendentious singular, for the arts
are complex areas of human activity and any attempt
to delineate them within a precise boundary or to
identify a white-hot centre is doomed to failure.[26]
Nevertheless, I still maintain that the arts do
have central characteristics that are of fundamental
human value and accordingly, of value in education.
I have not tried to destroy utilitarianism, for so
many aspects of life are bound to be utilitarian.
My thesis is that utilitarianism which is not
critically and rigorously examined becomes either
vacuous or dangerous, perhaps both.

The many utilitarian features of the arts are very
worthwhile. It not only *may* be that they develop
the emotions, illuminate moral problems, develop a
variety of skills which may prove socially and
individually useful, enable people to enjoy reward-
ing leisure pursuits, etc., etc.; the arts very

often *do* have such outcomes and many others, which are facilitated by committed and imaginative teaching. Furthermore when such ends do occur, they are not entirely separate from the means by which they are achieved. In other words, the very involvement in the art activity is inextricably related to the outcomes. It is this relationship which underpins the idea of the arts as a "way of knowing". But there is also the possibility of a whole variety of tangential and even accidental or negative offshoots dependent on all manner of contingencies, thus it does not necessarily follow that certain results will always obtain.

Clearly the arts have many features and may be characterized in a number of ways; a strong epistemological thesis is that they provide means of expression and ways of exploring the world that are unique and untranslatable. From this point emerge several observations about their rôles and value. First, we can only make this claim because the arts have consistently been a fundamental part of the evolution of our culture[27] in the broadest sense. Historically they have changed, fulfilled different rôles and so on, but they are so crucially a part of our evolution that it is incoherent to think of mankind without them; just as it is for, e.g. mathematics, religion, philosophy, science, to the extent that they make us what we are. Second, we can regard the arts as "languages" or "forms of representation", and the development of "literacy" in these forms is vital to any conception of wholeness and balance in our education. Third, they especially emphasize personal, idiosyncratic and creative expression. Much of the work in the arts which takes place within education is not creative in the public

sense of marking great achievements and signifi-
cant extensions to man's knowledge; rather it is
creative in the trivial sense of being limited to
the narrow compass of an individual's experience
and fulfilment, but it signals our valuing of the
individual and of how his creative expression, no
matter how slight, is internally related to what
we might call the strength of his inner life, his
identity, or to him as a *person*.

In conclusion, I shall present one further reason
for the value of the arts in education which I
hope will be convincing and which might demonstrate
the reason for my rejection of untrammelled utili-
tarianism. This case is crucial to the proposal
that the arts provide the aesthetic dimension in
education, and to its *meaning*. I do not subscribe
to the use of the word "aesthetic" as merely a
glib, fine-sounding slogan.

Fundamentally the arts are characterized by a
perceptual stance that is contrary to the habits
of practical life in general and the utilitarian
attitude in particular.[28] In the arts we find,
delight in, and create form and order for its own
sake. We may at the same time do many other sorts
of things, but our caring about the form of what
we "say" is crucially aesthetic and is what differ-
entiates and distinguishes such "statements" as
works of art. Our primary interest is in the work
itself, the rest of the world goes by; or to put
it another way, our attention is "disinterested",
we artificially confine ourselves to the apprehen-
sion of the particular. It may be argued that
attention of this kind is "natural" and that it
precedes all other forms of attention on the
grounds that very young children attend to things

just for the joy and fascination of doing so, and
that they have to *learn* the "proper" uses until
the practical, utilitarian mode of perception is
totally assimilated and, in turn, becomes "natural".
A well-known story about Picasso is that he claimed
that he spent his whole life in trying to paint
like a child; a remark which is not unreasonably
interpreted as saying that he wished to see and
respond with a directness and spontanaeity not
governed by formal rules, conventions, or simply,
the *ordinary* way of looking at things. The
ordinary way of looking at anything is utilitarian,
in both the special and the broadest sense. It is
the antithesis of the aesthetic and artistic way
of regarding things,[29] which is decidedly not
ordinary. Of course, there are many cases where
the subject matter of art is mundane, from kitchen-
sink drama to Van Gogh's chair, but the way the
artist brings our attention to such things is quite
extraordinary and we often feel that we have never
noticed these things before, it is as if we were
really seeing them for the first time.

My case may be rejected on the grounds that I am
merely resurrecting the "aesthetic attitude"; a
theory that is no longer useful[30] and worse, it is
indelibly associated with an outmoded class system,
it is élitist and a prop to the art establishment
(and the political status quo) and quickly degener-
ates into "aestheticism".[31] I do not deny that
the notion of the "aesthetic attitude" is prone to
abuse, which is one reason why I have no great
desire to have my view so labelled. I have
already argued against tendentious, reductive
assumptions. Secondly, there *are* dangers of
élitism (in the pejorative sense) and regression.
However, I refuse to confine the use of the word

"élite" to the expression of sneering disapproval,
for any view of education that is at all develop-
mental or aspirational in character, that is bent
on improvement, may be described as "élitist".
Thirdly, I contend that the mode of attention
which we describe as "aesthetic" is a basic human
faculty or characteristic[32] that is exemplified in
a naïve and primitive form by all of us at some
time or other when we stop, if only for the briefest
moment, and attend to some phenomenon just for the
fascination of it, and without any other reference.
I hasten to add that *education* in the arts is con-
cerned with learning and the development of skills
that derive from and relate to this perceptual
stance. It includes a lot more besides, for the
arts are a diverse, multifaceted, yet inter-related
cluster, but fundamental to them is what we might
describe as perception for its own sake.

Thus, in summary, the arts in education are con-
cerned with appreciation in the broadest and richest
sense, which embraces the artist as well as the
observer, i.e. the perception of the one in the
creative act and of the other in what is fruitfully
considered as the re-creative act. Furthermore,
this is of value in itself without need of being
explained away by utilitarianist justifications.
This echoes and is consistent with Denis Donoghue's
complaint that the tendency to account for art in,
e.g. psychological or sociological terms, may give
insights into individuals or society but tells us
little or nothing about art itself. As he said,
"In one way the arts are useless: they won't cure
a toothache. But in another way they are really
momentous, because they provide for spaces in
which we live in total freedom".[33] In other
words, the arts are of value in themselves. My

thesis is that value in education is not only
oriented to external ends, it is *apparent* in the
discipline or activity itself independently and/or
irrespective of future considerations or outcomes.
Thus a central aspect of the value of the arts in
education is *manifest* in the mode of perception
which distinguishes them from ordinary perceptions,
as well as from those characteristic of other
disciplines. It is also manifest, as I suggested
in many other aspects of these complex, unstable,
frustrating and singularly human pursuits. I began
by recalling Wilde and shall end, without qualifi-
cation or apology, with Pater:

> Art comes to you proposing frankly to
> give nothing but the highest quality
> to your moments as they pass, and
> simply for those moments' sake.[34]

REFERENCES

[1] Oscar Wilde at the end of his Preface to *The
Picture of Dorian Gray*, Ward Lock, 1891.
[2] Robin Barrow, *Common Sense and the Curriculum*,
George Allen and Unwin, London, 1976, p. 84,
section 2, also p. 102, note 6.
[3] Ibid. p. 84.
[4] A.C. MacIntyre "Against Utilitarianism" in *Aims
in Education*, ed. T.H.B. Hollins, Manchester
University Press, 1964.
[5] Barrow, *op. cit.* p. 85.
[6] I am indebted to Harold Osborne for this point
[7] MacIntyre, *op. cit.*
[8] Barrow, *op. cit.* p. 84.
[9] Allan Bullock and Oliver Stallybras (eds.)
The Fontana Dictionary of Modern Thought.

Fontana/Collins, 1977, p. 657.

[10]Barrow, *op. cit.* p. 85.

[11]See, e.g. Elliot Eisner's discussion of what he terms *"contextualist"* justifications for Art Education in his *Educating Artistic Vision,* Collier-MacMillan, London, 1972.

[12]This description may be said to be the modern idea of art which has evolved at least since Kant's *Critique of Judgment* and is now engrained in our cultural traditions and attitudes. But it has not always been so, nor is it necessarily so in every society throughout the world today. This point has often been made with typical eloquence and wisdom by Harold Osborne.

[13]Herbert Read's *Education Through Art,* Faber, London, 1943, remains the classic exposition of this view.

[14]See, e.g. John Eggleston, *Developments in Design Education,* Open Books, London, 1976.

[15]See, e.g. R.S. Peters *Mental Health as an Educational Aim* in Hollins, *op. cit.*

[16]It may, with some justification, be objected that at this point I am straying away from utilitarianism. Whilst this might be conceded, I would maintain that utilitarianism and the instrumentalism which I am now discussing, are not entirely unrelated and have in common the pitfalls inherent in the means-end model.

[17]For a thoughtful and scholarly discussion of the notion of "the humanities", see Albert William Levi, "The Humanities: Their Essence, Nature, Future" in *The Journal of Aesthetic Education,* Vol. 17, No. 2, Summer, 1983.

[18]See Eggleston, *op. cit.* p. 21.

[19]Robert W. Witkin *The Intelligence of Feeling,* London, Heinemann, 1974.

[20]Barrow, *op. cit.* p. 89.

[21]I believe this is MacIntyre's point which, with respect, I hope I am re-emphasizing.

[22]A notion that Louis Arnaud Reid has explored very fruitfully, e.g. his *Meaning in the Arts*, George Allen and Unwin, 1969.

[23]J.H. White, *Towards a Compulsory Curriculum*, Routledge and Kegan Paul, 1973.

[24]Barrow, *op. cit.* p. 72.

[25]This is taken from a more full quotation from H.J. Paton, *The Moral Law* (translation of Kant's *Groundwork of the Metaphysic of Morals*) Hutchinson 1962, p. 96, in the paper by Terry J. Diffey, "Aesthetic Instrumentalism" *The British Journal of Aesthetics*, Vol. 22, No. 4, pp. 337-49, and which, in my view, is a signally perceptive and timely analysis of the instrumentalist - autonomist argument.

[26]Wollheim's destruction of this fallacy is especially masterly, see *Art and Its Objects*, Harper Row, 1968, section 39.

[27]The cultural-epistemic approach underlies many views, e.g. P.H. Hirst "Liberal Education and the Nature of Knowledge", R.D. Archambault (ed.) *Philosophical Analysis and Education*, Routledge and Kegan Paul, 1965; also Ernst Cassirer *An Essay on Man* Harvard U.P., 1944.

[28]This point has again been made most convincingly by Harold Osborne, see e.g. his "The Cultivation of Sensibility in Art Education" *Journal of Philosophy of Education*, Vol.18, No.1, 1984.

[29]Here I have deliberately conflated "aesthetic" and "artistic" but there are many occasions when they are, and should be, clearly distinguished.

[30]George Dickie in his "The Myth of the Aesthetic Attitude" *American Philosophical Quarterly* Vol. 1, No. 1, 1964, argues that the notion has outlived its usefulness.

[31]R.K. Elliott points out the dangers of "aestheticism" in his paper Aestheticism, Imagination and Schooling: a Reply to Ruby Meager. *The Journal of Philosophy of Education*, Vol. 15, No. 1, 1981.

[32]Here I realize that I am implying a metaphysical account of what it is to be human.

[33]Denis Donoghue "The Arts Without Mystery" BBC Reith Lectures, 1982, printed in *The Listener*, 11 Nov.-16 Dec., 1982, lecture 6.

[34]Walter Pater *The Renaissance*, MacMillan and Co. Ltd., 1873, conclusion.

Questioning the Curriculum: Arts, Education and Ideology

JANET WOLFF

It is a major limitation of much of the literature
and debate on arts education, including contribu-
tions to earlier volumes in this series, that the
two central terms - "arts" and "education" - are
rarely subjected to serious sociological or his-
torical examination. Of course, there is plenty of
discussion of what is meant by "art" (for example,
in Chapter 2 of Maurice Barrett's *Art Education: a
Strategy for Course Design*).[1] There is a common
recognition, too, that "art" includes a variety of
practices, disciplines and media, which may have
implications for differences in teaching. The
second part of Robert Witkin's influential book,
The Intelligence of Feeling, for instance, con-
siders separately the teaching practice in English,
drama, art and music;[2] the report of the Leverhulme
SRHE seminar on *The Arts and Higher Education*
devotes long and detailed sections to six different
art disciplines.[3] One or two writers have pointed
out that the dominant conceptions of what consti-
tutes "art" exclude the cultural activities of
large sections of our multi-cultural society, and
depend on the definition of a small élite: examples
of this are Chapter 3 of the Gulbenkian Foundation's
report, *The Arts in Schools*,[4] and the essays by

Michael Golby and Horace Lashley in the first
volume of this series.[5]

In this essay, I want to argue that these inter-
ventions do not go far enough. It is not simply a
question of avoiding a vague or undifferentiated
notion of "art", or even of insisting on the
inclusion of other cultural practices and arti-
facts, not previously granted the status of "high
art" in society or in the curriculum (photography,
film, craft, ethnic arts, for example). Indeed,
the point is that these marginal or excluded forms
and media *cannot* be incorporated on equal terms,
given the historical development and present nature
of both our education system and our "cultural
heritage". For the institutions of culture and of
education are founded in basic inequalities and
power relations in society, and in various complex
(and sometimes contradictory) ways, they confirm
and maintain those inequalities and relations. I
shall go on to review some of the recent work in
the sociology of education and the sociology of
culture, which exposes the ideological nature and
function of art and education (and, *a fortiori*, of
art education), particularly in relation to the
inequalities of class and of gender in our society.

The liberal view of education sees education as an
independent and neutral system, dispensing
knowledge, and operating to redress inequalities
and offer the possibility of social mobility.[6]
The rise of the present system of education is
taken as part of the extension of "civilization"
and the democratization of culture from an élite
to the whole population. A close look at the
social history of schooling, however, reminds us
that institutions, including educational ones, do

not develop in a vacuum, and that the origins of
the existing educational system lie in the particu-
lar social and economic conditions of the nine-
teenth century. Richard Johnson has traced the
early history of mass schooling in England, show-
ing its connections with the industrial revolution
and the changing class structure in the period to
1850.[7] From its origins in the Sunday School move-
ment of the early 1780s, through the monitorial
day schools of the early nineteenth century, to
the sustained growth of educational provision in
the 1830s and 1840s, the concern of educators with
the need to control the population is evident.
Johnson documents this in the language of contemp-
orary writers; the monitorialists in particular
talk in terms of "habits of order" and "inner
restraint". In relation to this, Johnson considers
the alternative aims of teaching occupational skills
and of extending literacy as of secondary import-
ance to the educators and educational theorists.
The period of the mid-nineteenth century was one
of the consolidation of the economic and political
power of the bourgeoisie, and of the rise of insti-
tutions and ideologies which legitimated this
power. The extension of the franchise, the
improvement of conditions of life (housing, sani-
tation, the provision of parks), the shortening of
the working-day through legislation, and the trans-
formation of popular culture to render it compat-
ible with a capitalist economic system and a capi-
talist ethic,[8] were some of the means through which
the values of the middle-class began to permeate
the whole society. The decline of radical working-
class politics, particularly the demise of Chartism
in the late 1840s, is related by Johnson more or
less directly to the success of middle-class
endeavours in the field of education, which was

one of the key arenas in which ideology was con-
veyed. For the educators, whether Sunday School
teachers, philanthropic workers, or liberal educa-
tionalists, as well as those involved in the set-
ting up of educational establishments, were them-
selves members of the middle-class (though not its
ruling fraction of industrial capitalists, bankers
and merchants).[9] In the following period, too, up
to the 1870 Education Act, the class basis of
developments in schooling are clear; Harold Perkin,
in his book on the social history of England after
the industrial revolution, refers to the commis-
sions and legislation of this period (1850 to 1870)
as "the complete triumph of the entrepreneurial
ideal throughout education".[10]

The origins of the present educational system,
then, lie in the particular social and economic
features of that period which saw the birth of
contemporary education. Similarly, developments
in educational theory and practice in this century
have been closely related to the needs of the
economy and the social and ideological concerns of
policy-makers and educationalists.[11] The sociology
of education, in America and in Britain, has looked
closely at the connection between educational
ideals and the specific features of contemporary
capitalism. This approach, like the social history
of education already discussed, is far from a
reductionist account which sees education as
simply the ideological tool of the bourgeoisie; on
the contrary, it is fully aware of the contradict-
ory ideas present in liberal philosophy and mani-
fested in schools themselves. For the very
ideology of "neutrality" often preserves education
from the encroachment of the State, and provides
the basis for the development of critical or even

radical thinking. (Hence, for example, the
colleges and universities in both countries were
the locus for student protest and the politics of
the New Left in the late 1960s.) But in general,
legislation (the 1870 Act and 1944 Act in Britain)
and government intervention into education, either
direct or indirect (through funding priorities, or
through agencies like the UGC) can only be under-
stood in the context of wider political and economic
imperatives. Moreover, other types of work in the
sociology of education have supported the con-
clusions of this "political economy of education".
For example, writers in various countries have
shown how the school system reproduces the class
system, by recruiting differentially and providing
a kind of education which both assumes and rewards
a middle-class pupil. The language of the class-
room and the subject-matter of the lesson are
familiar to the middle-class (and white) pupil,
and congruent with their family backgrounds, in a
way which is not true for working-class (and black)
pupils. From his studies of the French education
system, Pierre Bourdieu concludes that social
advantage produces educational advantage, and that
handicap is therefore cumulative.[12] It is
certainly still the case, despite comprehensiv-
ization and other "progressive" moves in education
in Britain, that a disproportionately small number
of working-class children go to University; a dis-
proportionately high number of students at Oxford
and Cambridge come from public schools; and a
reasonably constant rate of generational reproduc-
tion of the class structure is maintained.
(Paul Willis's book, which is sub-titled "How work-
ing class kids get working class jobs", shows how
the school culture operates to ensure this sort of
reproduction.)[13]

More recently, research by feminist sociologists
has brought to our attention the ways in which the
education system has also operated in a gender-
differentiated manner. Put most simply, the evi-
dence is that education reproduces the inequalities
of sex, just as it reproduces those of class.
Women employed in education cluster at the bottom
of the system - in primary school teaching (though
not as primary school heads), in lower-status
posts in secondary education, and in part-time or
temporary posts in higher education (where, in any
case, their numbers are far lower than those of
men.)[14] Teaching in schools remains gender-
specific, boys gravitating (or being directed)
towards technical subjects and girls to the arts
(again, this division being greatly magnified at
the level of higher education.) Moreover, teaching
practices have been shown to be biased. Teachers
often anticipate a certain type or standard of
work from boys and a different one from girls, an
anticipation which may be self-confirming. In her
study of seven "A" level classes in schools,
Michelle Stanworth found that teachers, male and
female, were more responsive to the needs of the
male pupils, and had more positive involvements
with boys than with girls.[15] Perhaps unsurpris-
ingly, the ideology of gender which pervades our
society is very apparent in schools (as it has
continued to be in the official discourse of
government reports, like the 1959 Crowther Report
and the 1963 Newsom Report.)[16] It is, of course,
important not to overlook the contribution to the
divisive effects of education which is made by
pupils themselves - their own attitudes, aptitudes
and expectations. But these very characteristics,
sex-differentiated though they appear to be, are
produced in socialization, in early experience in

the family, in the first readers children
encounter, and in a multitude of examples con-
stantly visible in the surrounding culture of
television, advertisements, and popular literature.

So far, I have argued that the education system is
not a neutral one; its dominant institutions have
developed in close relationship with wider social
and economic factors, and the curriculum itself
reflects the origins and functions of the school
in maintaining and reproducing a class- and
gender-divided society. In the second part of my
argument, I want to suggest that the arts can be
similarly understood as the product of very
specific historical processes. Moreover, the place
of the arts *in* education raises additional ques-
tions, about the genesis of this part of the
curriculum, and the rôle played by arts education
in schools and in higher education.

Traditional approaches conceive of the history of
art as a history of one artist following another,
one style or period following another, more or
less detached from other social processes. The
persistent myth of the-artist-as-genius perpetuates
the Romantic notion that great artists are unaffec-
ted by their circumstances, and are able to trans-
cend the mundane and the specific in their creative
endeavours. This notion operates to exclude any
social history of art. Recently, however, sociolo-
gists and social historians of art and literature
have raised important questions about the produc-
tion of art, and also of artists, questioning the
orthodoxy that "great" art somehow simply emerges.
Here, we may consider together the particular
effects of both class and gender in producing the
arts. The appearance of any new art form can only

be understood in relation to the circumstances in which it occurs. Ian Watt thus relates the rise of the novel to the development of capitalist society and the creation of a new middle class.[17] William Weber has traced the development of concert life to the period in the 1830s and 1840s in London, Paris and Vienna in which this particular social practice began, arguing that the specific arrangements of this life, as well as differences between the three cities, were the product of the changing relationship between the middle class and the aristocracy, and of the improved economic conditions which favoured the production and sale of instruments and publications to boost and support musical activity.[18] Social historians of art have also related content and style of painting to the social relations in which it is produced, in terms of what Nicos Hadjinicolaou has called "visual ideology".[19] This is not to say that art or literature or music can be reduced to its social coordinates, or that art is merely ideology; neither is it to deny that art can appeal across cultures and across generations, and, perhaps, exhibit qualities and perceptions which appear to be human universals (though some writers would deny this.) It is to point out that art is a social product; that artists are socially located; and that the language of art is itself culturally specific, both enabling and limiting the creation of cultural products.[20]

An investigation of the recruitment and training of artists and writers also confirms the partial and selective nature of the "great tradition". Women have been systematically excluded from artistic production, particularly in music and the fine arts.[21] The social conditions of their existence

have made it difficult or impossible for them to
practise the arts, to have access to training, and
to gain membership of crucial institutions, like
the Royal Academy in London, for most of the modern
period in the West. Although feminist art histor-
ians have rescued from oblivion a large number of
excellent women painters, many of these turn out
to have been the daughters, the wives, or the mis-
tresses of practising male artists, and hence to
have had special access to materials and training,
or else to have been aristocrats, and therefore
financially and socially independent of prevailing
constraints. Even women novelists, who did not
face the same problems of access to training, were
disadvantaged by their lack of freedom to travel,
to meet publishers, and to pass the time in clubs
and coffee houses, where literature and ideas
would be discussed by men of letters. And the
critical reception of writing or painting by
women, which produces innumerable examples of
prejudice on the part of male critics and reviewers
against women (including in the present),[22] has
conspired in the overall social processes which
have preserved "Art" as "male art". At the same
time, those arts in which women have predominated,
and into which they were often pushed by their
exclusion from other forms, have been marginalized
and demoted as "lesser arts" or crafts - for
example, embroidery, flower painting, quilt-making.

We may bring this diagnosis of the sex biases in
the arts up to date, and ask, for example, why
there are so few women composers, or choreographers
of classical ballet, or sculptors. The answer will
be a complex one, involving women's own expect-
ations and intentions, prejudices in schools and
arts establishments, and familial and social

constraints which continue to make such a career
more difficult for women than for men. In a study
of an English college of art in the late 1960s,
Charles Madge and Barbara Weinberger found notable
differences in confidence among students on the
Pre-Diploma course, with boys predominating among
those whose confidence had increased after a
series of tutorials.[23] Male students were far
more successful than female in gaining high staff
approval, and hence, in gaining admission to
Diploma courses in Fine Art and Graphic Design;
female students were far more likely to proceed to
courses in Textiles and Fashion. Those who did go
on to follow the Diploma course in Fine Art also
became segregated by sex, the girls working in the
painting studio, and the boys moving over to the
sculpture studio.[24] In another area of the arts,
the recent Gulbenkian Enquiry into *Dance Education
and Training in Britain* notes a general failure to
recruit boys into dance at all levels of educa-
tion[25] (though it also records the beginnings of
changes in attitude here, as well as the keener
interest of boys in contemporary dance than in
classical dance.)

Here, we have moved into the area of art education,
suggesting that it is also responsible for the
processing of arts graduates in gender-specific
ways. As in the world of education, this on the
whole has meant that men end up in the occupations
of higher prestige; even in the dance, where
women outnumber men, it is men who appear more
likely to become choreographers. It should not be
surprising that art education is as sexist as the
society in which it exists. Nor is it as sacri-
ligious as some might think to propose that art
education is in any way open to intervention by

political and social interests. The Schools of
Design themselves were set up as a result of a
Government Select Commission in the 1830s; the
major concern behind this Commission was industrial
design, and particularly increasing competition in
trade from France, where more attention was paid
to design.[26] In the Report of the Commission in
1836, the close link between art education and
industrial design is emphasized with regard to the
proposal for a Normal School of Design:

> It appears to the Committee that, in
> the formation of such an institution,
> not mere theoretical instruction only,
> but the direct practical application
> of the Arts to Manufactures ought to
> be deemed an essential element. In
> this respect, local schools, where the
> Arts reside as it were with the manu-
> facture to which they are devoted,
> appear to possess many practical advant-
> ages. In such situations it is probable
> that the Arts will eventually strike
> root and vegetate with vigour. But if
> a more central system be adopted, the
> inventive power of the artist ought
> equally to be brought to bear on the
> special manufacture which he is
> destined hereafter to pursue. This
> principle is judiciously adopted in
> the Gewerb Institution at Berlin; in
> which, after one year of general
> instruction in art, the pupil selects
> a branch of manufacture as his trade,
> and passes two years in the practical
> application of art to the peculiar
> manufacture which he has chosen.

> Unless the Arts and Manufactures be
> practically combined, the unsuccessful
> aspirants after the higher branches of
> the Arts will be infinitely multiplied,
> and the deficiency of manufacturing-
> artists will not be supplied.[27]

A hundred and fifty years later, such a recommend-
ation about our schools of art is regarded as
heresy. But pointing to the original motivation
for the founding of art education is not to commend
such a utilitarian conception of fine art. It is
to provide further evidence that the idea of Art
as a protected realm is, and has always been, a
myth. The ideology of the essential independence
of art from mundane and practical matters does not
accord either with the history of art and of art
education, or with the actualities of the practice
and learning of the arts today.

The work of the French sociologist, Pierre Bourdieu,
brings together some of the issues I have attempted
to cover so far, identifying the class basis of
both education and the arts. His researches have
been mainly conducted in French schools and museums,
but his arguments have a wider applicability, as
attested to by the inclusion of many of his essays
in translation in a number of volumes on the
sociology of education in Britain and America.[28]
I have already mentioned his view that social
advantage results in educational advantage: that
is, that the "cultural capital" which families
possess on the basis of their class membership is
passed on to the children, who in turn are better
able to take advantage of the equally class-based
educational culture purveyed by the school. Some
of Bourdieu's work has been on the class

composition of audiences for different forms of
art and entertainment, and he has shown, first,
that access to the "high arts" coincides with
educational level, and, secondly, that this in
turn correlates with class position (although
those in the professional and managerial classes
are more likely to acquire cultural capital than
heads of industry and commerce.)[29] The education
system and the arts thus collude in reproducing
social divisions which are reinforced by the
separation of groups on the basis of symbolic
possessions. The presentation of both education
and culture as neutral bodies of knowledge hides
and distorts the fact that access to them is
unequal, and is not simply based on "gifts" and
merit. It is in this sense that Bourdieu and his
collaborator, Jean-Claude Passeron, talk of
pedagogy as "symbolic violence".[30] And the
obverse of all this is that those art forms enjoyed
by the lower middle classes and working classes
are not accorded legitimation by the dominant
culture.

This brings us back to the starting point of this
essay. Although it is crucial to point out that,
for example, ethnic arts are ignored in Britain
and in the education system, the remedy cannot be
simply to devote a couple of teaching periods a
week to ethnic arts - or to the "popular" arts,
like pop music, television and film. This will do
nothing to challenge the hierarchy of the arts
(not least because the public schools and the
major grammar schools are far less likely to be
multi-cultural in the first place, and they will
retain their dominant position in the transmission
of cultural capital, without becoming places for
the introductuon of newer or alternative cultures).

The historical development of the arts in our
society has left us with a heritage which is per-
vaded by the inequalities of class, gender, race
and ethnicity. This cannot be counteracted by any
simple political programme; nor should it be taken
to offer any licence for cultural vandalism or
philistinism. At the very least, though, an
education in the arts should incorporate the self-
reflexivity of an historical and sociological
understanding of both art and education. The
Report of the Gulbenkian Enquiry on *The Arts in
Schools* stresses the diversity of cultures in
Britain. And, while commenting that a good cultural
education brings pupils into contact with other
cultures, it goes on to argue that such an educa-
tion "emphasizes cultural relativity by helping
(pupils) to recognize and compare their own cultural
assumptions and values with these others", and also
"encourages a cultural perspective by relating
contemporary values to the historical forces which
moulded them".[31] Arts education, whether in
schools, colleges or professional arts institutions,
must incorporate this kind of perspective, which
goes beyond the condescension of giving space to
minority groups, or attempting to encourage girls
to try sculpture, and which subjects to a necessary
critical scrutiny the orthodoxies and assumptions
of contemporary arts education.

REFERENCES

[1]Maurice Barrett: *Art Education. A Strategy for
 Course Design*, Heinemann, London, 1979.
 Chapter 2: "What is the nature of art?"
[2]Robert W. Witkin: *The Intelligence of Feeling*,
 Heinemann, London, 1974.

[3]Ken Robinson (Ed.): *The Arts and Higher Education*,
Society for Research into Higher Education,
Guildford, Surrey, 1982. Chapters 6 to 11.
[4]Calouste Gulbenkian Foundation: *The Arts in
Schools. Principles, Practice and Provision*,
London, 1982. Chapter 3: "Arts education and
the cultural heritage".
[5]Michael Golby: "The responsive school", and
Horace Lashley: "Arts education, the curriculum
and the multi-cultural society", in
Malcolm Ross (Ed.): *The Arts and Personal
Growth*, Pergamon, Oxford, 1980.
[6]For an exposition and critique of this view, see
the Introduction to Roger Dale *et al.* Eds.:
*Schooling and Capitalism. A Sociological
Reader*, Routledge & Kegan Paul/Open University,
London, 1976.
[7]Richard Johnson: "Notes on the schooling of the
English working class 1780-1850", in Roger Dale
et al. Eds.: *Op. cit.*
[8]On the transformation of popular culture, see
Robert W. Malcolmson: *Popular Recreations in
English Society 1700-1850*, Cambridge, 1973.
[9]Frances Widdowson argues that elementary teach-
ing, up to about the 1840s, was essentially a
working-class occupation. (*Going Up Into the
Next Class. Women and Elementary Teacher
Training 1840-1914*, Women's Research and
Resources Centre Publications, London, 1980.)
She does not document this, however, her study
being mainly concerned with the period in
which the occupation was recruiting middle-
class women, and in the text merely says that
"Before 1846, teachers had come from a variety
of social groups, although the majority
probably came from working-class homes"; p.15.

[10]Harold Perkin: *The Origins of Modern English Society 1780-1880*, Routledge & Kegan Paul, London, 1969, p. 299.

[11]See *Unpopular Education. Schooling and Social Democracy in England since 1944*, essays by the Education Group, Centre for Contemporary Cultural Studies, Hutchinson, London, 1981.

[12]Pierre Bourdieu: "The school as a conservative force: scholastic and cultural inequalities", in Roger Dale *et al*. Eds.: *Op. cit.*

[13]Paul Willis: *Learning to Labour. How Working Class Kids Get Working Class Jobs*, Saxon House, Farnborough, Hants. 1977.

[14]See, for example, the essays in Rosemary Deem, Ed.: *Schooling for Women's Work*, Routledge & Kegan Paul, London, 1980.

[15]Michelle Stanworth: *Gender and Schooling. A Study of Sexual Divisions in the Classroom*, Women's Research and Resources Centre, London, 1981. For a summary of similar research in the United States, see Gail P. Kelly and Ann S. Nihlen: "Schooling and the reproduction of patriarchy: unequal workloads, unequal rewards", in Michael W. Apple, Ed.: *Cultural and Economic Reproduction in Education. Essays on Class, Ideology and the State*, Routledge & Kegan Paul, London, 1982.

[16]See Ann-Marie Wolpe: *Some Processes in Sexist Education*, Women's Research and Resources Centre Publications, London, 1977.

[17]Ian Watt: *The Rise of the Novel. Studies in Defoe, Richardson and Fielding*, Penguin, Harmondsworth, 1963.

[18]William Weber: *Music and the Middle Class. The Social Structure of Concert Life in London, Paris and Vienna*, Croom Helm, London, 1975.

[19]Nicos Hadjinicolaou: *Art History and Class Struggle*, Pluto Press, London, 1978.
[20]These issues are discussed at greater length in my book, *The Social Production of Art*, MacMillan, London, 1981.
[21]With regard to women in the history of fine art, see Germaine Greer: *The Obstacle Race. The Fortunes of Women Painters and their Work*, Secker & Warburg, London, 1979; and Roszika Parker and Griselda Pollock: *Old Mistresses. Women, Art and Ideology*, Routledge & Kegan Paul, London, 1981.
[22]See, for example, Griselda Pollock's analysis of the critical reception of an exhibition in London of work by women artists: "Feminism, femininity and the Hayward Annual Exhibition, 1978", *Feminist Review*, 2, 1979.
[23]Charles Madge and Barbara Weinberger: *Art Students Observed*, Faber and Faber, London, 1973, p. 35.
[24]*Op. cit.*, p.45.
[25]Calouste Gulbenkian Foundation: *Dance Education and Training in Britain*, London, 1980, paras. 114, 128, 245, 264.
[26]See Quentin Bell: *The Schools of Design*, Routledge & Kegan Paul, London, 1963, and Stuart Macdonald: *The History and Philosophy of Art Education*, University of London Press, 1970.
[27]Reprinted in Clive Ashwin, Ed.: *Art Education. Documents and Policies 1768-1975*, Society for Research into Higher Education, London, 1975, p. 13.
[28]See Notes 12, 29 and 30. Also Pierre Bourdieu: "Systems of education and systems of thought", in Roger Dale *et al.* Eds.: *op. cit.*, and in Michael F.D. Young, Ed.: *Knowledge and Control,*

230 Janet Wolff

New Directions for the Sociology of Education,
Collier-Macmillan, London, 1971. (First
published in *International Social Science
Journal*, Vol. XIX, No. 3, 1967.) "Intellectual
field and creative project", in
Michael F.D. Young, Ed.: *op. cit.* (First
published in English in *Social Science Inform-
ation*, Vol. 8, No. 2, 1968.)
[29]Pierre Bourdieu: "Cultural reproduction and
social reproduction", in Jerome Karabel and
A.H. Halsey, Eds.: *Power and Ideology in
Education*, Oxford University Press, 1977.
(First published in Richard Brown, Ed.:
Knowledge, Education, and Cultural Change,
Tavistock, London, 1973.).
[30]Pierre Bourdiau and Jean-Claude Passeron: *Repro-
duction in Education, Society and Culture*,
Sage Publications, London, 1977, p. 5.
[31]Calouste Gulbenkian Foundation: *The Arts in
Schools. Principles, Practice and Provision*,
London, 1982, para. 55.

Index

231